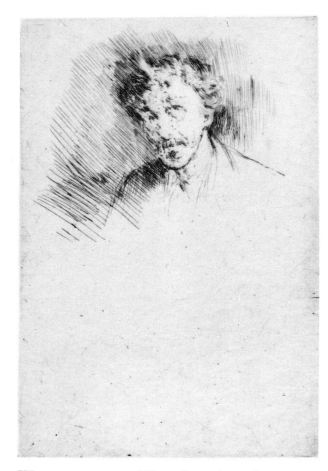

WHISTLER WITH THE WHITE LOCK (K.172)

Etchings of
James McNeill Whistler

JAMES MCNEILL WHISTLER

Selected and Edited by Maria Naylor

DOVER PUBLICATIONS, INC.
Mineola, New York

ACKNOWLEDGMENTS

The editor wishes to acknowledge the invaluable assistance given by the following individuals in the preparation of this book: J. Lessing Rosenwald, Jenkintown, Pennsylvania; Mrs. Ruth Lehrs, Curator, and Anthony Rosati, Assistant to the Curator, Alverthorpe Gallery, Jenkintown; Miss Elizabeth E. Roth, Keeper of Prints, The New York Public Library, New York City, and her assistants Roberta Waddell and Bobby Rainwater. In particular, thanks go to Marjorie B. Cohn, Associate Conservator, and Elizabeth Lunning, Assistant in Conservation, Fogg Art Museum, Harvard University, Cambridge, Massachusetts, for their helpful and unstinting generosity in providing advice and technical information, and for their assistance in the photographing of many of the plates, some made from originals provided by a friend.

Published in the United Kingdom by David & Charles, Brunel House, Forde Close, Newton Abbot, Devon TQ12 4PU.

Bibliographical Note

This Dover edition, first published in 2003, is an unabridged republication of *Selected Etchings of James A. McN. Whistler,* an original work first published by Dover Publications, Inc., New York, in 1975.

Library of Congress Cataloging-in-Publication Data

Whistler, James McNeill, 1834–1903.
 Etchings of James McNeill Whistler / James McNeill Whistler ; selected and edited by Maria Naylor.—Dover ed.
 p. cm.
 Originally published: New York : Dover Publications, 1975.
 ISBN 0-486-42481-2 (pbk.)
 1. Whistler, James McNeill, 1834–1903—Catalogs. I. Naylor, Maria. II. Title.

NE2012.W45 A4 2003
759.13—dc21

2002034975

Manufactured in the United States of America
Dover Publications, Inc., 31 East 2nd Street, Mineola, N.Y. 11501

List of Plates

Introduction

WHISTLER THE PAINTER conducted a series of running battles throughout his career. He involved himself in one struggle after another with critics, fellow artists and the art "establishment" of his day, with his patrons, and even with himself, since he was often dissatisfied with his own canvases.

As an etcher, Whistler had none of these antagonists to contend with: his etchings were hung by the Parisian Salon of 1859 that refused his *At the Piano*, and the London Royal Academy in the following year hung five etchings, together with the painting rejected in Paris. Within five years of publishing his first etching, Whistler had received critical acclaim for his prints, and in 1863 he won a gold medal at an international exhibition in Amsterdam. The British Museum gave him official recognition by purchasing a number of etchings for the Print Room, and continued to accumulate Whistler's work until forced to halt by the belated discovery that the museum was not allowed to buy the work of living artists. Although some critics greeted the initial exhibition of the first Venetian set with scorn, within an extremely brief time the Venetian etchings, with atmospheric effects entirely new to the medium, were considered not only beautiful, but in a way a standard of beauty. Comparisons of his work with that of Rembrandt were often made to Whistler's advantage; and even after years of bitter personal and professional quarreling, Seymour Haden declared that were he forced to part with his own collection of prints, he would let his Rembrandts go before giving up his Whistlers. (He sold both, but the Whistlers went first.)

Though medals and critical praise are not always synonymous with financial success, more than once Whistler's stature as an etcher proved the means of solving various of the financial crises created by his activities as a painter and decorator. Certainly, much of the prosperity of the last years was as much due to the popularity of his graphic work as to the gradual acceptance of his ideas and practices as a painter.

The beginnings of Whistler's career as an etcher stem directly from his dismissal from West Point on the grounds of failure in chemistry. It was 1854 and he was twenty. Faced with family plans to apprentice him as a draughtsman to a locomotive works in Baltimore, young Jimmy went to the Secretary of the Army in Washington, Jefferson Davis, to plead for reinstatement at West Point. Failing in this, he applied for a commission in the Navy, which the Secretary of the Navy also had to decline. This second application, however, led to his appointment to the United States Coastal and Geodetic Survey, headed by a Captain Benham, who had been a friend of the artist's father. The appointment began in the first week of November and Whistler resigned in February 1855.

The work of the Survey consisted of drawing and etching coastal and topographical maps for the government; it was both exacting and tedious. There is evidence that it was his repeated absences from the job, rather than the uncalled-for details he is supposed to have added to plates he worked on, that led to the request for his resignation. (Whistler was paid for less than two weeks' work during the first two months of 1855.)

One thing he did do in these few months

spent in Washington: he learned to etch and bite a plate with great skill. To enliven the dullness of his required tasks, Whistler etched half a dozen little figures upon a plate that was supposed to depict the coastline of Anacapa Island. Preserved by one of his co-workers on the Survey, this plate gives proof that even before he went to Paris to study, Whistler's knowledge of the technicalities of etching was already at the level of the French set, published some three and a half years later. Only his abilities as a draughtsman needed to develop and mature.

After leaving the Survey, Whistler convinced his family with little difficulty to send him to Paris to study art. The family bought him a ticket and arranged to pay him an allowance of $350 annually; by the summer of 1855 he was in Paris. He enrolled in the studio that Charles Gleyre had inherited from Paul Delaroche, but studied as much in the galleries of the Louvre as he did in the studio, and probably as much again in the streets, boulevards and cafés of the surrounding quarters. He entered upon the *vie de Bohème* of an art student with a wholehearted zest possible only to one who knew Murger practically by heart and could count on a quarterly remittance from thoughtful relatives.

The years of his childhood and youth spent in Russia (where his father was building a railroad for the Tsar) and England gave him an outlook on life far removed from the raw provincialism then usually displayed by young American artists on their first trip to Europe; for the most part Whistler found his French fellow students, such as Henri Fantin-Latour and Alphonse Legros, more to his tastes than the English, but his friends also included the Englishmen George du Maurier and Edmund A. Poynter. Other friendships were formed with the artist-musician Becquet and the sculptor Charles Drouet, both of whom Whistler portrayed in prints a few years later. The painter Ernest Delannoy, another friend from this period, accompanied him on the trip to the Rhineland and Alsace in 1858 from which came the French set entitled (in English) *Twelve Etchings from Nature* (Plates 1-9 & 11-14).

The prints in the French set made on this sketching trip were not the first the artist had made in Europe. The scarce "Au Sixième," which Haden identified as the artist's first etching, predated the trip, and was perhaps the print that Whistler was supposed to have made in the house of Valentin the engraver, father of Bibi Valentin (the subject of K.50.)

The portraits of the young Hadens, "Annie" (K.10) and "Little Arthur," which were included in the French set, were also undoubtedly made before the 1858 trip. Whistler probably did them during his visit to England in the late summer of 1857, when he attended the Manchester Exhibition. Shortly after his return to Paris in the autumn of 1858, the *Twelve Etchings from Nature* appeared, printed by August Delâtre and sold by Whistler at a price of two guineas per set. The set bore on the title plate (Plate 14 in the present volume) the publication date of November 1858; later the set was published by Whistler from the house of his brother-in-law Seymour Haden in Sloane Street, London, where Whistler lived and kept a studio periodically during his stays in England for the next few years.

With the ending of this *Wanderjahr* and the publication of this first set of prints, Whistler's student days were over. From early 1859 until he leased a house in Chelsea in 1863, his time was divided between England and France. He spent part of 1859 and 1860 in Paris, where he did a number of his early drypoint portraits. The summer of 1861 was spent in Brittany, and that of 1862 also in France, near the Pyrenees. The same year he made his sole trip to Spain (a journey abortively ended just across the border from France), while in 1863 he first visited Holland.

Portions of the years 1859–1863 were also spent in England, either at the Hadens' house, or in a studio which he shared briefly with George du Maurier in 1860 or for weeks at a time at various inns on the banks of the Thames. Unsettled as it was in regard to residence, this period was one of intense activity for the artist, particularly as an etcher. The years 1859–1860 saw the production of the Thames plates that were later published in 1871 as a set (Plates 18-23, 25, 28, 35-40 & 46). At about this time he did etchings on the Thames above London, as well as in the dock-

side area. Most of the upriver subjects were done when he was staying with Mr. and Mrs. Edwin Edwards at Sunbury. During this same span of years Whistler produced a series of portraits in drypoint (Plates 27ff.)—artists, friends of his student days in Paris, or the children of friends, among them the portrait of "Annie Haden" (K.62, Plate 32), the print upon which Whistler himself said he would have his reputation rest.

In the early sixties Whistler acquired a publisher for his prints in Serjeant Thomas, who arranged to have the prints sold in the shop at 39 Old Bond Street which was managed by his son Edmund. Thomas also furnished the artist with a place to bite his plates and a press to prove them on in the upper part of the house where the Thomas family lived. He even brought over August Delâtre from Paris, the only man who could print Whistler's etchings as the artist would have printed them. Whistler's relations with the Thomas family were cordial and warm, but the business connection did not last long, since Edmund Thomas soon gave up the print shop for his real love, the practice of law.

Whistler's dissatisfaction with the manner in which his prints were handled may have found expression in a few proofs of "Millbank" (Plate 37), an etching that was used as an advertisement for the shop. In state IV the original inscription at the lower right of the plate, reading "The Works of James Whistler: Etchings and Dry Points, are on View at E. Thomas' Publisher 39. Old Bond Street, London," was changed to read "are *not* on View," etc.; subsequently the words were erased entirely.

The Thames etchings and the Paris portraits alike show a decided advance over the earlier *Twelve Etchings from Nature*. They earned Whistler his first official recognition in the form of the above-mentioned Amsterdam medal, and the praise of Baudelaire in *Le Boulevard* when they were exhibited in Paris in 1862. Elizabeth and Joseph Pennell, Whistler's "authorized" biographers and supreme idolaters of his work, thought these prints never surpassed in the handling of line.

Late in 1863 Whistler began forty years of residence, off and on, in Chelsea by moving into No. 7 Lindsey Row. This move marked the start of the first extensive hiatus in his activity as an etcher, a break which was to last, with one or two exceptions, until the end of the decade, partly because of his intensified work as a painter. Painting took on a new importance in his life, following the furor created by his *White Girl* at the Salon des Refusés in Paris earlier that year.

In 1866 came the Valparaiso expedition, the most mysterious of all Whistler's jaunts. Perhaps inspired by his martial schooling, he went there with the intention of taking part in the war in which Chile and Peru were united against Spain. But he returned to London within a year, apparently without having participated in the fighting.

The resumption of interest in etching came in 1867, the date of "Shipping at Liverpool" (K.94). Whistler undoubtedly first visited that city in connection with various commissions for F. R. Leyland, a wealthy Liverpool shipbuilder. He produced many prints, largely in drypoint, in the period from about 1870 to the breaking off of relations with the Leyland family in 1877 over the extent and cost of decorations of the Peacock Room in Leyland's London house. The prints from this period (Plates 48 ff.) are known quite fittingly as the Leyland group, for they include a number of portraits of the Leyland family and their circle, as well as scenes in Liverpool, and of property connected with the Leyland family.

The human figure is especially prominent in the plates of this period, both in portraits and in figure studies drawn from nude models. Although a considerable number of proofs are known of some of these subjects, others are quite scarce, and some subjects are known in impressions from the cancelled plate only. Although Whistler doubtless sold impressions from these plates, it does not appear that any of these subjects were published, with the exception of "Tatting" (Plate 55), issued by Dowdeswell and Dowdeswell some years after its execution.

In later years, portraits and studies of the human figure never occupied so prominent a position in Whistler's etched prints as they did in this Leyland period, although they were frequently subjects for lithographs and pastels.

In the etchings from the late seventies on, Whistler employed figures largely as decorative elements in his composition, to be altered, added or deleted as his design demanded; however, he did do some figure studies and studies of models in the eighties and a handful of portraits (K.332–348, Plates 133 & 134, and later prints such as "Mrs. Whibley" and "Robert Barr") and some subjects in which the figures shown are the center of interest. Toward the end of the seventies, there was a renewed interest in doing etchings in Chelsea, along the Thames and in other parts of London.

Although Whistler had done a substantial number of plates in the seventies, he had not printed them with any regularity. C. Augustus Howell, an enterprising if somewhat shady figure in the art world of London at that time, was credited by Whistler himself with reviving his interest in printing and issuing his plates during the unsettled times of the break with Leyland, the Ruskin trial and the declaration of bankruptcy in 1879. A number of important plates were etched in this period: "The 'Adam and Eve,' Old Chelsea" (Plate 72), "Price's Candleworks" (Plate 63), "Battersea: Dawn" (Plate 64), "The Large Pool" (Plate 71), "Under Old Battersea Bridge" (Plate 73), "Old Battersea Bridge" (Plate 74), "Old Putney Bridge" (Plate 75) and "The Thames Towards Erith" (Plate 67).

Whistler called this period a time of "fiendish slavery to the press," and his renewed application to making and printing plates was probably due to more than just a reawakening of interest, for the publicity of the Ruskin trial had made it difficult for him to sell his paintings or obtain commissions for portraits. When bankruptcy proceedings forced the sale of Whistler's studio and its contents, it was his reputation as an etcher that proved the means of reestablishing his reputation as an artist and rebuilding his shattered fortunes. In September 1879 he left for Italy with a commission from The Fine Art Society in London for a series of twelve etched views of Venice to be completed in three months' time.

Whistler returned at the end of November 1880, fourteen months later. During this period he had received over £350 in advances and expenses from The Fine Art Society and had obtained additional loans from friends in Venice. The delay in producing the plates was not due to inertia on Whistler's part, although he did experience some difficulty in adjusting his vision to the entirely different atmosphere of the region. "He rose early, worked strenuously, and retired late," wrote Otto Bacher, an American etcher who knew Whistler well in Venice. The wealth of subjects offered by the city troubled him at first and he always feared that, no matter what he selected to draw, a better subject could be found just a little farther on. Combing the city on foot and by gondola, he was at last able to settle down to his task, and the experiences of his Venetian stay were collected in nearly fifty etchings and drypoints, over 100 pastels and a few paintings.

Venice, a Series of Twelve Etchings, the first Venice set (Plates 77–89), was published by The Fine Art Society in December 1880, and was exhibited at the Society's Bond Street Gallery the same month. All of the plates had been drawn on the spot in Venice and most of them were bitten there also, although, according to T. R. Way, some of the plates were bitten as well as printed after Whistler's return to London. A few proofs pulled in Venice were probably no more than preliminary trial sheets. Whistler wrote to tell Otto Bacher that he would be amazed at the beauty of the prints made in London.

The first exihibtion of the prints of Venice was rather indifferently received—"not the Venice of a maiden's dreams"—but an exhibition of Venetian pastels early in 1881 was a great success, and before long the etchings shared in this success. Whistler never forgave the early criticism of this first Venice set, and never allowed the critics to forget their reversals of opinion. Sir Frederick Wedmore, a frequent target of Whistlerian ridicule, objected that the first exhibition consisted of earlier, unfinished states—"unready and unripe," Wedmore termed them—while the praise was given to the later, more completely realized states. Certainly Whistler made extensive changes to most of the Venetian subjects, particularly those published in the sets, and the final states of some of the first Venice set were not

achieved until 1891, over ten years after their etching. In some cases, Whistler specifically designated these last, late states as the most satisfying versions.

The first Venice set was published in a limited edition of 100 sets, and Whistler undertook the printing of the proofs himself. Though the bulk of the edition was printed by 1892, the publishers were still awaiting delivery of some prints ten years later, and the edition was completed only posthumously when the balance of the impressions of certain of the plates owed to The Fine Art Society were printed by Frederick Goulding.

The labor of printing so large an edition was complicated by the practice of wiping the plate to leave a film of ink on the surface, which would create effects of reflections, shadows and atmosphere. Perhaps the use of this time-consuming process was responsible for the relatively limited number of sets issued of *A Set of Twenty-six Etchings*, published in 1886 by the Messrs. Dowdeswell and known as the second Venice set although five English subjects were included (Plates 90–101, 105 & 106). Only thirty sets of these prints were published, with twelve extra impressions of fifteen of the subjects to be sold separately. (In fact, Whistler had already pulled a varying number of impressions of the subjects in this set between the beginning of 1882, when the sale of additional Venetian subjects was no longer restricted by his agreement with The Fine Art Society, and the publication of the set by Dowdeswell.)

A noteworthy addition to the second Venice set was the publication of a list of "Propositions" by the artist, including the statement that it was illogical for prints to have margins. Whistler had begun the practice of trimming his impressions to the plate mark sometime in the course of printing the first Venice set, although the very earliest impressions of these prints do not have the margins trimmed (for instance, those in the Avery Collection, New York Public Library). There were nearly fifty etchings and drypoints of Venice in all and only 33 of the subjects were issued in the two sets. The remaining prints, with the exception of two plates never finished and destroyed after only a handful of trial proofs had been pulled, were printed and sold only individually.

The Venice prints fall at approximately the halfway mark in Whistler's etching career, both in time and in the total number of etchings completed. The *Twelve Etchings from Nature* had been published some 22 years before the completion of the Venice trip, and Whistler's final plates were done twenty years after the return from Venice. Whistler never published another set of etchings, although he probably contemplated issuing sets of Parisian and Amsterdam subjects, and perhaps one of Belgian scenes as well. Possibly the fact that he had never fulfilled the contract with The Fine Art Society for printing their Venice set was the reason for the nonpublication of further sets. Certainly the Society, noting in 1902 that a number of recent prints had been exhibited in Paris, took the opportunity of reminding Whistler of the prints still owed to them in the edition begun at the end of 1880.

Among the more than 200 subjects Whistler etched after his return from Venice are a large number of scenes from London, including shops in Chelsea and the East End (Plates 110 ff.). In the eighties he made several trips to Belgium and Holland, where he made a number of plates of Amsterdam, Dordrecht, Brussels and Bruges (Plates 107 ff. & 135 ff.). In the late summer of 1888, Whistler married the widow of the architect Edward W. Godwin. From their honeymoon journey to the Loire Valley and Touraine came some thirty plates of towns visited on the way—Tours, Amboise, Bourges and Loches.

In the early nineties Whistler once more lived and kept a studio in Paris, and the approximately twenty etchings he made of Parisian parks, streets, shops and boulevards (Plate 148) effectively complete the catalogue of his etched work. During the last years of this period, from about 1887, Whistler's interest in lithography began to vie with his etching. At the same time, he was further preoccupied with his wife's final illness and his own deteriorating health. The middle of the nineties once more saw him inactive as an etcher, closing a period of strenuous productiveness beginning in 1870 and lasting a quarter of a century.

When preparing to spend the winter of 1900–1901 in North Africa and Corsica, Whistler took with him a dozen copper plates grounded by Joseph Pennell, and actually etched a number of prints during his Corsican visit. The plates, however, were spoiled when the grounds lifted in places, and were abandoned. Whistler blamed Pennell for preparing the grounds carelessly; Pennell asserted that the plates had not been allowed to dry properly before Whistler took them. Whatever the reason, Whistler was too discouraged to proceed with the biting and printing of the etchings, although some were published posthumously, printed and signed by Nathaniel Sparks. Excluding the Corsician subjects, the body of Whistler's published etchings and drypoints amounts to nearly 450 plates, an impressive number indeed for one whose other activities, both as an artist and as an individual, were equally demanding of his time and energies.

Whistler called his first published set of prints *Twelve Etchings from Nature*, and the description "from nature" could justly be applied to all his subsequent prints in the medium. The etchings and drypoints were all drawn directly on the plate, some being worked on over a period of time, some finished at one sitting. The artist himself said that he spent about three weeks on each of the Thames prints of 1861, though doubtless he did not work exclusively on any one plate for that period of time. In contrast, the later Chelsea subjects were said by Whistler's pupil Walter Greaves to have been completed in one session and never reworked. Some of the portraits were also finished in a very brief time: Drouet recalled that his took two sittings, totaling about five hours in all. Although portraits like "Maude, Standing" (Plate 57) and "The Velvet Dress" (K.105, a portrait of Mrs. Leyland), which the artist developed through many states, doubtless required much more time and endless posing on the part of the models, many of the portraits and figure studies were probably finished comparatively quickly.

From the time of his tramp through the Rhine Valley and Alsace-Lorraine, Whistler was accustomed to carry copper plates with him—grounded for etchings and ungrounded for drypoints—either wrapped in his pockets, or between the pages of a book. Also in his pocket were his needles, stuck into a piece of cork to preserve their points, and a bottle of varnish for stopping-out, with a brush for application. Thus prepared, he was able to make a record at a moment's notice of anything that caught his fancy, from bits of architecture, to children at play, to the effects of light on water.

He etched his plates almost anywhere: in a gondola in Venice, in the midst of curious onlookers in London streets, in a square in Brussels and beside a canal in Amsterdam. He preserved in three plates an afternoon's performance given by Buffalo Bill's Wild West show at Earl's Court, London (Plates 130–132) and even recorded an impression of the Jubilee service at Westminster Abbey celebrating Queen Victoria's fiftieth year on the throne (though whether he worked from a sketch or directly on a plate is not known for certain). For forty years he put on his plates the visual memories of a passionate sightseer, with a mastery of the technical means of his medium that equaled his acuteness of vision.

Various artists have left statements on the surprisingly simple methods and techniques Whistler used in making his plates, which included an old-fashioned ground and an ordinary wax taper for smoking it. His early plates, according to the memories of some contemporaries, were bitten by immersing them in a deep bath of nitric acid (occasionally hydrochloric), then stopping-out all over; later, when making the Venice sets, he applied his acid directly to the plate with a feather (see Technical Note, below). The skill with which he managed his simple materials was all-important: he was so expert at manipulating the acid on the plate that he could make corrections during the process of biting by blowing the acid away from the spot, making the changes wanted, then covering the place once more with mordant.

About some things he was exceedingly particular. His plates had to be of an exactly determined thinness, and he was known to spend half an hour getting a point on his needle that would not tear the plate. Through-

out his career he preferred old paper for printing his etchings, from his student days in Paris when he had to surreptitiously remove blank pages from books in secondhand bookstalls, to the later, prosperous days when he openly searched the shops of Paris and Amsterdam and bought his favored old Dutch paper by the ream or the thousand sheets.

According to the reminiscences of various companions of his early days in Paris, Whistler learned the art of printing plates in the workshop of August Delâtre, watching him pull proofs of the French set. Certainly Whistler was printing plates himself from an early stage in his career in Paris, working with a small hand press and pulling proofs for customers while they waited. In later years he was never satisfied with professional printers' work, and customarily printed his own plates. If, as Mortimer Menpes states in *Whistler as I Knew Him*, he allowed either Menpes or his apprentice Walter Sickert to pull proofs on their own, it was because they worked following Whistler's training and entirely in accordance with his will. In Whistler's words, it was the same as if he had done the printing himself. Some of the last of the Paris plates were printed for Whistler by Sir Frank Short in 1900, perhaps because Whistler was not up to the strenuous effort of pulling the proofs himself.

Whistler's printing style changed as his printmaking style changed. For the prints of the late fifties and early sixties, he preferred a full, black proof. In printing his drypoints he sought a lighter, more silvery effect. The printing of the Venetian subjects was a complex affair, involving wiping with three cloths, then with the palm of the hand and the tips of the fingers until just the amount of ink film he wanted was left on the plate. Those who worked with or watched Whistler during the printing of his Venetian subjects testified that often only one or two proofs from an entire day's work would satisfy him; the rest would be destroyed.

Although the earliest sets of the *Twelve Etchings* of Venice were printed in black, the majority of the impressions of the Venetian subjects were printed in either a dark or pale-brown ink. Brown or black were the only

colors Whistler tolerated in printing etchings, and he was exacting about the inks he used. Menpes records that his blacks were made from the dregs of port wine and the browns from burnt umber. With the publication of the first Venice set by The Fine Art Society, Whistler adopted the practice of signing proofs with a butterfly in pencil in the margin, and an "imp" or "ip" to show that he had printed and approved the proof.

Some time during the publication of this first Venice set he adopted the practice of trimming off the margins of paper to the plate-mark, for the reasons given in his above-mentioned "Propositions." In the main, this gesture was a protest against the undue importance given the width of margins by collectors and dealers, and on all subsequent prints Whistler adhered to the practice of trimming off all but a small tab to bear his butterfly monogram. To trim these margins, Whistler worked with a knife on glass, without using a rule or straight edge, so that the knife would follow the plate mark "sympathetically." In most of the plates after the Venice series, the etched line predominated; sometimes the plates were covered so extensively with the etched lines that scarcely any ground remained, and the biting was necessarily very delicate. These plates were wiped clean for printing, although according to Joseph Pennell, Whistler commonly left some ink tone even on the Paris plates; the clean-wiped impressions, he said, were proofs made for the purpose of checking the biting of the plate.

Whistler was ever a severe critic of his own work. In regard to his etchings, the extreme care he took in printing his plates and in passing proofs meant that his work would necessarily be somewhat limited, although he is reported never to have limited the size of editions simply to raise the value of individual prints. In addition, as Howard Mansfield noted, he had all along "carefully destroyed plates, torn up proofs, and burned canvases," so that the remaining work might be only of the best. In the matter of prints, he was especially solicitous that "the future collector shall be spared the mortification of cataloguing his pet mistakes." A number of etchings are in fact known only from impressions from the

cancelled plates, and there are traces of others which can be seen only as ghosts on impressions of the plates which supplanted them (for instance, the two heads on the plate of "Bibi Lalouette" Plate 27, and heads on the portrait of "Annie Haden," K.62, Plate 32, and on the early states of "Weary," Plate 47).

The two Venice sets were both published in "limited editions"; some of the hundred sets of *Twelve Etchings* were still owed to The Fine Art Society at Whistler's death. The *Twenty-six Etchings* published by Dowdeswells was theoretically limited to thirty sets, with twelve extra impressions pulled of certain of the plates, but in fact a varying number of proofs of most of the plates had already been made prior to the publication as a set. With a few exceptions, the plates of Venice that were not included in either of the two sets are rarer than those that were.

Rarity, in Whistler's etchings, is usually a matter of comparison, although there are certain prints that are positively scarce—for instance "Gretchen at Heidelberg" (Plate 10), "Sketching, No. 2," "The Storm" (Plate 42) and "The Penny Boat." Sometimes the prints are rare because they were unfinished, as in the case of "Venice" (K.231), or abandoned, as was one version of the title plate for the French set. In some cases early impressions of plates are quite scarce, while later printings are fairly common, as with certain subjects in the *Twelve Etchings from Nature* and the Thames set before the 1871 publication. Some plates were printed in substantial editions by periodicals or in books, but are extremely rare in earlier impressions. An example of this is "The Menpes Children" (perhaps four impressions separately printed), which was later used as the frontispiece for the deluxe edition of *Whistler as I Knew Him*. Some plates were printed in comparatively small numbers because the nature of the plate did not permit extensive editions; this was true of most of the drypoint portraits, and of some of the later plates as well, for instance the scenes of Amsterdam and Brussels done in the eighties. These last were so delicately bitten that they could not withstand large printings. Rarity alone, however, is hardly a sufficient basis for judging the financial or aesthetic value of a Whistler print, though scarcity does add an undeniable interest to an already desirable subject.

Selecting the finest of the nearly 450 works of Whistler in etching and drypoint once the artist had passed his "apprentice" stage, and disregarding obviously unfinished plates, is largely a matter of personal preference, particularly if one follows Whistler's dictum that the size of a print does not indicate its importance. On more than one occasion Whistler assisted in the selection of groups of his prints for an exhibition. Those chosen for hanging at the Chicago Columbian Exposition in 1893 are of particular interest, for by that time his career as an etcher was more or less at an end, and he had virtually the whole catalogue of his work to select from. The prints he selected for this exhibition are as follows (titles followed by an asterisk are included in this book): Early Portrait of Whistler (K.7); The Unsafe Tenement;* La Vieille aux Loques;* The Kitchen;* Eagle Wharf;* Black Lion Wharf;* Longshoremen;* The Lime-Burner;* Becquet;* Portrait of Whistler;* Drouet; Arthur Haden; Annie Haden;* Mr. Mann;* Riault, the Engraver; Rotherhithe;* The Forge;* Jo; The Storm;* Weary;* Fanny Leyland;* Battersea: Dawn;* Steamboat Fleet; The Large Pool;* Old Putney Bridge;* The Little Putney, No. 3 (Whistler's title); Little Venice;* Nocturne;* The Palaces;* The Traghetto, No. 2;* The Beggars;* San Giorgio; Nocturne: Palaces;* The Riva, No. 2;* The Balcony; Garden;* The Dyer; The Smithy;* The Village Sweet-Shop;* Battersea Bridge (Old Battersea Bridge, K. 177);* Clothes-Exchange, No. 2; Windsor; Courtyard, Brussels; Palaces, Brussels;* Mairie, Loches; Chancellerie, Loches; Balcony, Amsterdam;* Hôtel Lallement, Bourges; Steps, Amsterdam;* Pierrot;* Long House—Dyer's—Amsterdam;* The Lace Curtain (The Embroidered Curtain);* Zaandam;* The Mill.*

M. N.

New York
March 1975

Technical Note

ANY DISCUSSION of Whistler's etchings should take into account the technical aspects of his work. Whether one feels that their success is linked integrally with the technical virtuosity they display, or whether one feels that the prints become less powerful as Whistler becomes increasingly involved with the more subtle mechanical complexities of his craft, one must acknowledge the degree to which he manipulated the traditional uses of the medium to his own ends.

An etching is made by coating a sheet of metal, usually copper, with an acid-resistant ground. The artist draws with a metal point on the prepared plate, his lines cutting through the ground to the surface of the copper. The plate is immersed in acid: the lines are etched, or bitten, into the exposed metal, while the portions of the plate still protected by the ground remain smooth. Before the plate is etched mistakes in drawing can be corrected by the local application of acid-resistant varnish, and lines which have already been bitten deeply enough can be protected in the same way from further biting; this is called stopping-out. In this manner an artist is able to strengthen his work by rebiting groups of lines selectively, without subjecting every line to the repeated action of the acid.

Drypoint lines are formed by working directly on a soft metal plate (usually copper) with a special needle. Although prints are occasionally executed in drypoint alone (e.g., "The Storm," Plate 42), one finds that it is used more frequently in conjunction with etching. Lines produced in this way are distinctive not only because they vary in depth according to the strength and angle of the needle's stroke, but because the edge of copper (burr) turned over by the needle as it ploughs through the metal will catch an indeterminate amount of ink, adding intensity and softness to the line printed by ink held in the furrow itself. However, the burr, raised as it is above the surface of the plate, is subject to rapid wear as the plate is wiped and put through the press for each impression.

Ordinarily, in inking an etched plate any ink lying outside the lines (that is, not held within the furrow) is meticulously wiped away. Occasionally, as in "Price's Candleworks" (Plate 63), a film of ink, called plate tone, is deliberately left on the surface of the copper to modify an area of the composition. Unbounded by etched lines, plate tone derives its effect from the dexterity of the printer, its appearance determined only by the manner in which the plate is wiped. Thus, each impression becomes unique, distinct from all others taken from the same plate, because no two wipings can be identical.

Whistler's early etching "Greenwich Park" (Plate 17) is a straightforward example of the etching technique and its parameters. The lines are deft and spontaneous; one senses the ease with which the etcher's needle moves through the ground. Individually, each line is uniform, having been bitten equally throughout by the acid, and yet one sees clearly that the fine lines in the distance, the trees in the middle ground and the larger trees in the foreground reflect successively longer exposures to the acid, the two fainter areas having been stopped out with varnish after

the first and second acid baths, respectively.* In the extreme foreground one can see several drypoint lines, scratch-like and angular compared to the etched lines as a result of the resistance offered by the copper to the needle. In "Black Lion Wharf" (Plate 22), where all the lines are uniform in depth and appear to have been etched in a single bite, one can see how the etcher achieves effects by varying the length, contour and interval of lines, rather than by modulating their breadth. Plate tone can be seen in the black doorway at the right edge and in the furled sail in front of it.

In both "Greenwich Park" and "Black Lion Wharf" the paper is left to play the roles which are beyond the grasp of the etcher's needle: that is, the amorphous, undelineated expanses of sky and water. While the success of this ploy is dependent in part on the way in which the artist has resolved the brightly sunlit scene into absolute lights and darks, it is noteworthy that in both cases Whistler has chosen to substitute Japanese paper for the more traditional Occidental paper. Unlike Western paper, Japanese paper characteristically has no grain; its surface is modulated only by the slight variations in color of unbleached fiber. Because it contains very little sizing it is softer and will accept ink with ease. In all, its character is less aggressive and more adaptable than that of Western paper and thus desirable in this case for the brilliance it imparts to the ink and the lustrous foil it provides for the subtly three-dimensional patterns of the web of printing ink.

If "Greenwich Park" and "Black Lion Wharf" evidence Whistler's ability to depict scenes bathed in bright sunlight, "Nocturne" (Plate 78) and "Nocturne: Palaces" (Plate 91) demonstrate the resolution through technical means of a much more difficult problem, that of describing shadowy, limitless visions

in a medium which is by definition linear and best suited for describing edges, contours and boundaries. In "Nocturne" lines have been reduced to shorthand notations, independent of the contour or internal detail of the objects rendered. Nothing is perceived with clarity as substance blends with its shadow and both merge with the heavy atmosphere which surrounds them. The paper, left white in "Black Lion Wharf" to define sky and water, here gives up its function to the ink and now serves primarily as a vehicle for the plate tone, which dominates the picture. This dominance is unusual, for few artists are willing to rely so heavily on an effect which must be created anew in each impression.

Unfortunately, reproductions do not allow one to see the enormous variety of color in Whistler's inks, nor that of his paper, but he experimented with both freely and each modifies the character of any print. In "Nocturne" the ink is black, and the grey-black plate tone evokes the quality of moonlight on the sea. In "Nocturne: Palaces," however, the ink is brown; the light is warm and heavy, and the time is clearly twilight.*

The prints I have described here should serve merely as an introduction to Whistler's ingenuity, for the interested student of his etchings will find that in each of the techniques cited the effects achieved are almost limitless. For example, consider the qualities of the etched line in "Street at Saverne" (Plate 9), "Fishing-Boats, Hastings" (Plate 65), "The Bucking Horse" (Plate 132) and "The Embroidered Curtain" (Plate 145). Disparate uses of drypoint are revealed in "Thames Warehouses" (Plate 18), "Mr. Mann" (Plate 33), "The Guitar Player" (Plate 59) and "From Pickle-Herring Stairs" (Plate 68); and a range of the ways in which plate tone might be used can be seen in "The 'Adam

*Most probably at the period of "Greenwich Park" Whistler followed this traditional method of successively biting and stopping-out, although in his first etchings (for the Coastal Survey) and in some later prints (particularly the Venice series) his methods varied considerably from the norm. See Introduction. [M.N.]

*Whistler used greyish-black ink for the early proofs and also for an uncertain number of published portfolios of his first Venice set for The Fine Art Society. Later he changed to a brown or sepia ink. See Introduction. The first state of the "Two Doorways" is also printed in grey-black ink. [M.N.]

and Eve,' Old Chelsea" (Plate 72), "The Beggars" (Plate 88), "Savoy Scaffolding," (Plate 112) and "Monitors" (Plate 126). Taken individually these prints elucidate the variables of etching as a technique; collectively, they display not only Whistler's sensibilities as an artist, but his curiosity, dexterity and resolve as a craftsman.

ELIZABETH LUNNING

Cambridge, Mass.
January 1975

THE CAPTIONS give the following information: the title of the print as it appears in the Kennedy catalogue (Edward G. Kennedy, *The Etched Work of Whistler*, The Grolier Club of the City of New York, 1910); the Kennedy catalogue number (in the form K.9, K.10, etc.); the state of the print as established by Kennedy (in roman numbers; thus, "K.9, IV" means Kennedy catalogue number 9, fourth state); the medium (etching, drypoint or etching with drypoint); the original dimensions (in inches, height before width) only in the few cases where our illustration has been reduced; and the set to which the print belongs, where applicable. Except for the ten prints reproduced from photographs (credited in the appropriate captions), all the illustrations have been reproduced directly from original impressions in various collections.

The reader's attention is invited to the Notes on the Plates which begin on page xix.

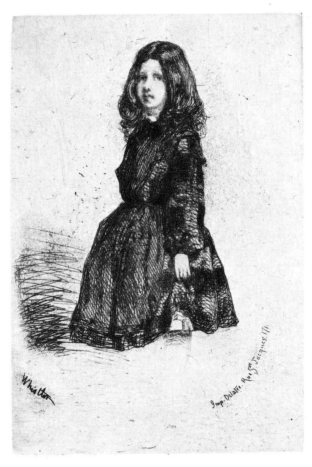

1 LITTLE ARTHUR (K.9, IV).
From *Twelve Etchings from
Nature* (French set).

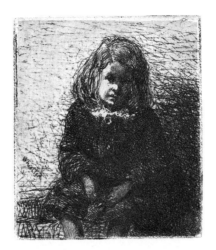

2 ANNIE (K.10, IV). Etching with drypoint.
From *Twelve Etchings from Nature*.

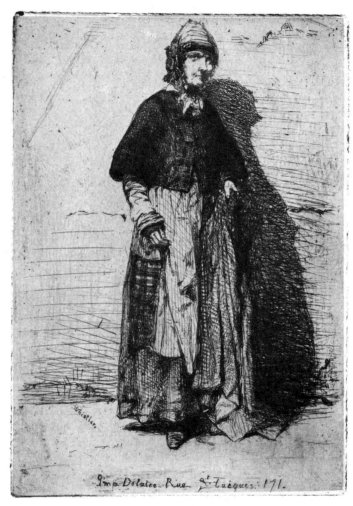

3 LA MÈRE GÉRARD (K.11, IV). Etching. From *Twelve
Etchings from Nature*.

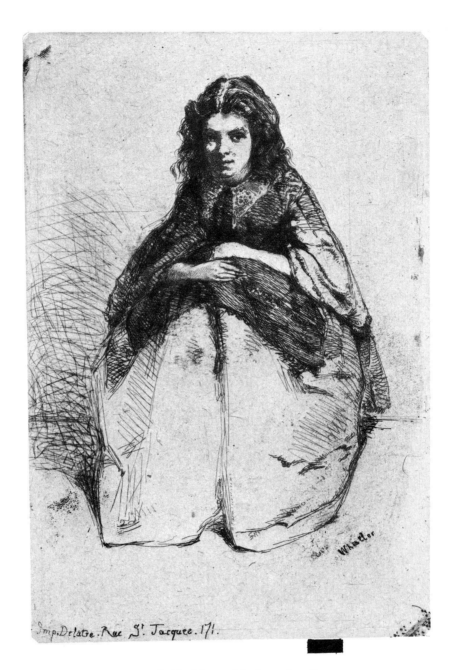

4. FUMETTE (K.13, IV). Etching with drypoint. From
Twelve Etchings from Nature.

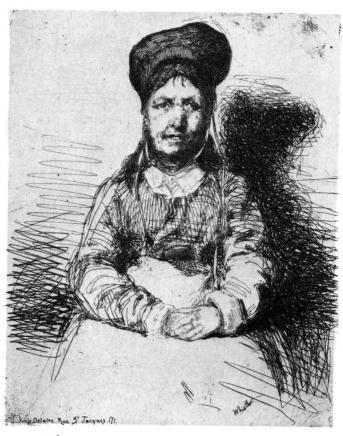

5 LA RÉTAMEUSE (K.14, II). Etching. From
Twelve Etchings from Nature.

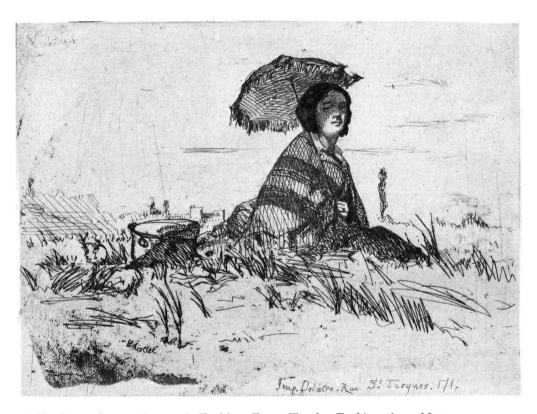

6 EN PLEIN SOLEIL (K.15, II). Etching. From *Twelve Etchings from Nature*.

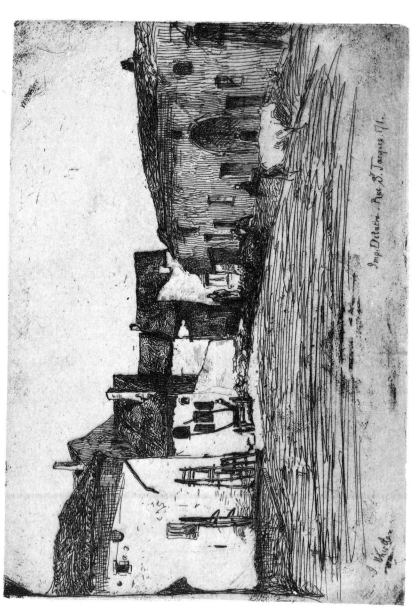

7 LIVERDUN (K.16, II). Etching. From *Twelve Etchings from Nature.*

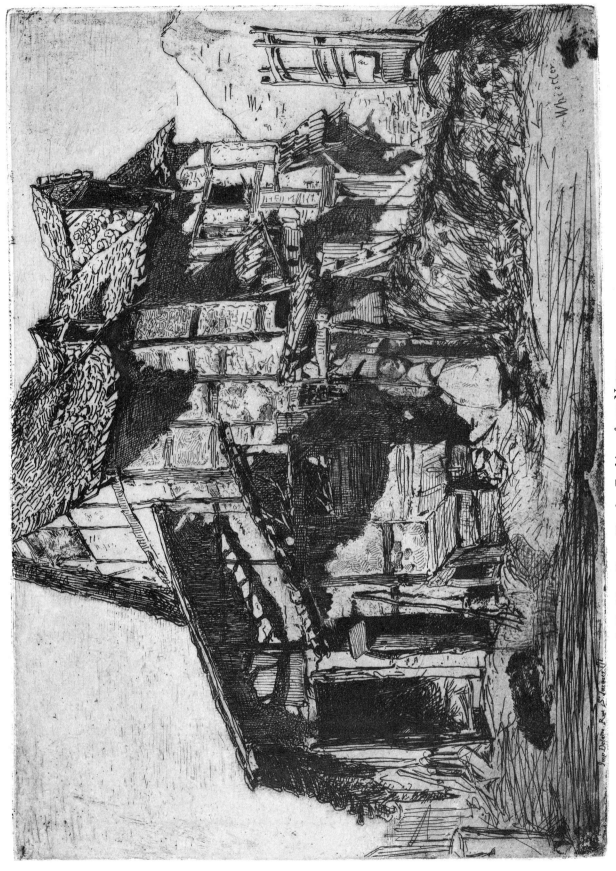

8 THE UNSAFE TENEMENT (K.17, III). Etching. From *Twelve Etchings from Nature*.

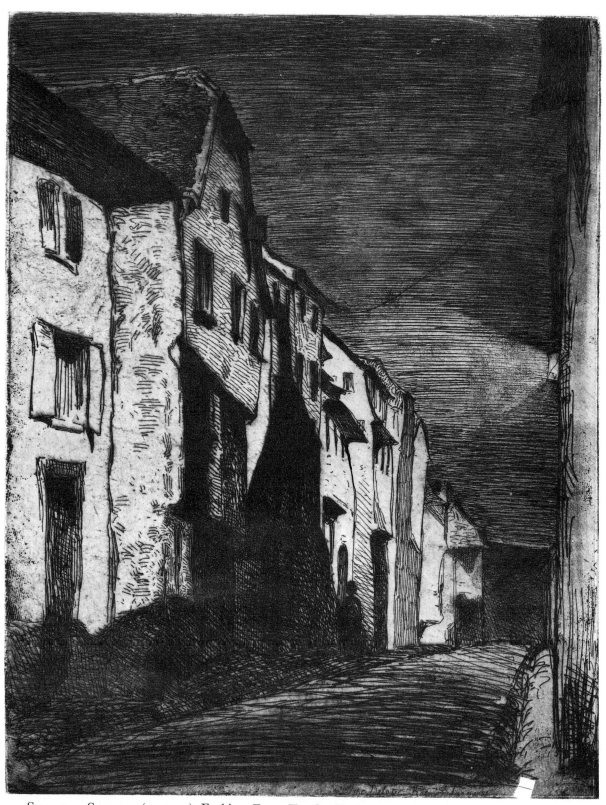

9 STREET AT SAVERNE (K.19, IV). Etching. From *Twelve Etchings from Nature*.

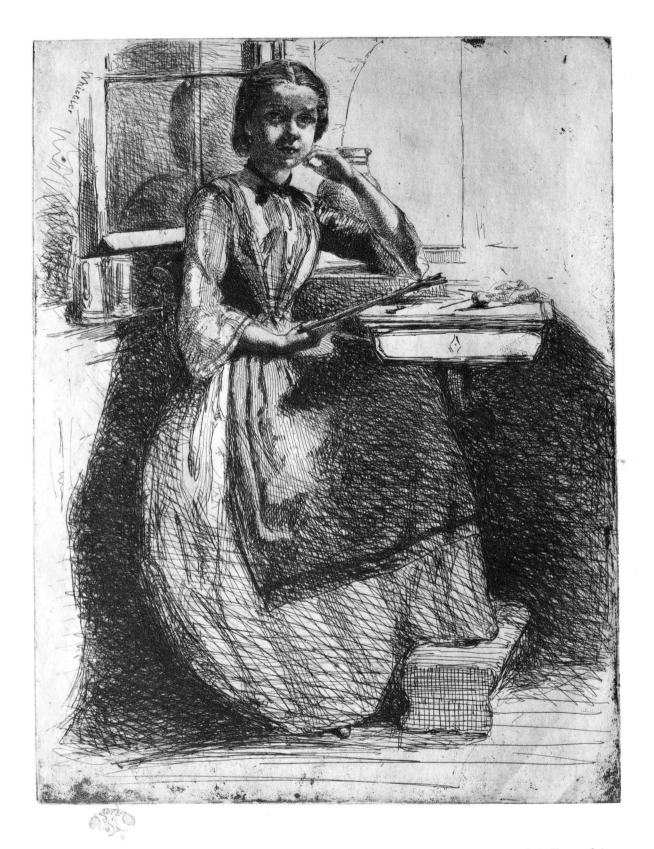

10 G<small>RETCHEN AT</small> H<small>EIDELBERG</small> (<small>K.20, ONLY STATE</small>). Etching. (Photo courtesy National Gallery of Art, Rosenwald Collection)

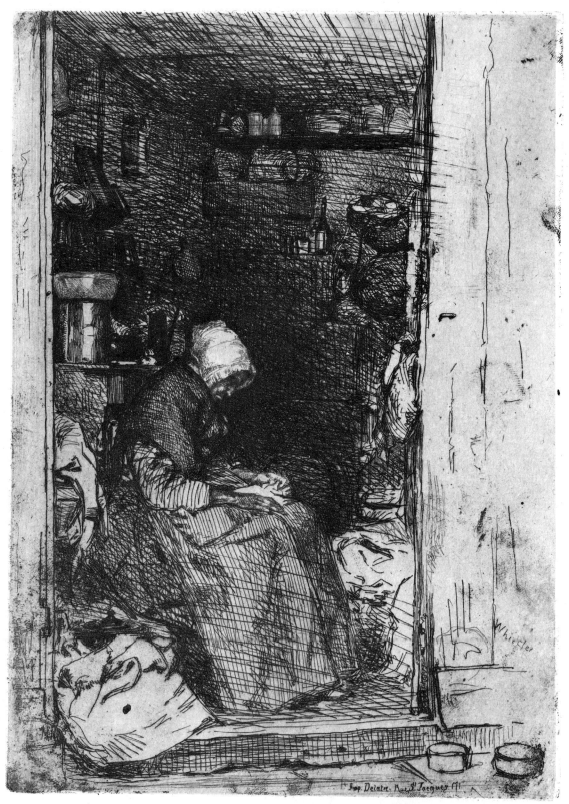

11 LA VIEILLE AUX LOQUES (K.21, II). Etching. From *Twelve Etchings from Nature*.

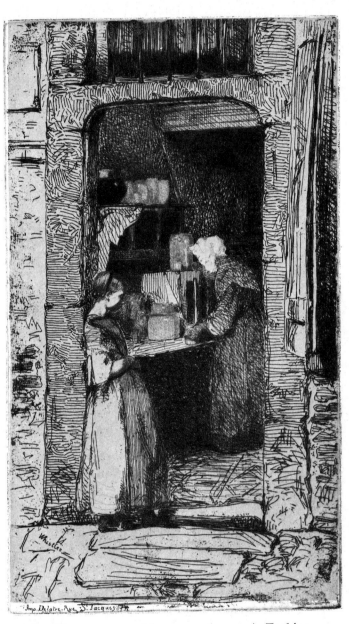

12 LA MARCHANDE DE MOUTARDE (K.22, II). Etching.
From *Twelve Etchings from Nature*.

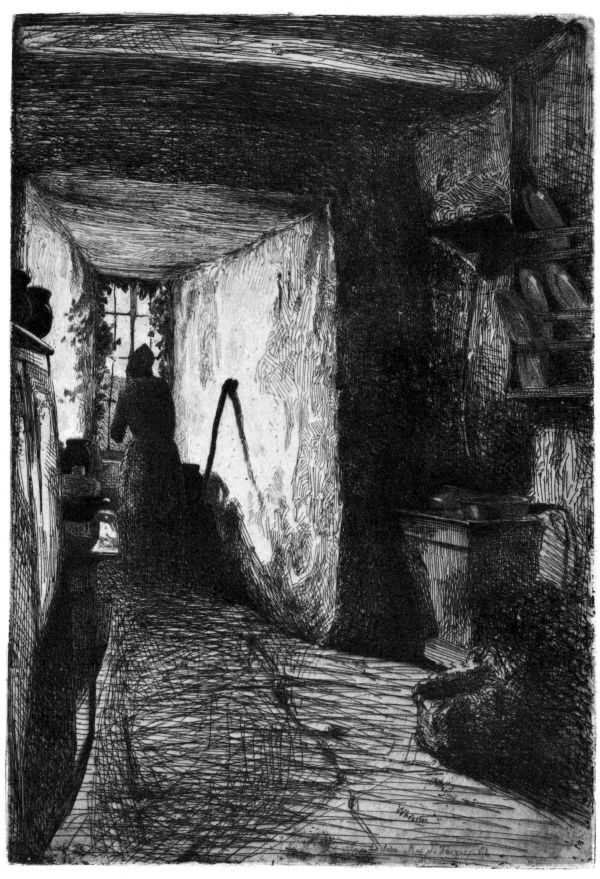

13 THE KITCHEN (K.24, II). Etching with drypoint. From *Twelve Etchings from Nature*.

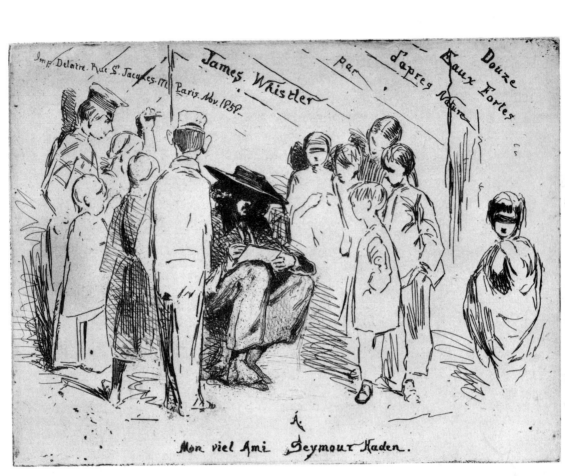

14 WHISTLER SKETCHING (K.25, ONLY STATE). Etching. Title plate of *Twelve Etchings from Nature*.

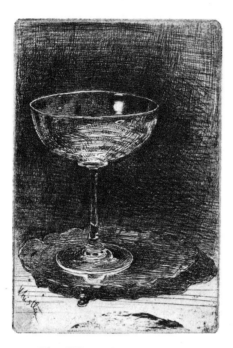

15 THE WINE-GLASS (K.27, II).
Etching with drypoint.

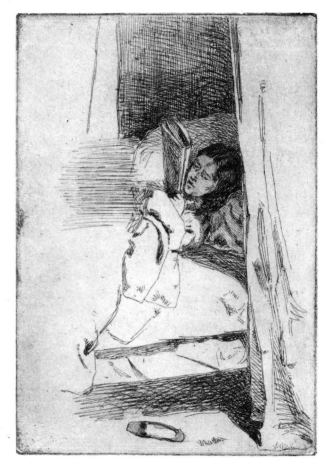

16 READING IN BED (K.28, I). Etching.

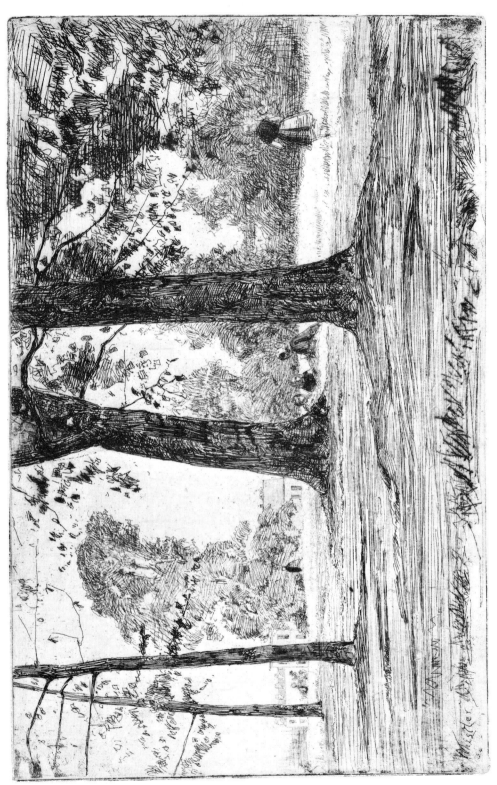

17 GREENWICH PARK (K.35,1). Etching.

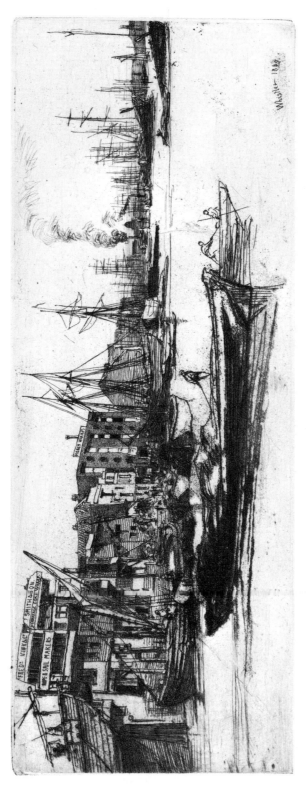

18 THAMES WAREHOUSES (K. 38, 1). Etching. From *Sixteen Etchings . . . on the Thames . . .* (Thames set).

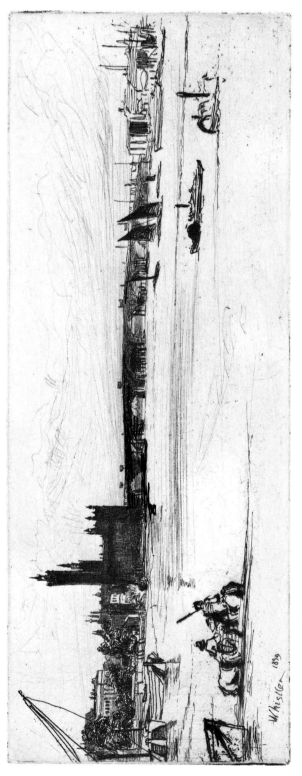

19 OLD WESTMINSTER BRIDGE (K.39, 1). Etching. From *Sixteen Etchings*.

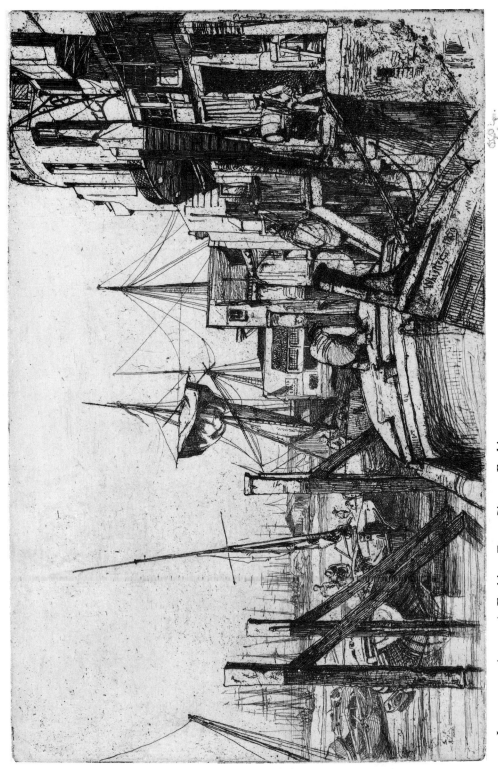

20 LIMEHOUSE (K.40, II). Etching. From *Sixteen Etchings*.

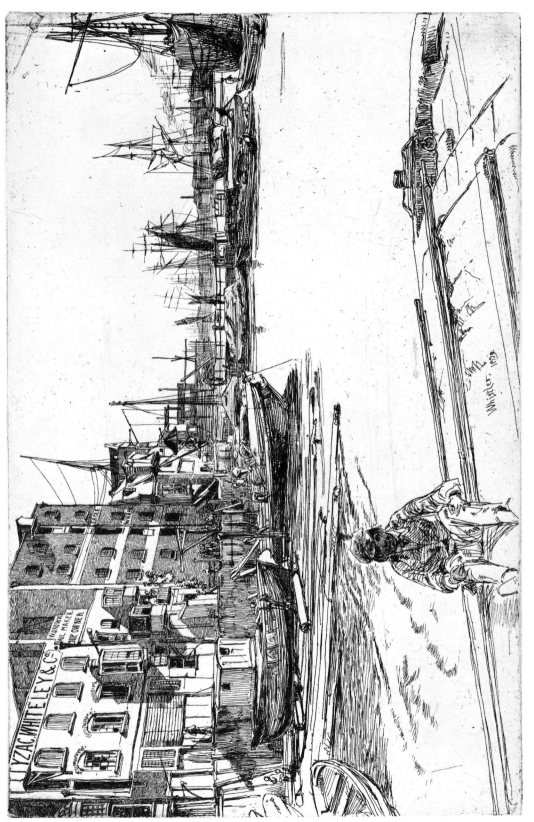

21 EAGLE WHARF (K.41, ONLY STATE). Etching. From *Sixteen Etchings*.

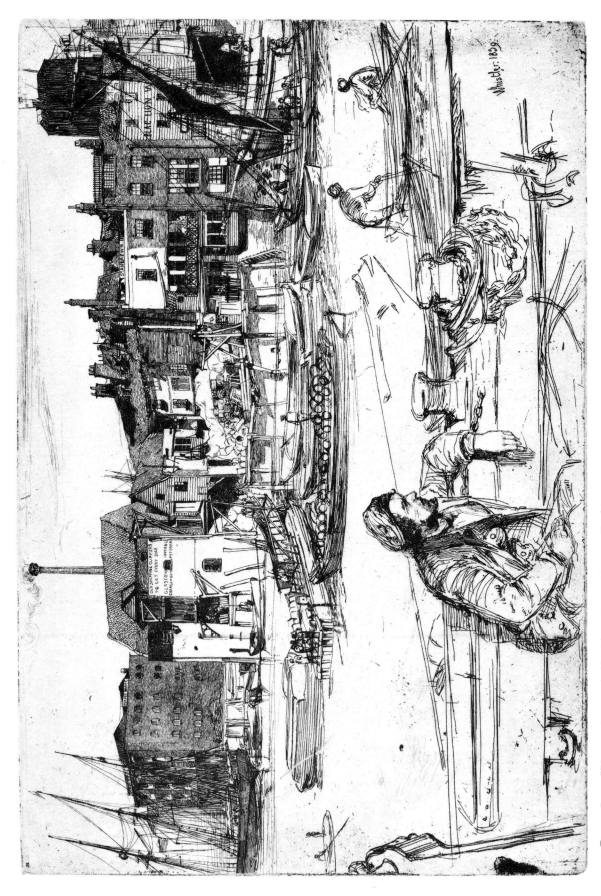

22 Black Lion Wharf (k.42, ɪɪ). Etching. From *Sixteen Etchings*.

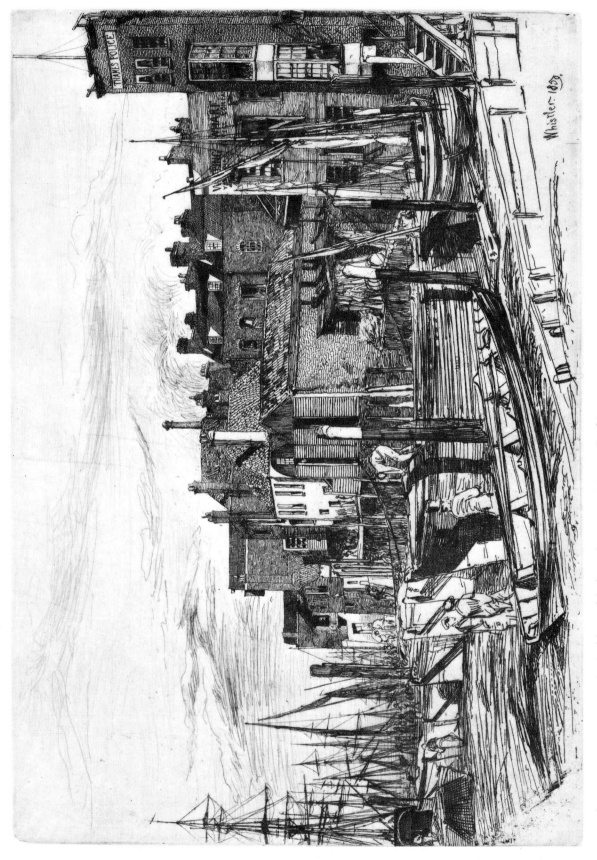

23 THAMES POLICE (K.44, II). Etching with drypoint. From *Sixteen Etchings*.

24 Longshoremen (K.45, only state). Drypoint.

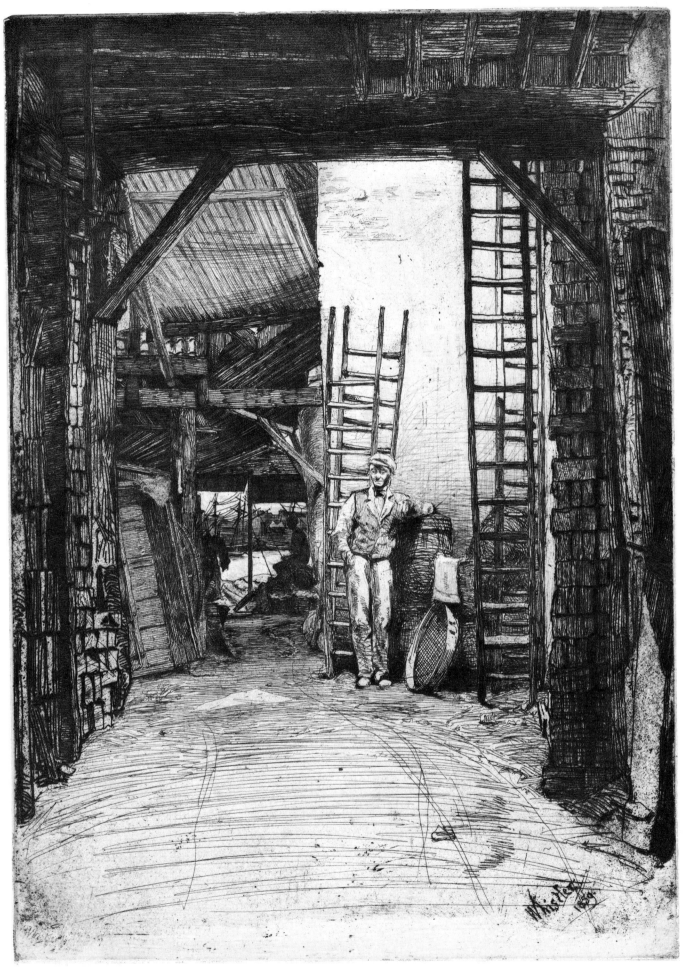

25 THE LIME-BURNER (K.46, II). Etching with drypoint. From *Sixteen Etchings*.

26 SOUPE À TROIS SOUS (K.49, ONLY STATE). Etching.

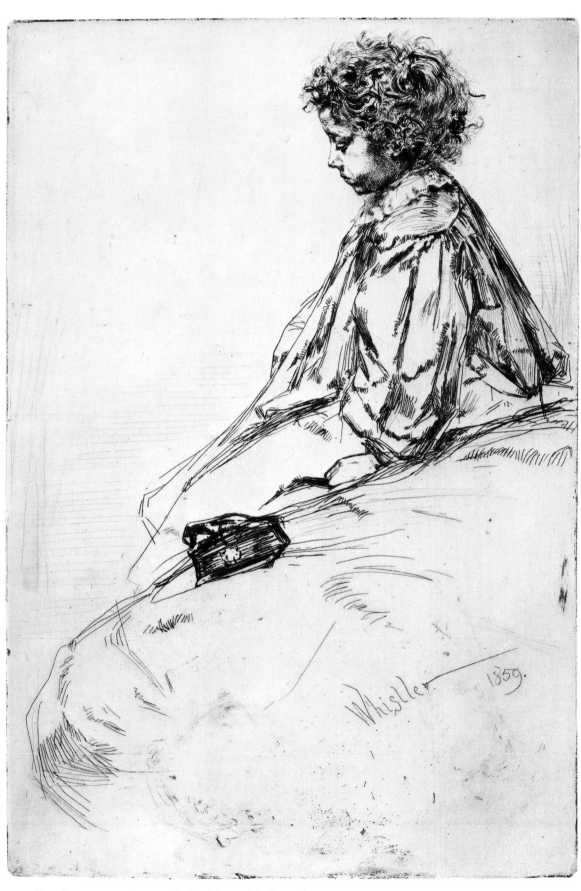

27 BIBI LALOUETTE (K.51, II). Etching with drypoint.

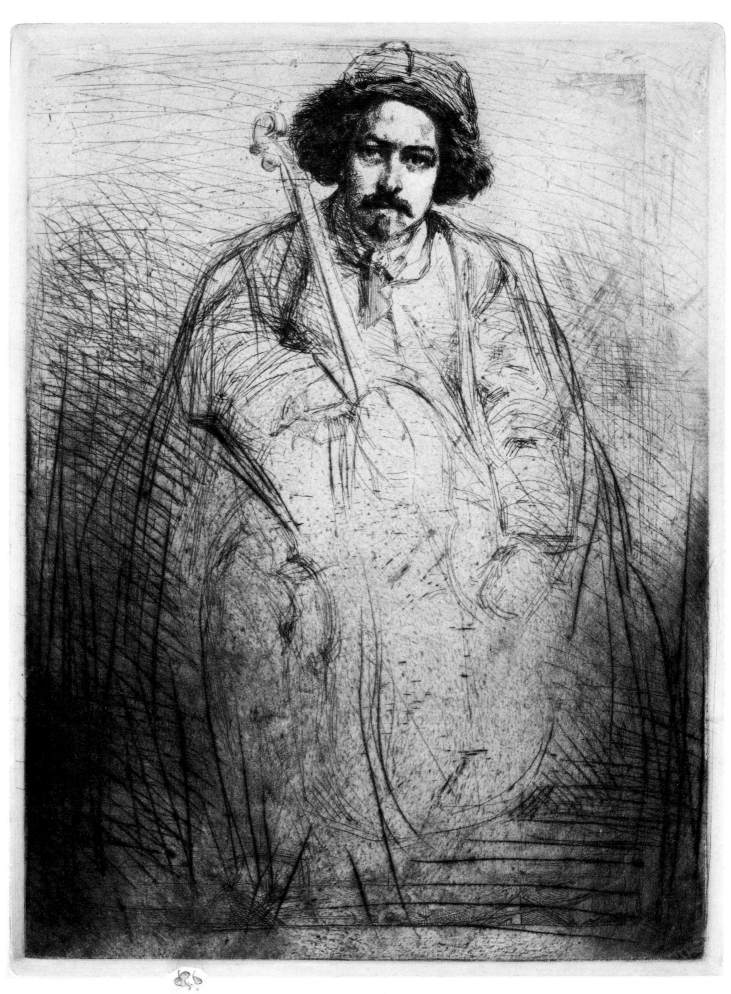

28 BECQUET (K.52, III). Etching with drypoint.

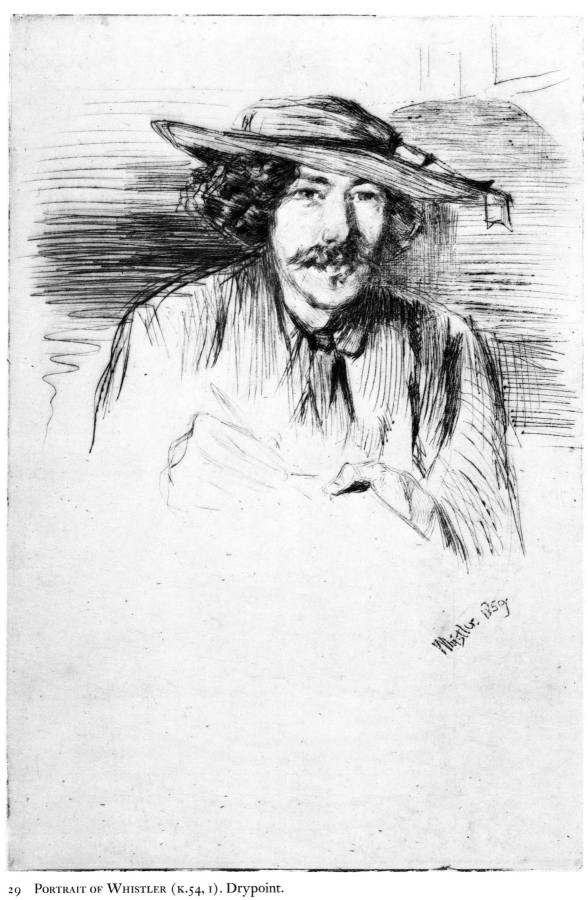

29 PORTRAIT OF WHISTLER (K.54, I). Drypoint.

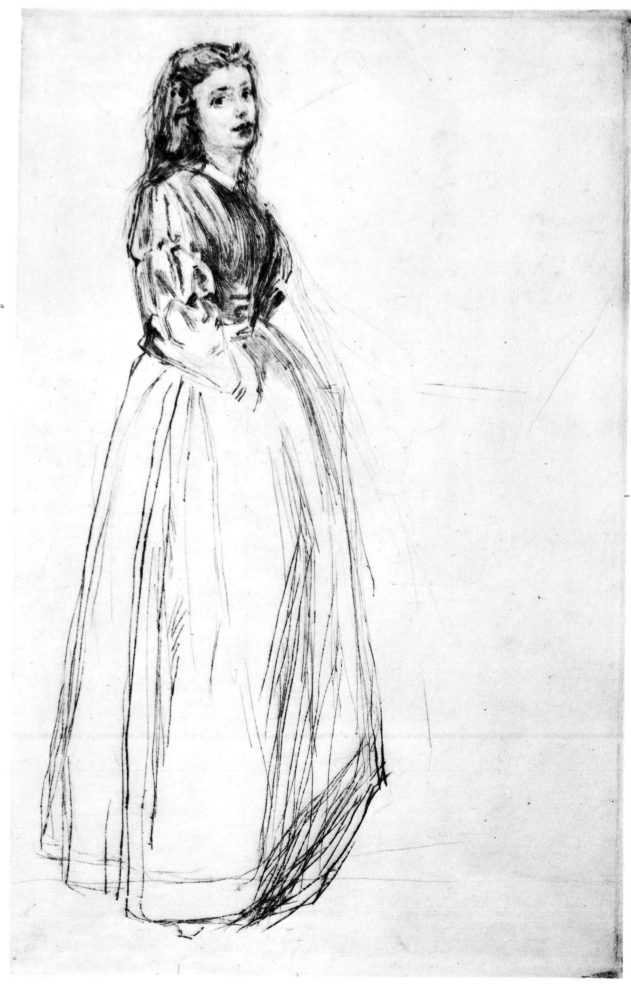

30 FUMETTE, STANDING (K.56, 1). Drypoint. Original dimensions 13⅝ x 8½.
(Photo courtesy National Gallery of Art, Rosenwald Collection)

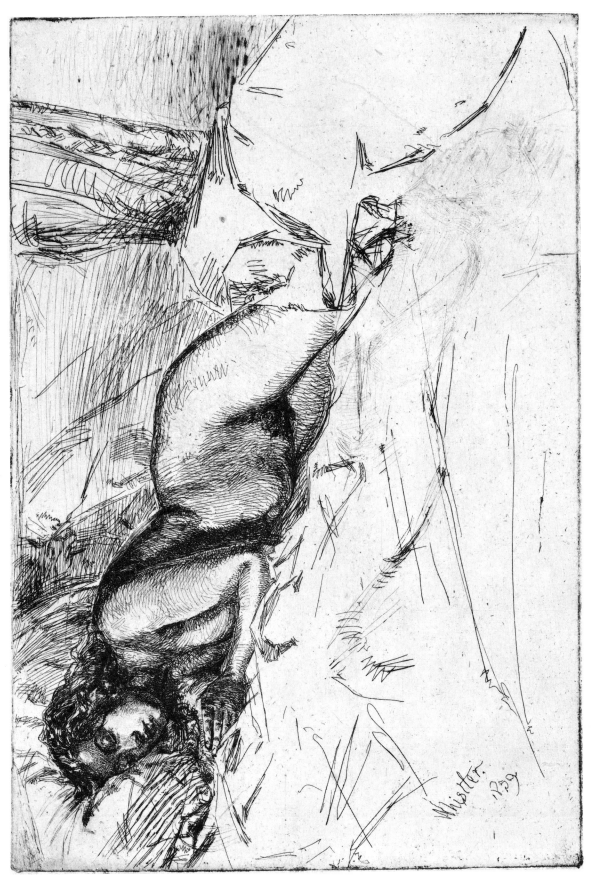

31 VENUS (K.59, 1). Etching with drypoint.

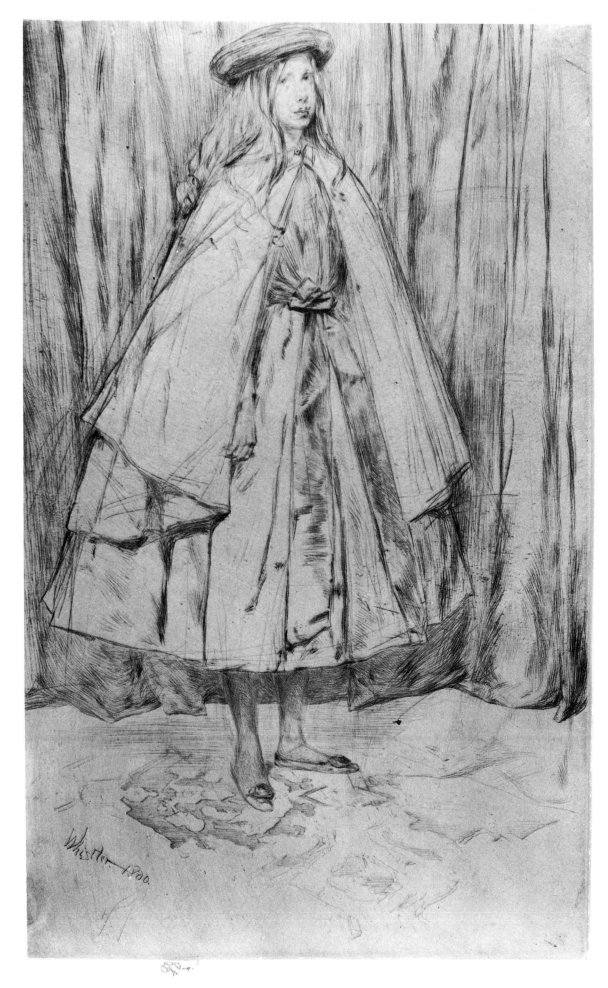

32　ANNIE HADEN (K.62, III). Drypoint. Original dimensions 13¾ x 8⅜. (Photo courtesy National Gallery of Art, Rosenwald Collection)

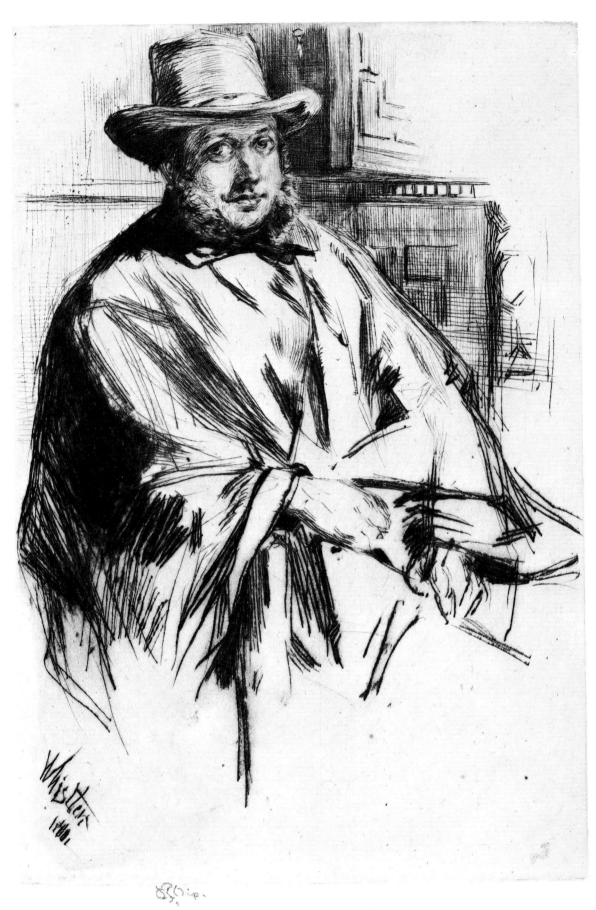

33 Mr. Mann [Henry Newnham Davis] (k.63, ii). Drypoint.

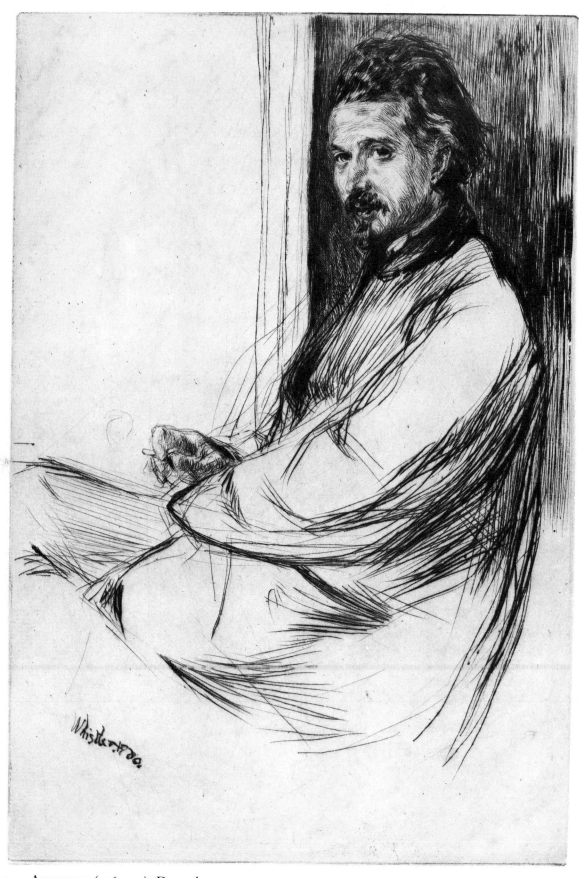

34 AXENFELD (K.64, III). Drypoint.

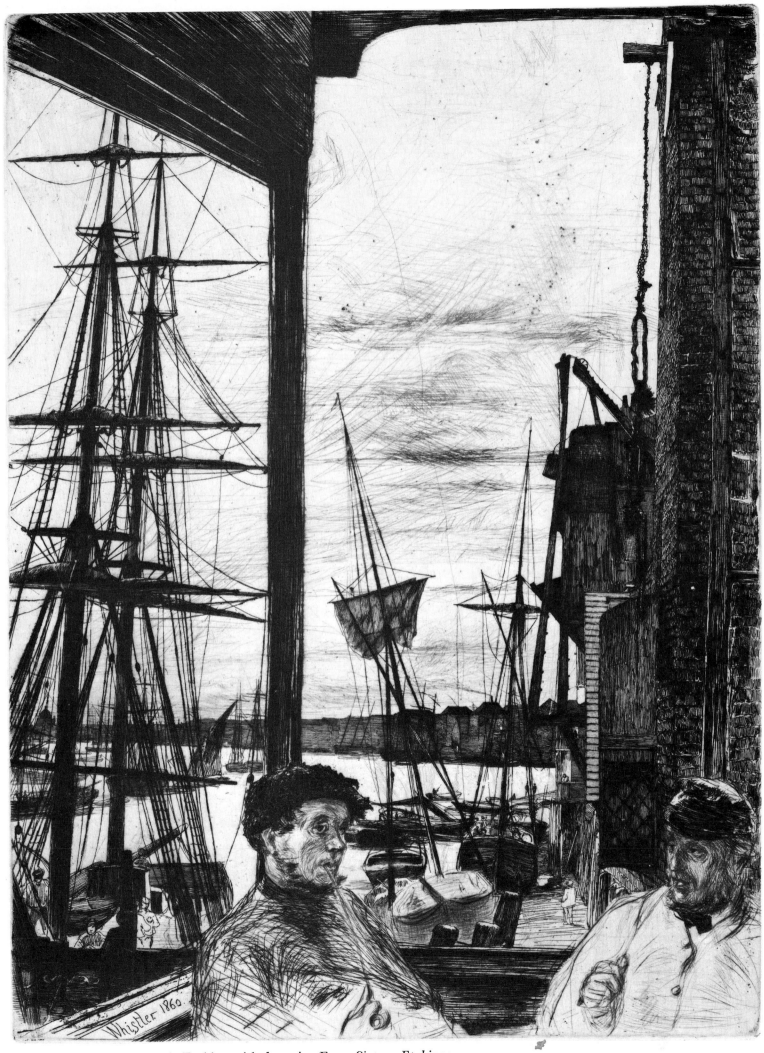

35 ROTHERHITHE (K.66, III). Etching with drypoint. From *Sixteen Etchings*.

36 THE FORGE (K.68, III?). Drypoint. Original dimensions 7⅞ × 12⅜. From *Sixteen Etchings*.

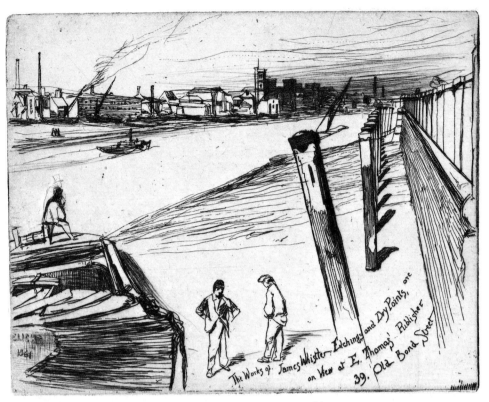

37 MILLBANK (K.71, II). Etching. From *Sixteen Etchings*.

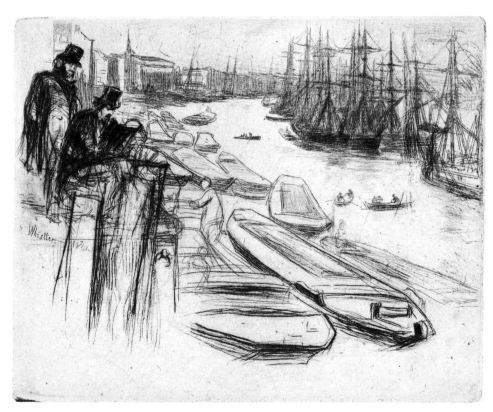

38 THE LITTLE POOL (K.74, VIII). Etching. From *Sixteen Etchings*.

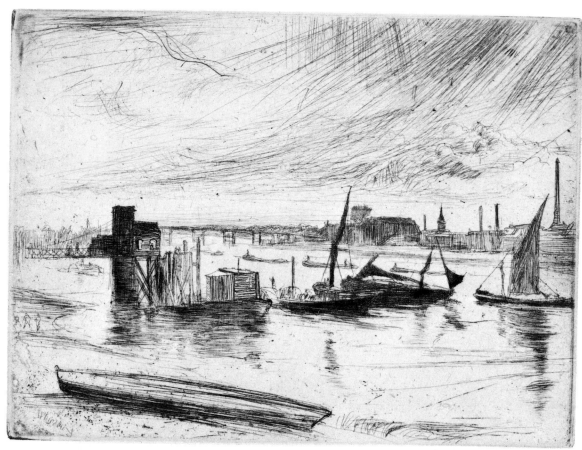

39 EARLY MORNING, BATTERSEA (K.75, ONLY STATE). Etching. From *Sixteen Etchings*.

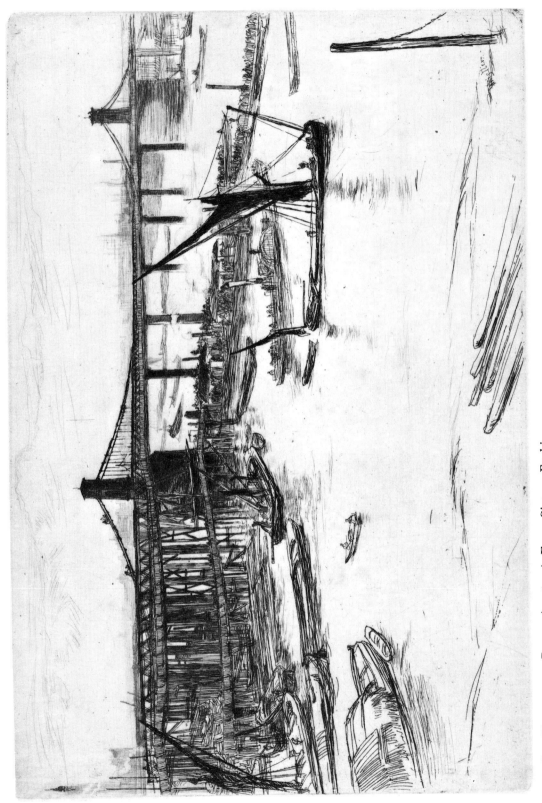

40 OLD HUNGERFORD BRIDGE (K.76, III). From *Sixteen Etchings*.

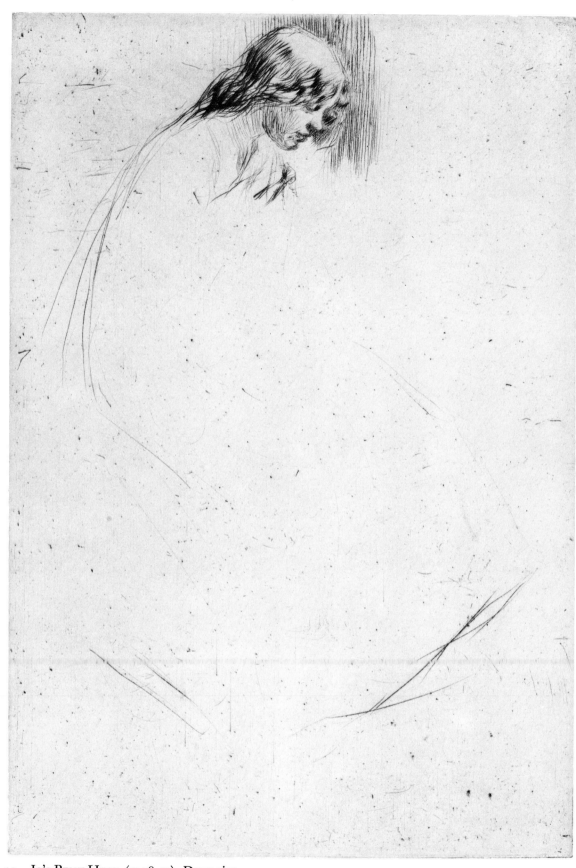

41　Jo's Bent Head (K.78, II). Drypoint.

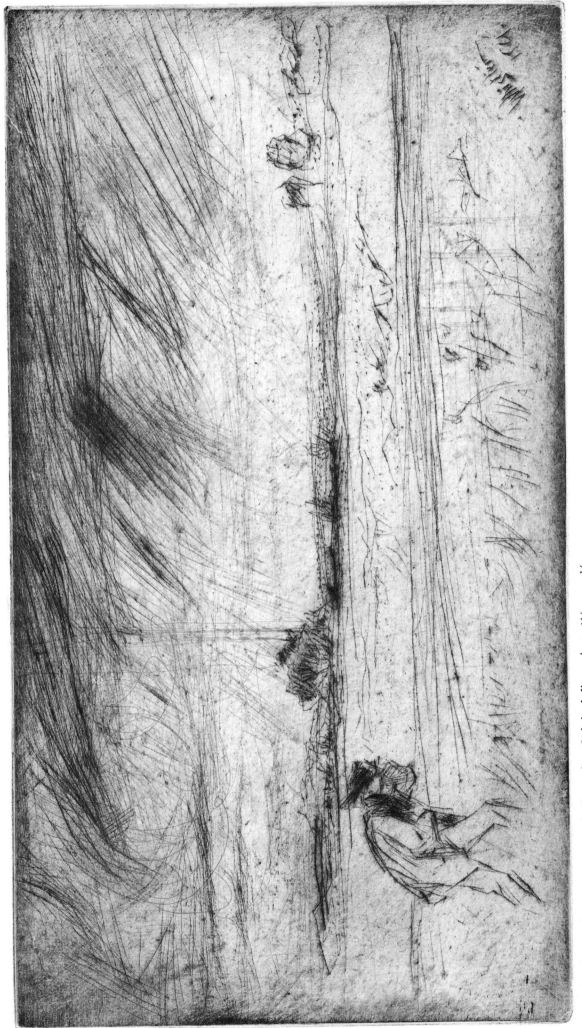

42 THE STORM (K.81, ONLY STATE). Drypoint. Original dimensions 6⅛ x 11¼.

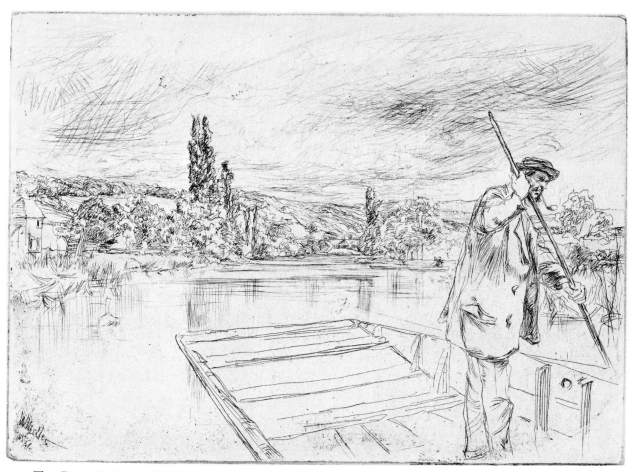

43 THE PUNT (K.85, 1). Etching.

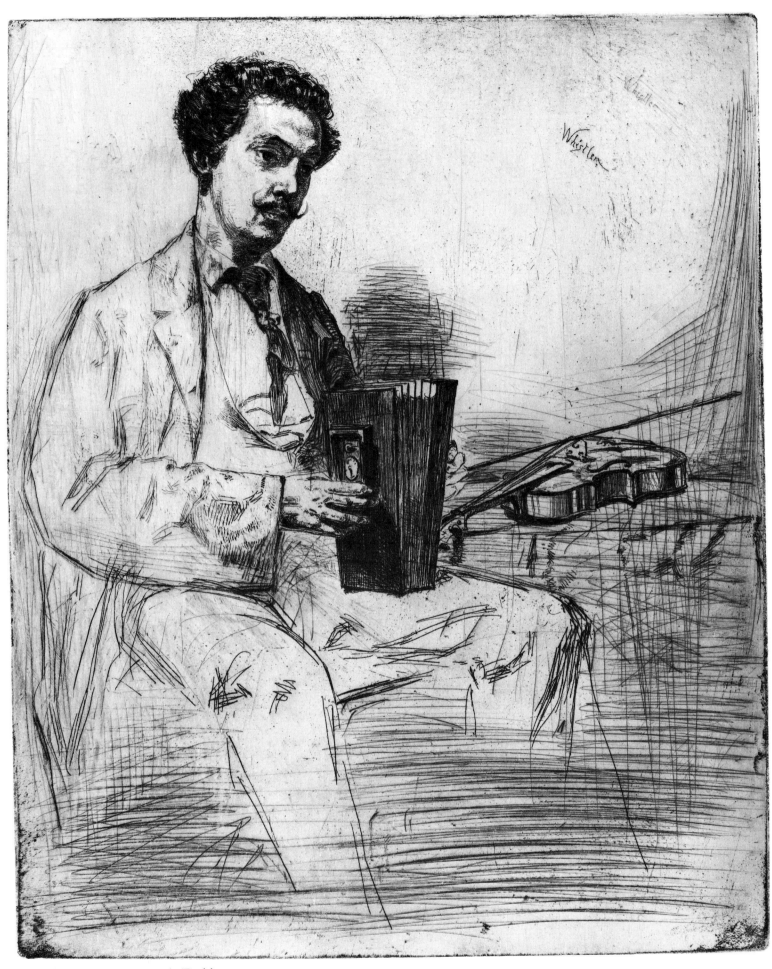

44 ROSS WINANS (K.88, 1). Etching.

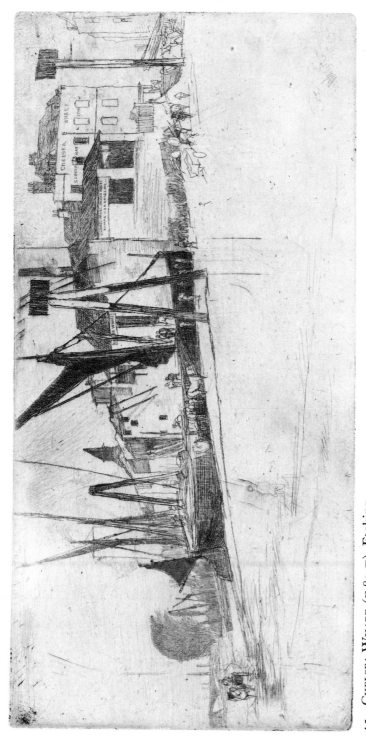

45 CHELSEA WHARF (K.89, II). Etching.

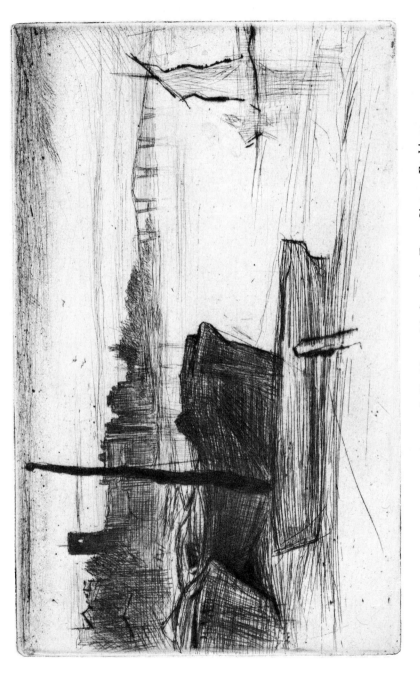

46 CHELSEA BRIDGE AND CHURCH (K.95, VI). Etching with drypoint. From *Sixteen Etchings*.

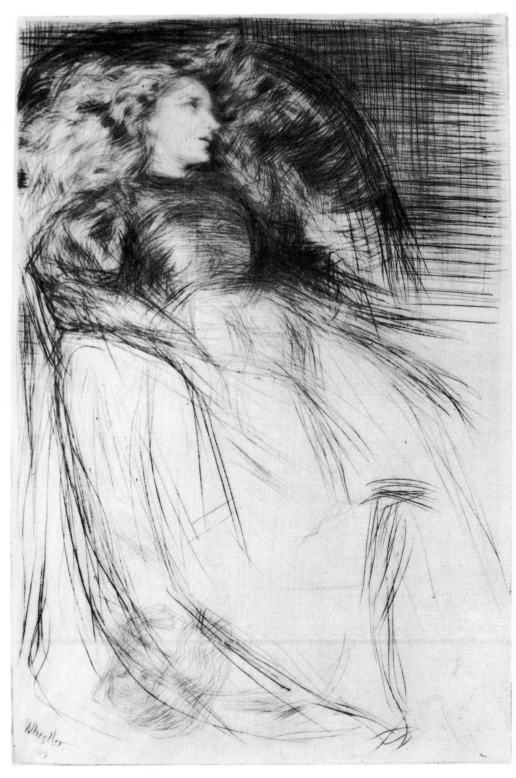

47 WEARY (K.92, IIa). Drypoint. (Photo courtesy National Gallery of Art, Rosenwald Collection)

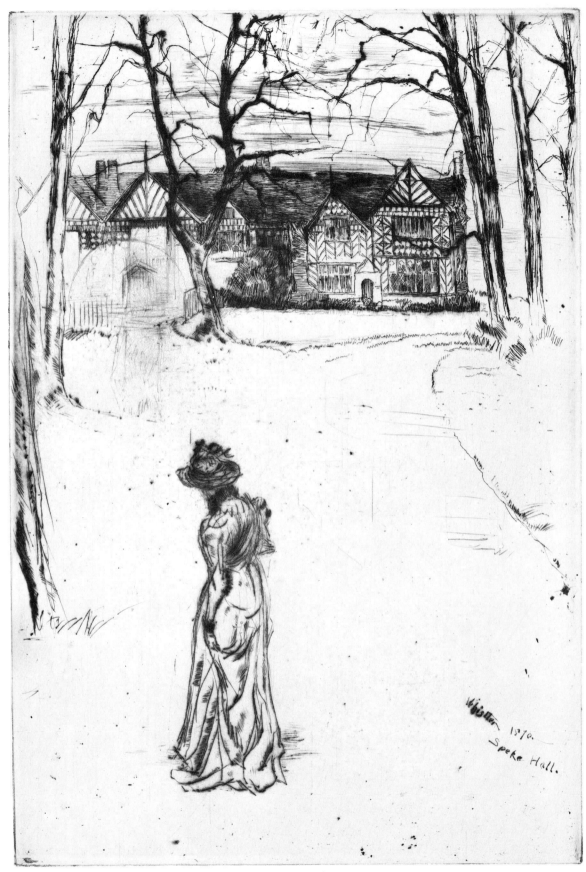

48 SPEKE HALL, No. 1 (K.96, 1). Etching with drypoint.

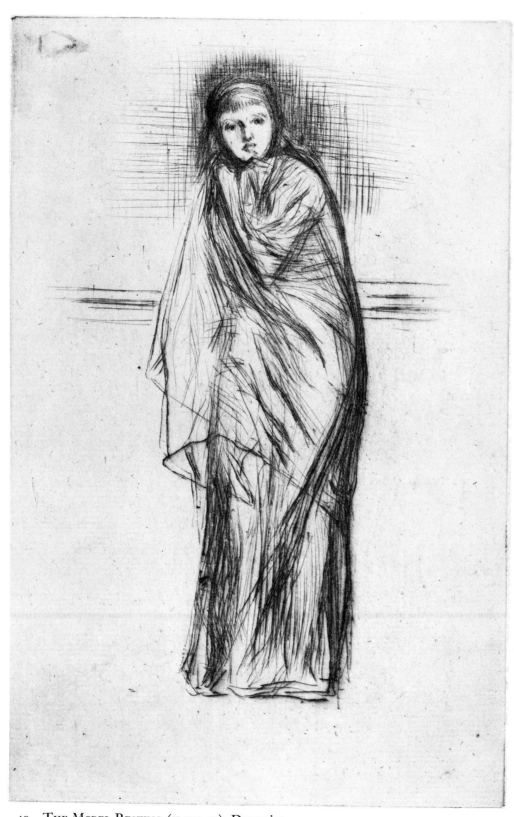

49 THE MODEL RESTING (K.100, II). Drypoint.

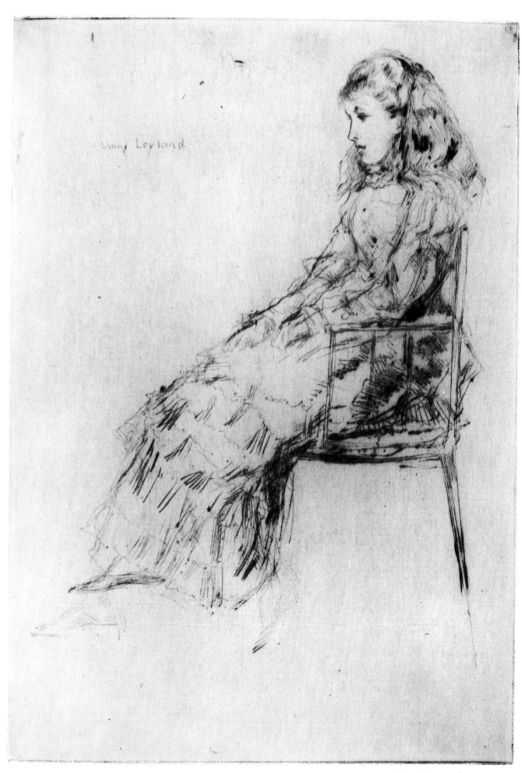

52 FANNY LEYLAND (K.108, 1). Drypoint. (Photo courtesy National Gallery of Art,
Rosenwald Collection)

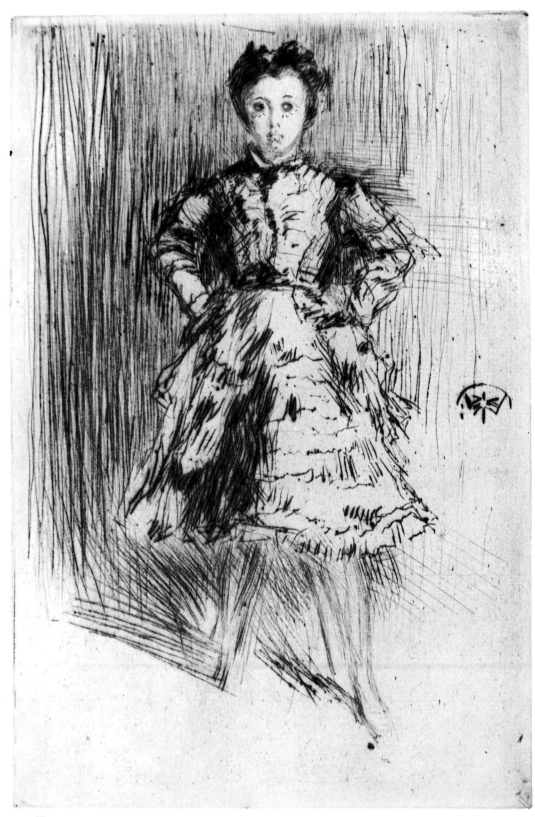

53 ELINOR LEYLAND (K.109, III). Drypoint. (Photo courtesy National Gallery of Art, Rosenwald Collection)

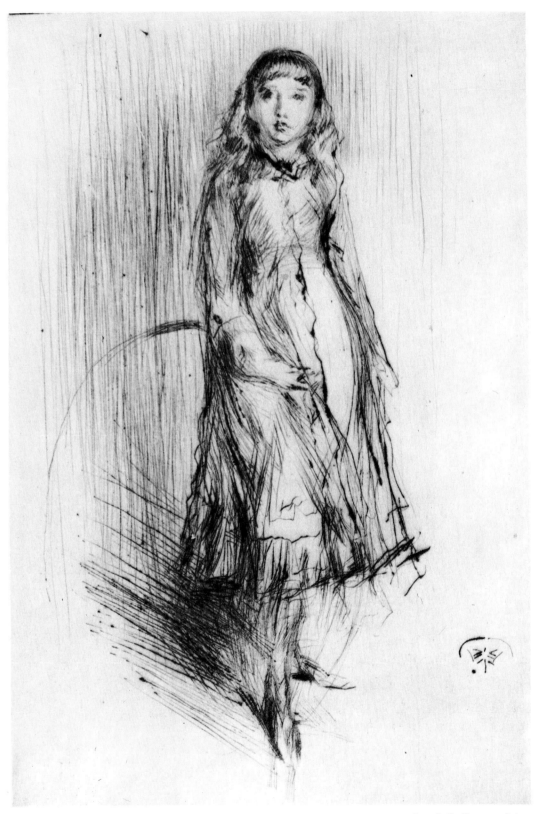

54 FLORENCE LEYLAND (K.110, III). Drypoint. (Photo courtesy National Gallery of Art, Rosenwald Collection)

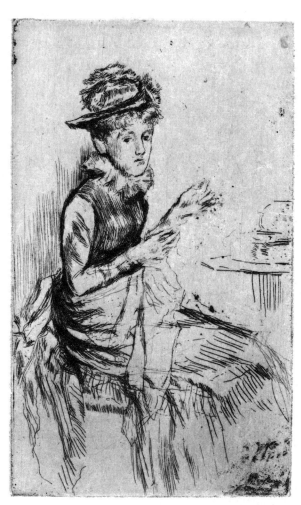

55 TATTING (K.112, ONLY STATE). Etching
with drypoint.

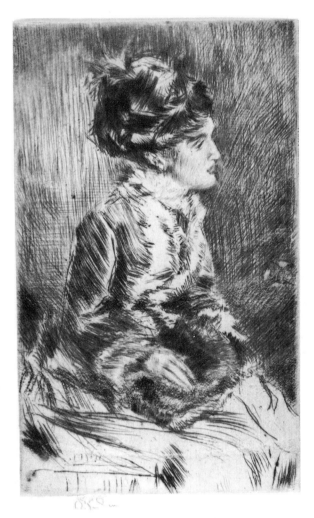

56 THE MUFF (K.113, III). Drypoint. (Photo
courtesy National Gallery of Art, Rosenwald
Collection)

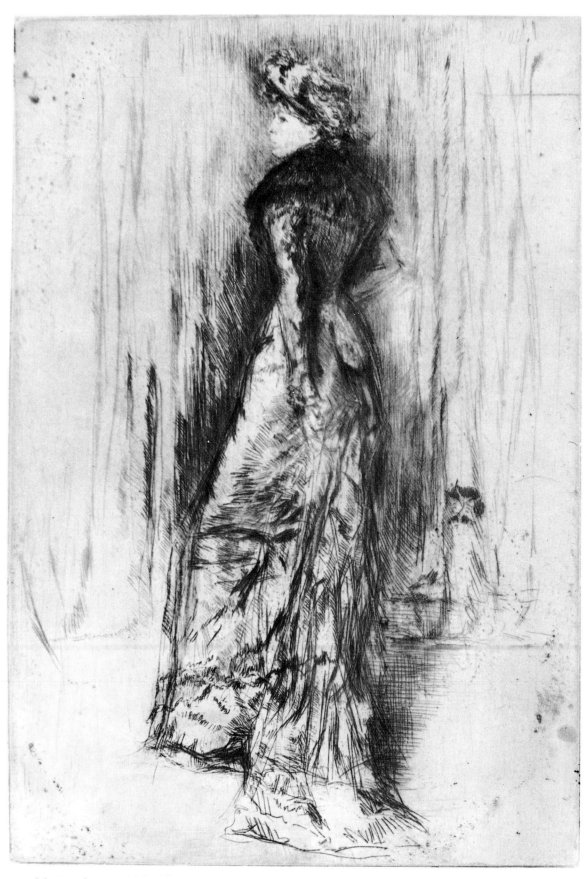

57 MAUDE, STANDING (K.114, IX). Drypoint. (Photo courtesy National Gallery of Art, Rosenwald Collection)

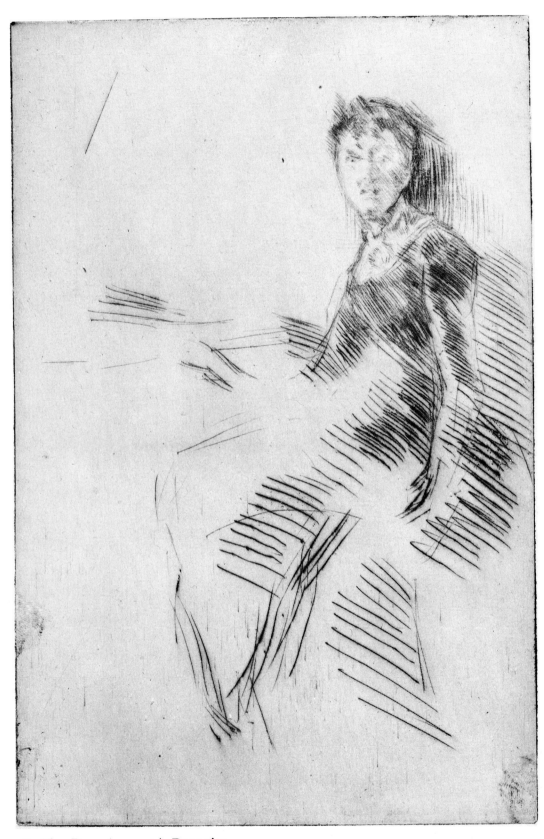

58　The Desk (k.133, ii). Drypoint.

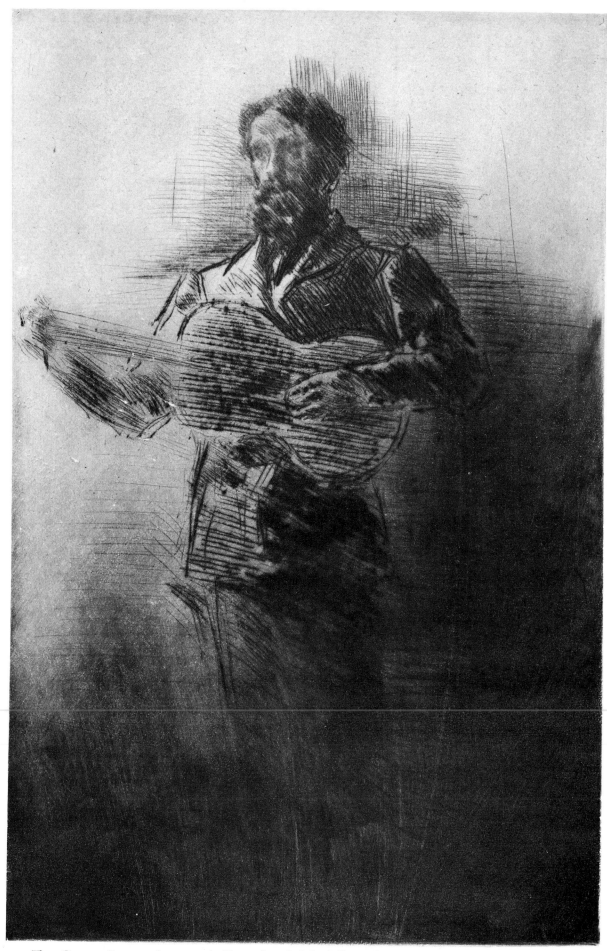

59 The Guitar Player (k.140, iii). Drypoint. Original dimensions 10⅞ x 7.

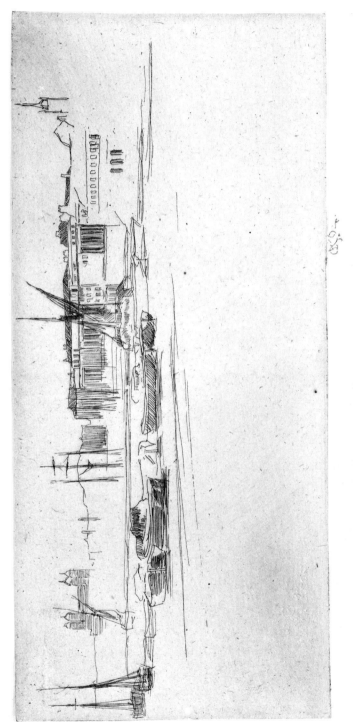

60　The White Tower (k.150, only state). Etching.

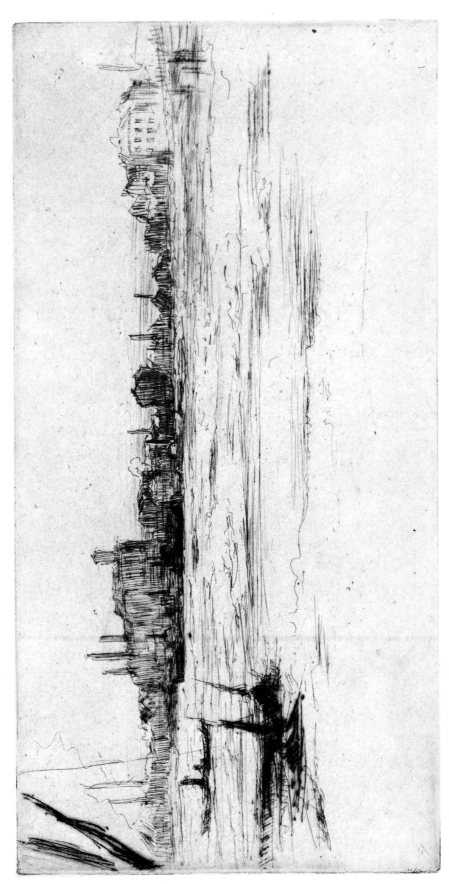

61 THE TROUBLED THAMES (K.152, III). Etching.

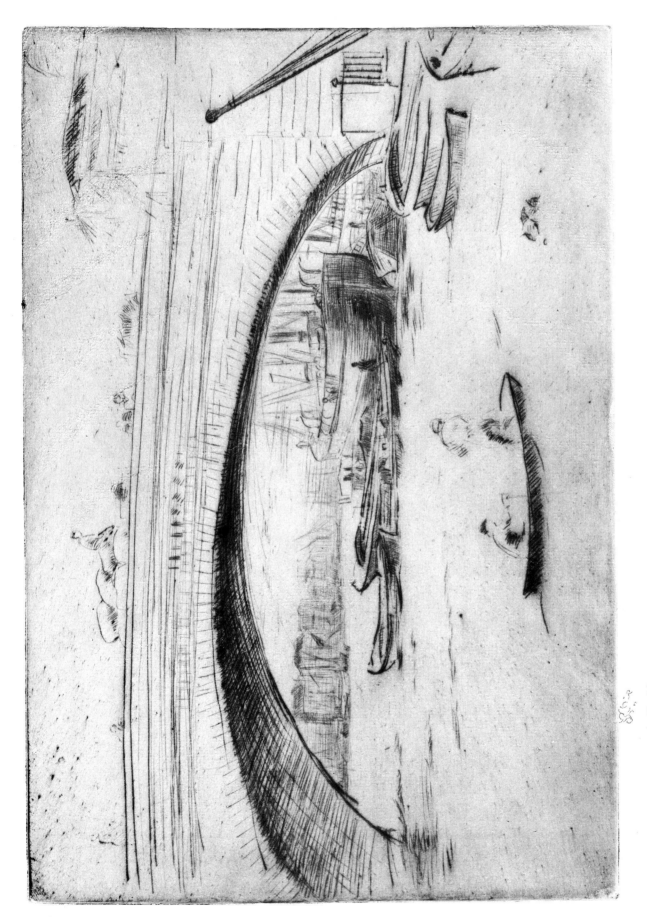

62 LONDON BRIDGE (K.153, V). Etching.

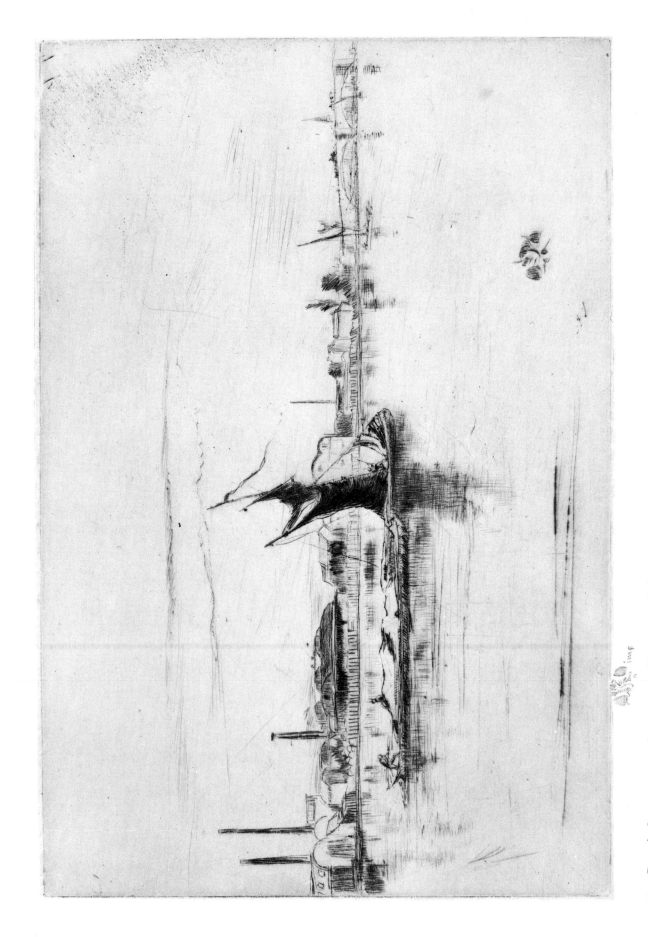

63 PRICE'S CANDLEWORKS (K.154, IIIa). Etching with drypoint.

64 BATTERSEA: DAWN (K.155, II). Drypoint.

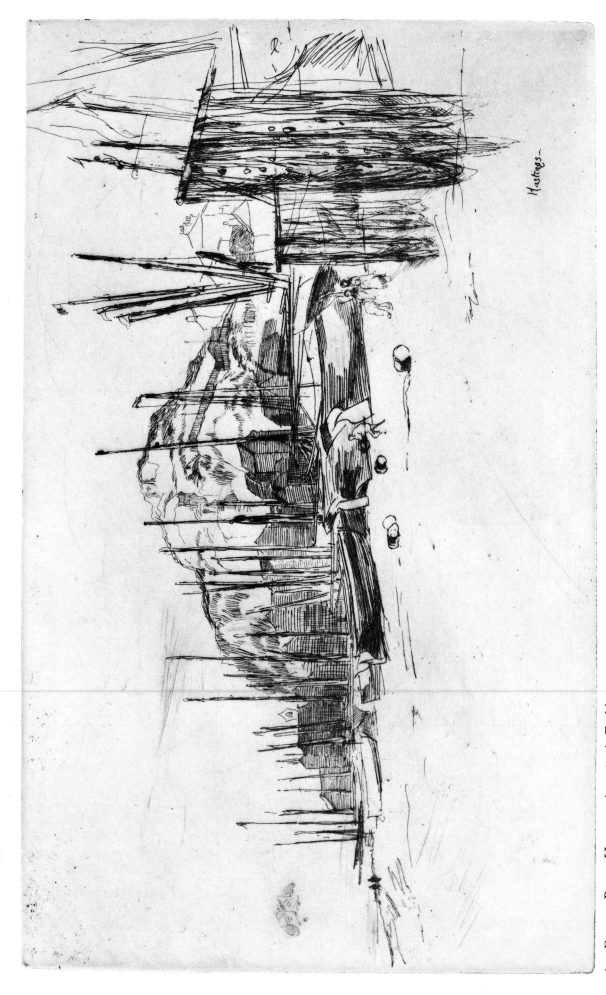

65 FISHING-BOATS, HASTINGS (K.158, II). Etching.

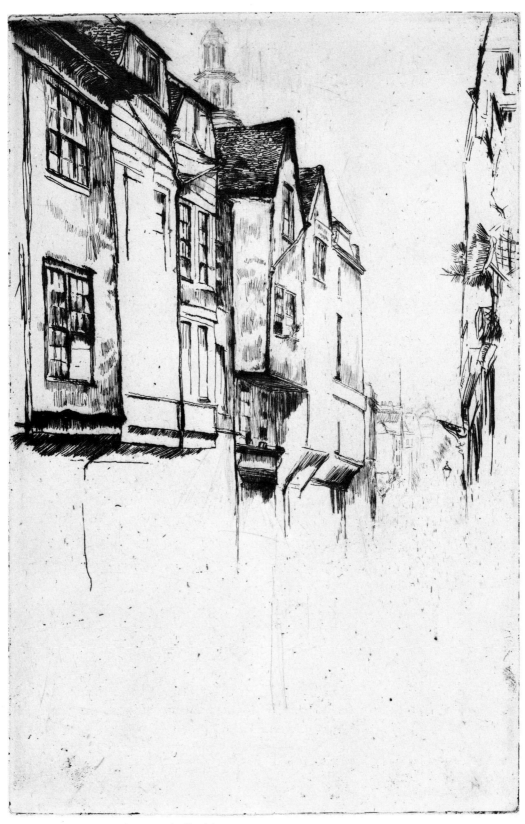

66 WYCH STREET (K.159, 1). Etching.

67 THE THAMES TOWARDS ERITH (K.165, II). Drypoint.

68 FROM PICKLE-HERRING STAIRS (K.167, IV). Etching.

69 A Sketch from Billingsgate (K.168, VI). Etching.

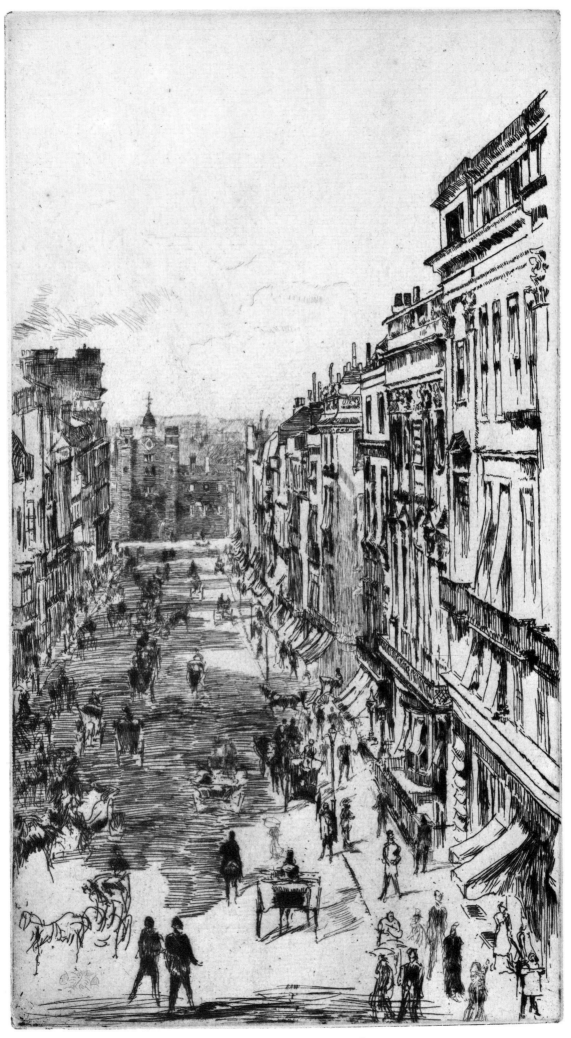

70 St. James's Street (K.169, IV). Etching. Original dimensions 11 x 6.

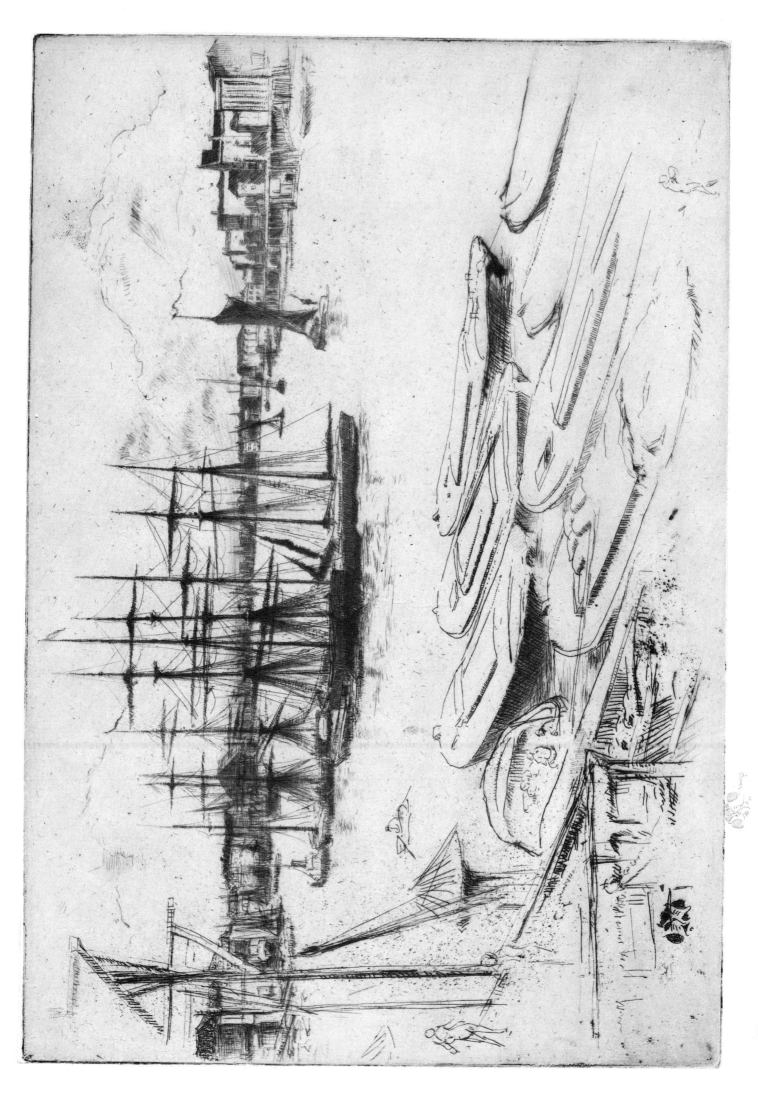

71 THE LARGE POOL (K.174, VII). Etching.

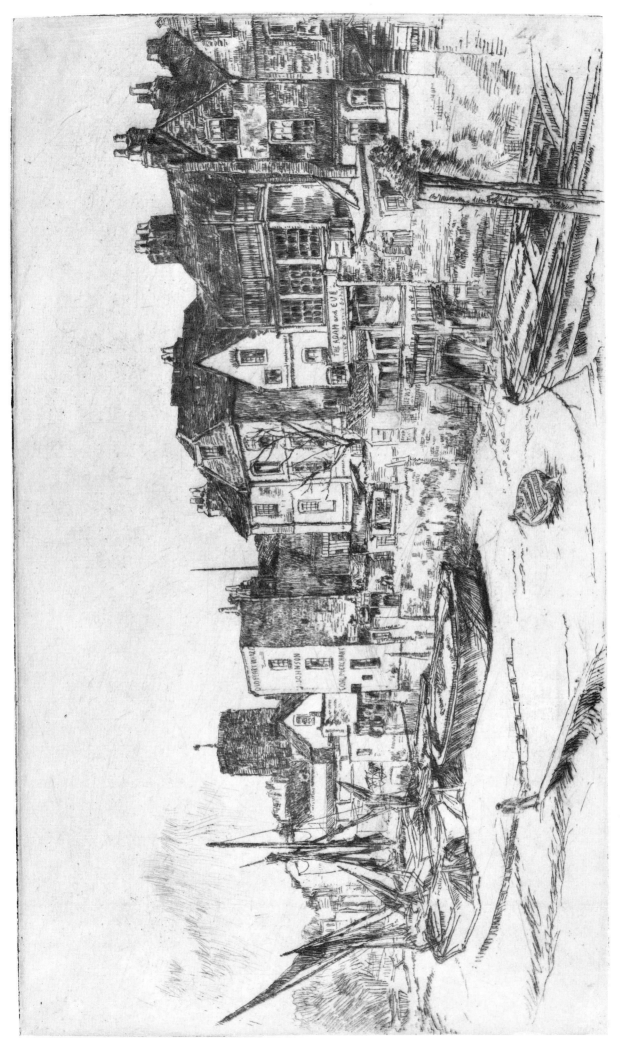

72 The "Adam and Eve," Old Chelsea (k.175, 1). Etching. Original dimensions 6⅞ × 11⅞.

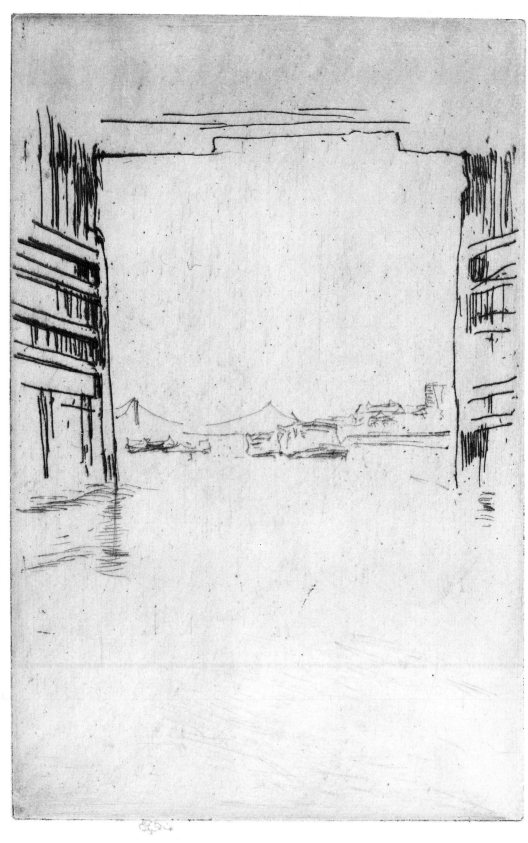

73 UNDER OLD BATTERSEA BRIDGE (K.176, 1). Etching.

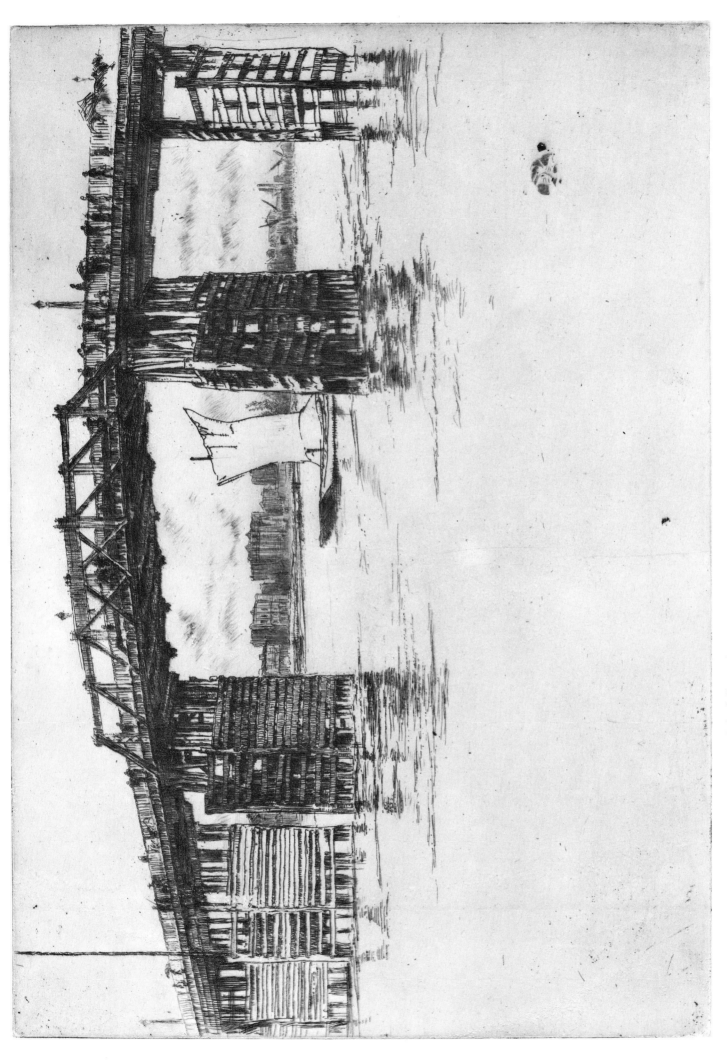

74 OLD BATTERSEA BRIDGE (K.177, IV). Etching. Original dimensions 7⅞ x 11⅝.

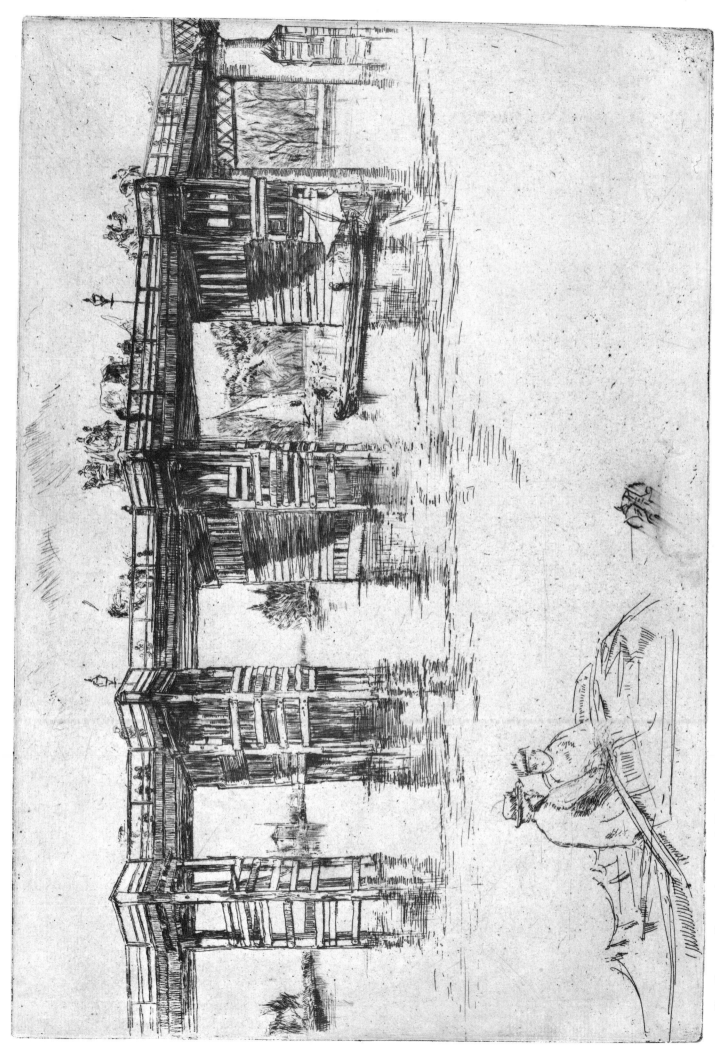

75 OLD PUTNEY BRIDGE (K.178, IV). Etching with drypoint. Original dimensions 7⅞ x 11¾.

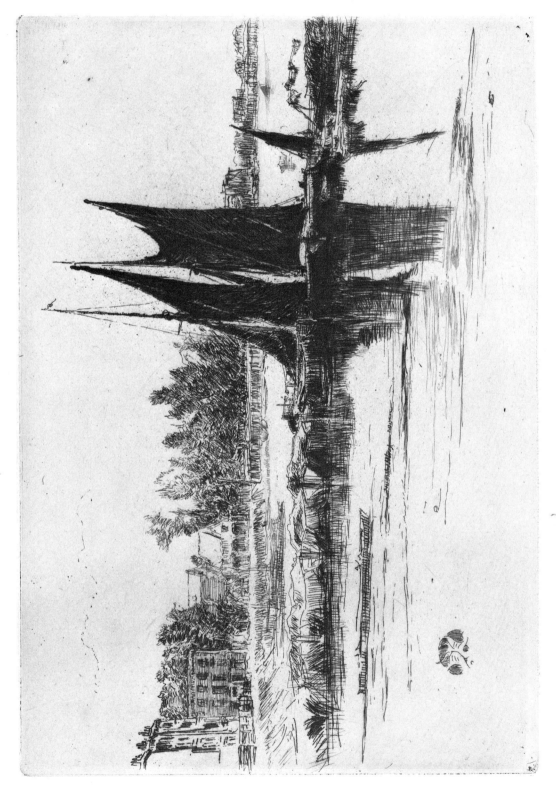

76 HURLINGHAM (K.181, III). Etching.

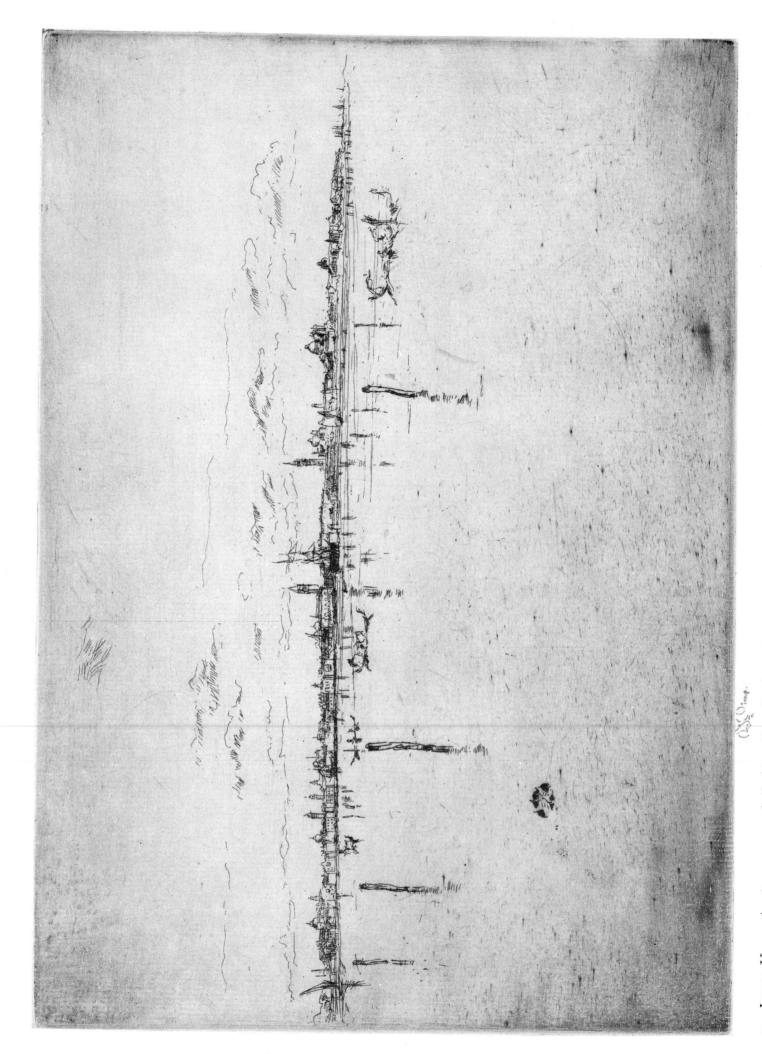

77 LITTLE VENICE (K.183, ONLY STATE). Etching. From *Venice, a Series of Twelve Etchings* (first Venice set).

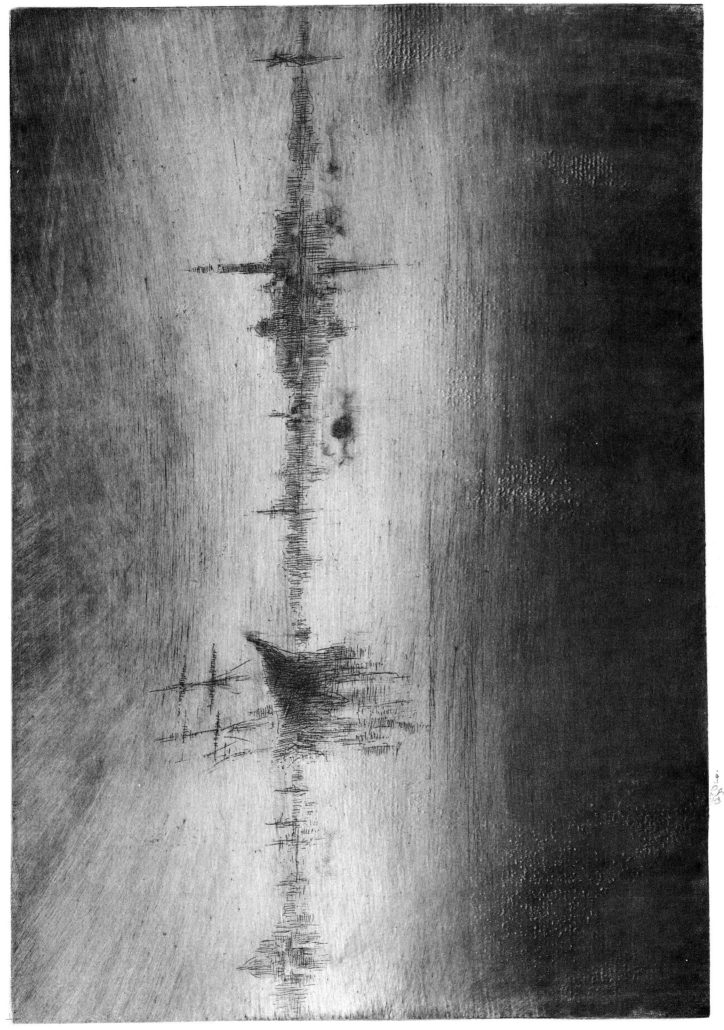

78 NOCTURNE (K.184, IV). Etching with drypoint. Original dimensions 7⅞ x 11⅞. From *Venice*.

79 THE LITTLE MAST (K.185, II). Etching. From *Venice*.

80 THE LITTLE LAGOON (K.186, II). Etching with drypoint. From *Venice*.

81 THE PALACES (K.187, III). Etching. Original dimensions 9⅞ x 14⅛. From *Venice*.

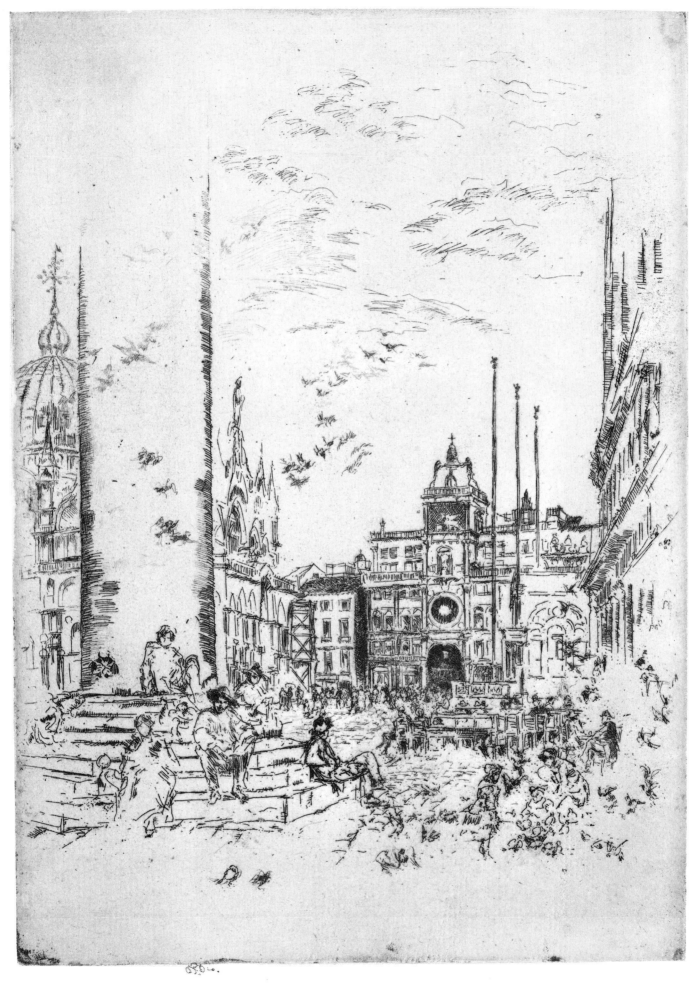

82 THE PIAZZETTA (K.189, V). Etching with drypoint. 10 x 7⅛. From *Venice*.

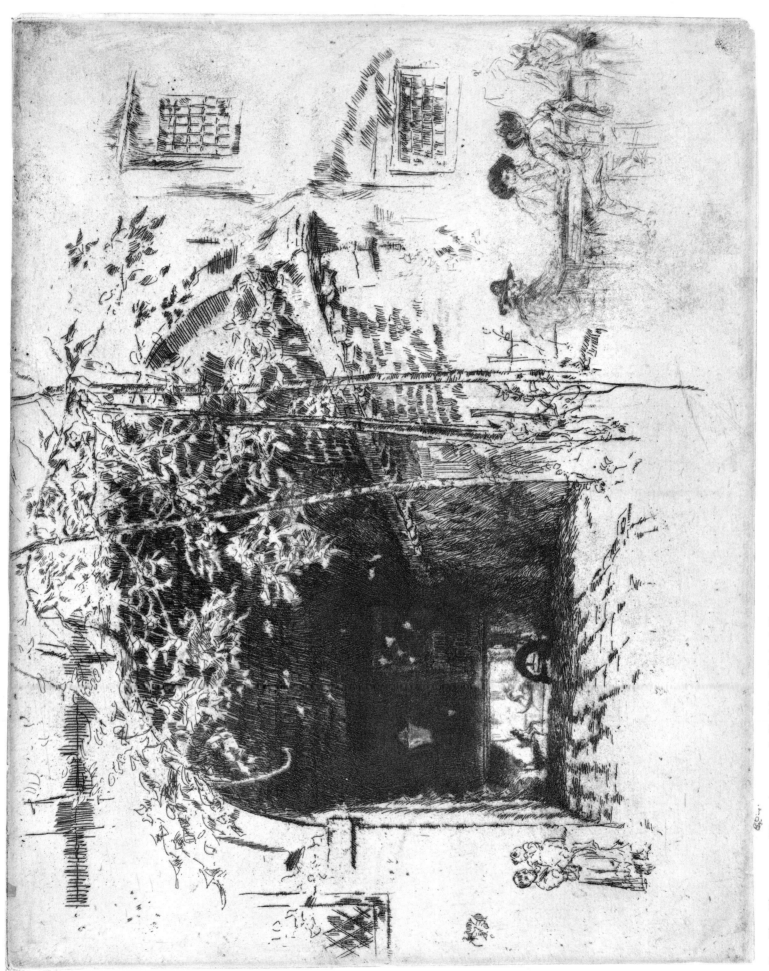

83 THE TRAGHETTO, No. 2 (K.191, IV). Etching. Original dimensions 9¼ x 12. From *Venice*.

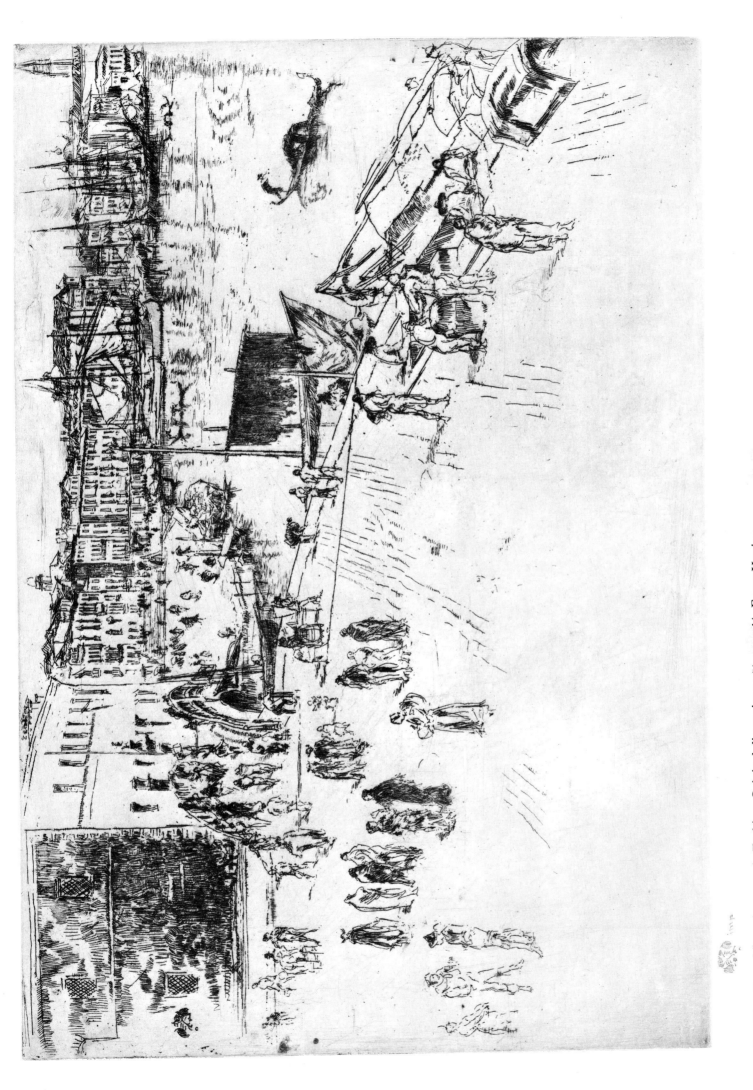

84 The Riva, No. 1 (k.192, iii). Etching. Original dimensions 7⅞ x 11½. From *Venice*.

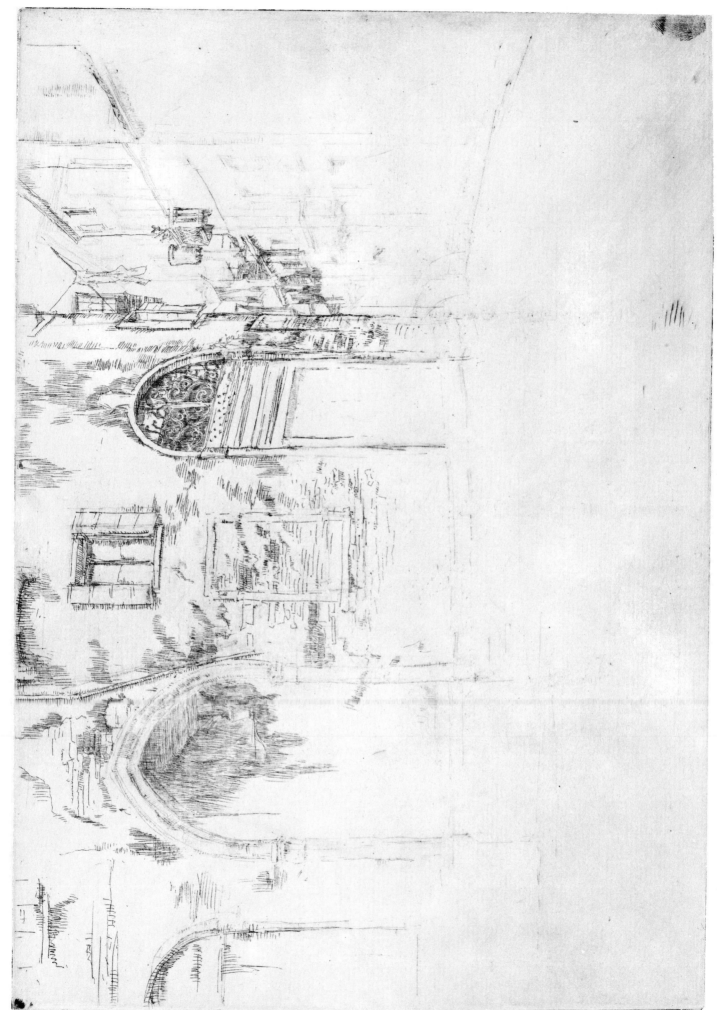

85　The Two Doorways (K.193), state 1. Etching with drypoint. Original dimensions 8 x 11½. From *Venice*.

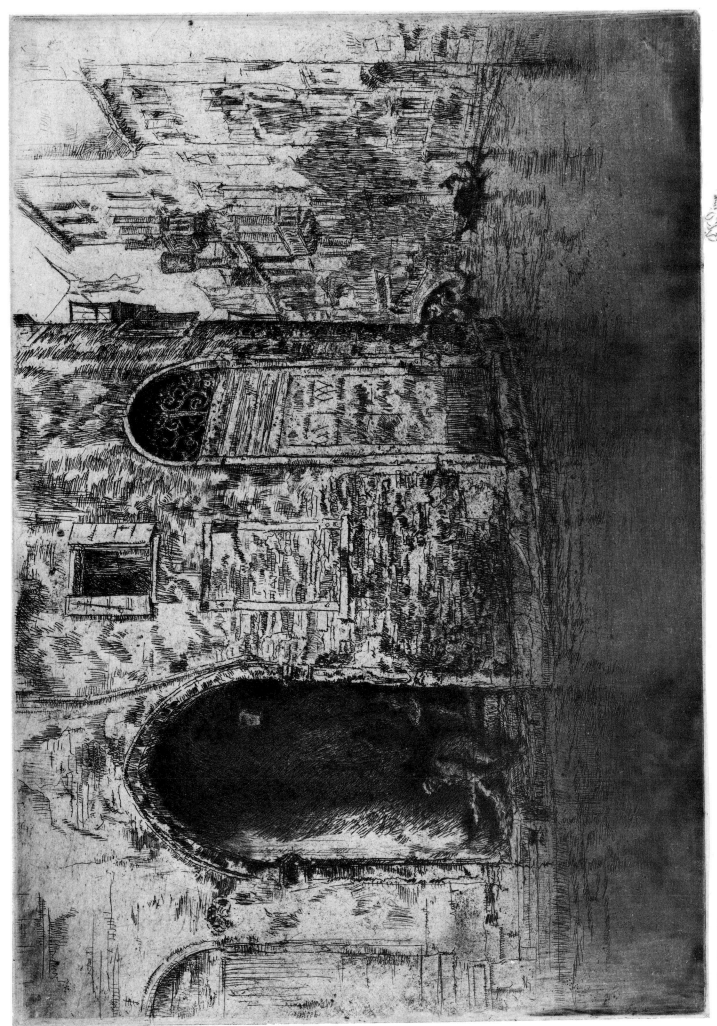

86 The Two Doorways, STATE IV.

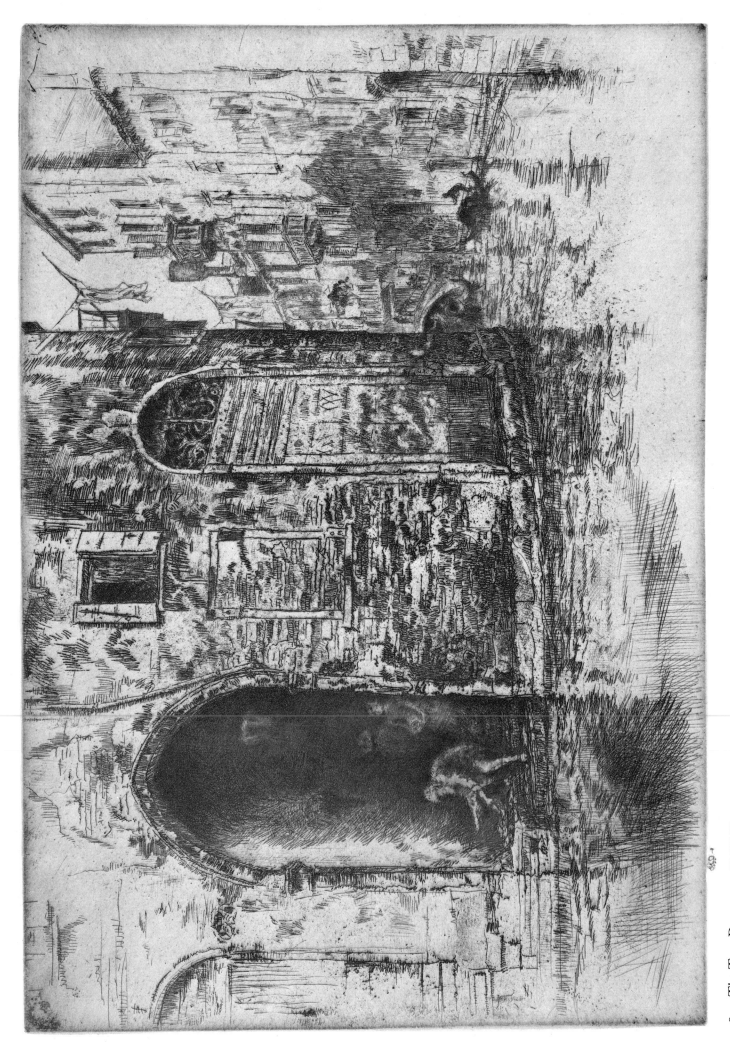

87 The Two Doorways, STATE VI.

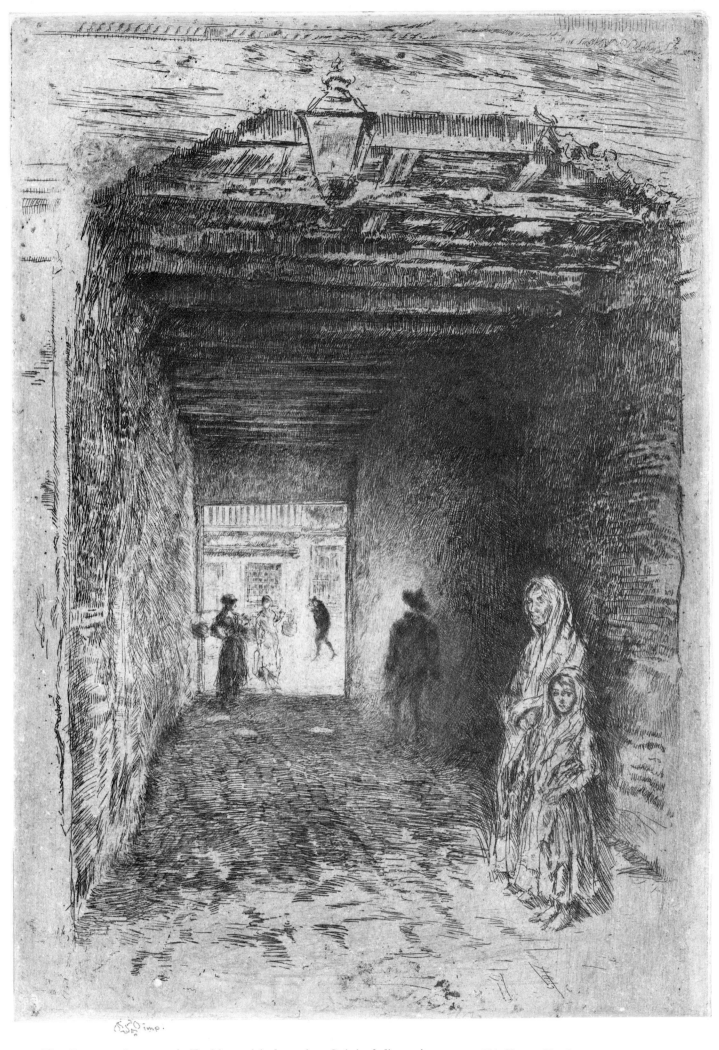

88 THE BEGGARS (K.194, IV). Etching with drypoint. Original dimensions 12 x 8¼. From *Venice*.

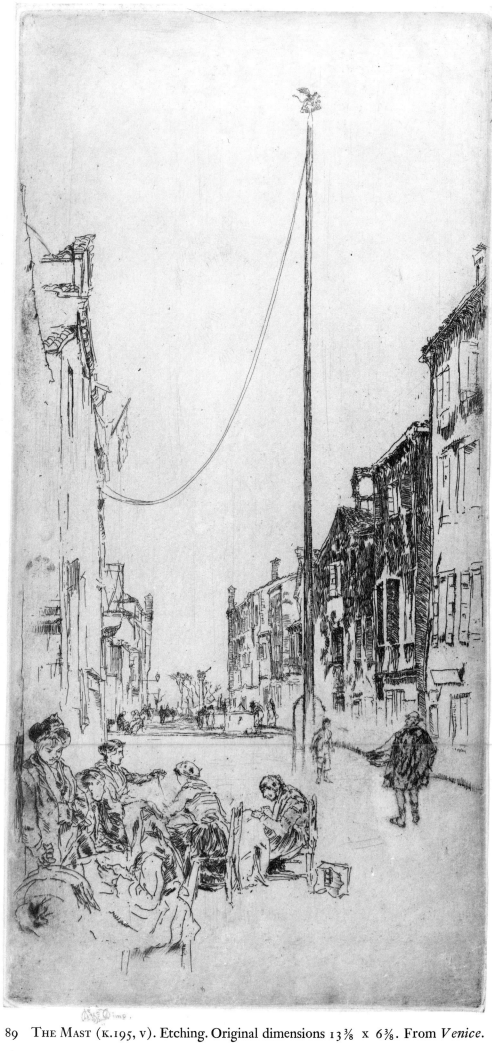

89 THE MAST (K.195, V). Etching. Original dimensions 13⅜ x 6⅜. From *Venice*.

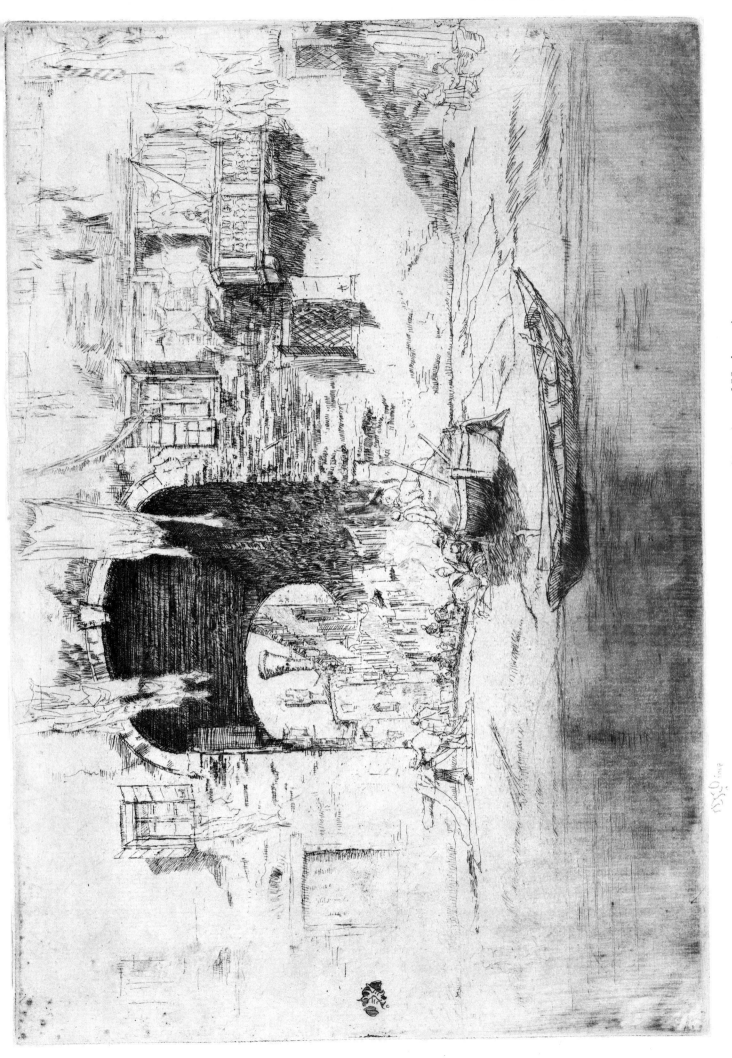

90　SAN BIAGIO (K.197, IV). Etching. Original dimensions 8¼ x 12. From *A Set of Twenty-six Etchings* (second Venice set).

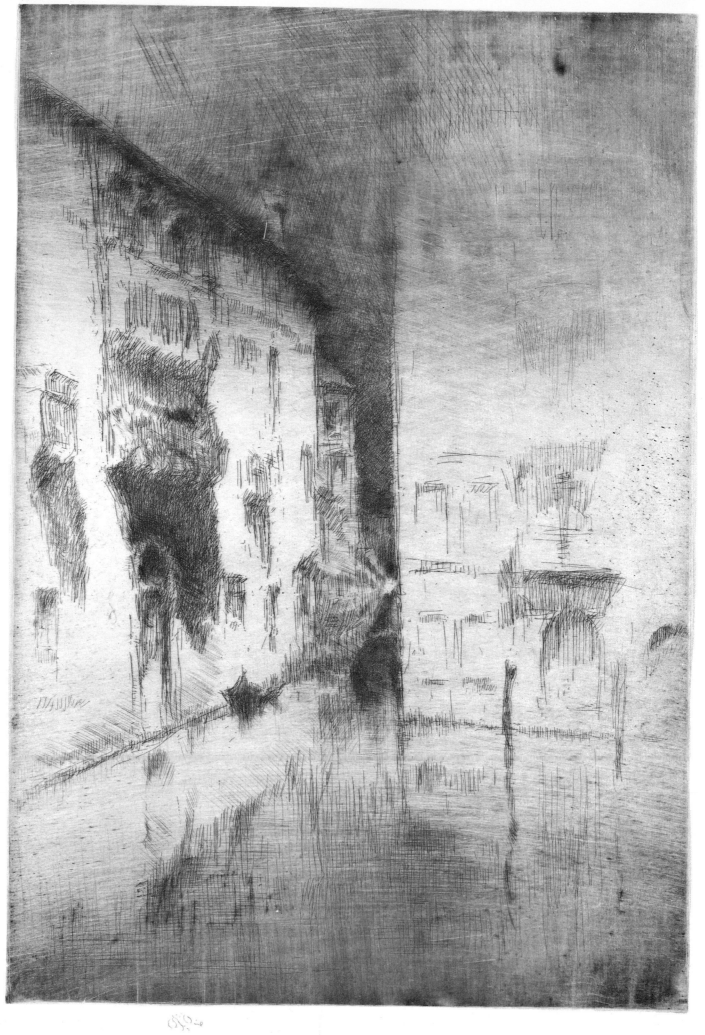

91 Nocturne: Palaces (k.202, viii). Etching with drypoint. Original dimensions 11⅝ x 7⅞. From *Twenty-six Etchings*.

92 LONG LAGOON (K.203, 1). Etching. From *Twenty-six Etchings*.

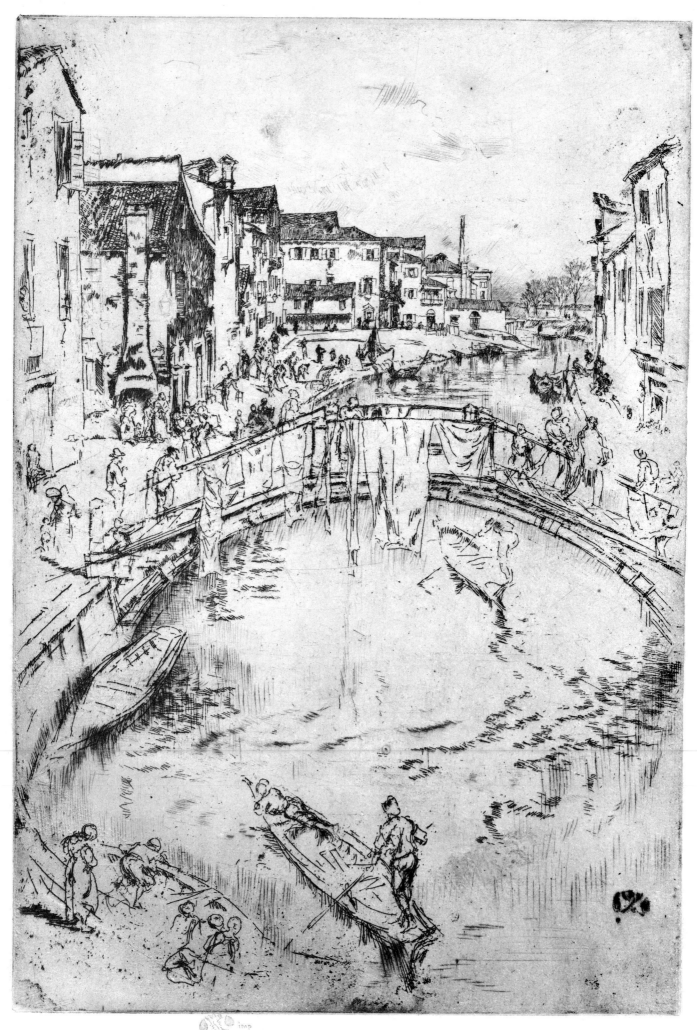

93 THE BRIDGE (K.204, VII). Etching. Original dimensions 11 ¾ x 7⅞. From *Twenty-six Etchings*.

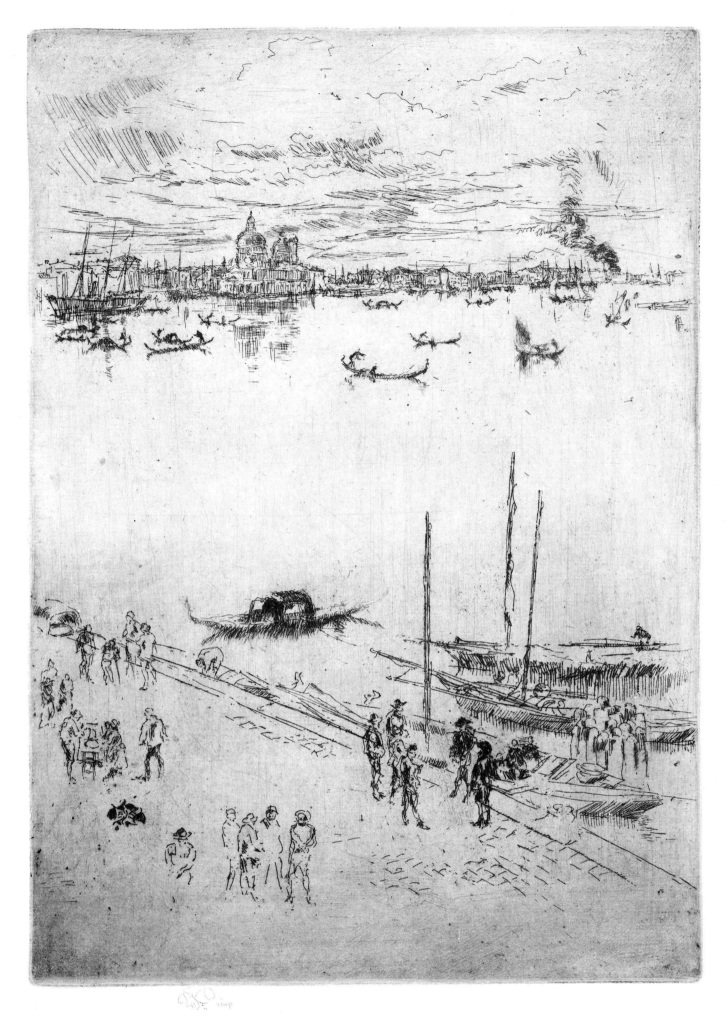

94 UPRIGHT VENICE (K.205, II). Etching. From *Twenty-six Etchings*.

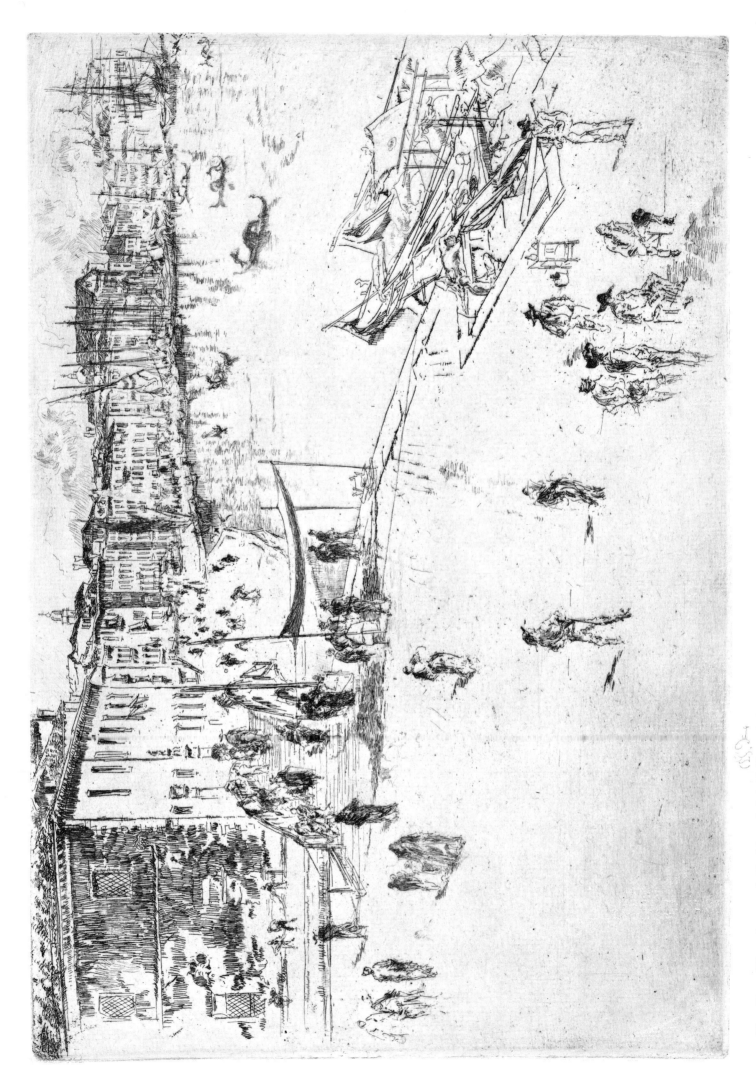

95　THE RIVA, No. 2 (K.206, I). Etching. Original dimensions 8¼ x 12. From *Twenty-six Etchings*.

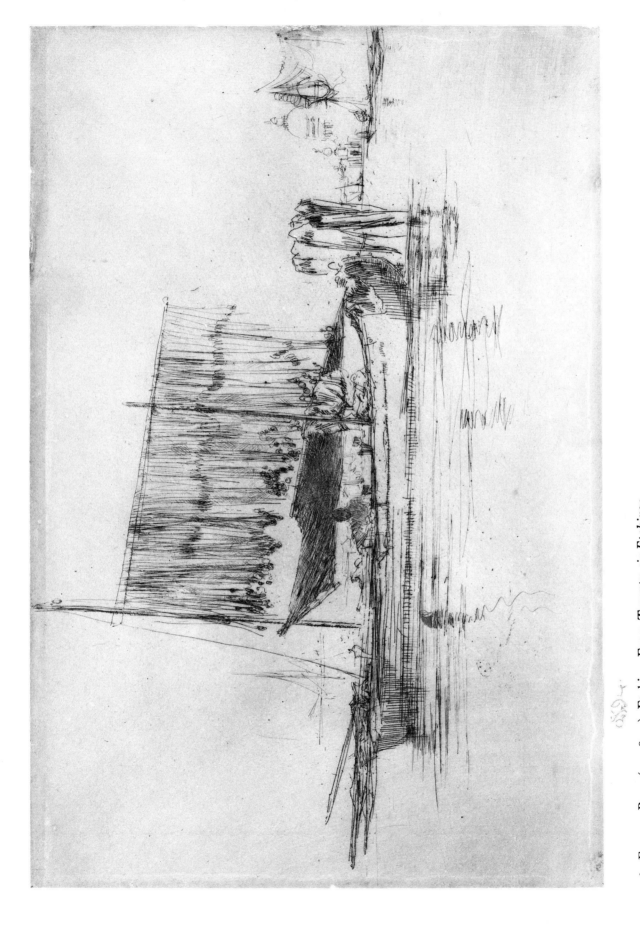

96 FISHING-BOAT (K.208, IV). Etching. From *Twenty-six Etchings*.

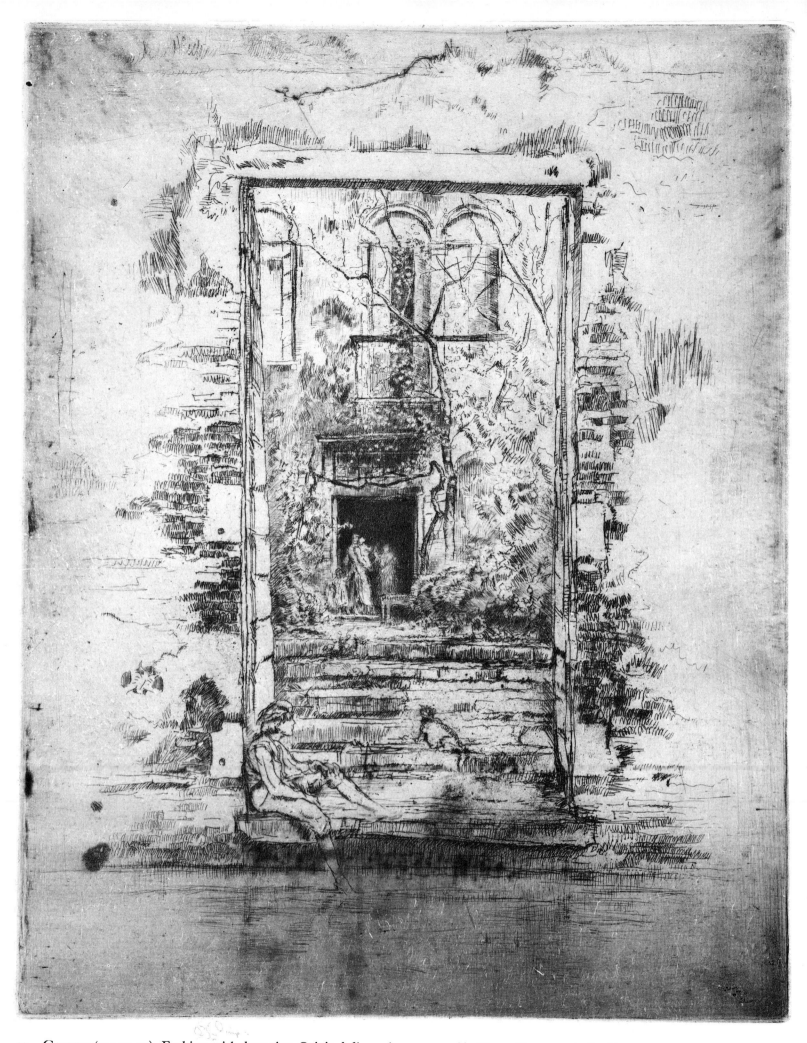

97 GARDEN (K.210, IV). Etching with drypoint. Original dimensions 12 x 9¼. From *Twenty-six Etchings*.

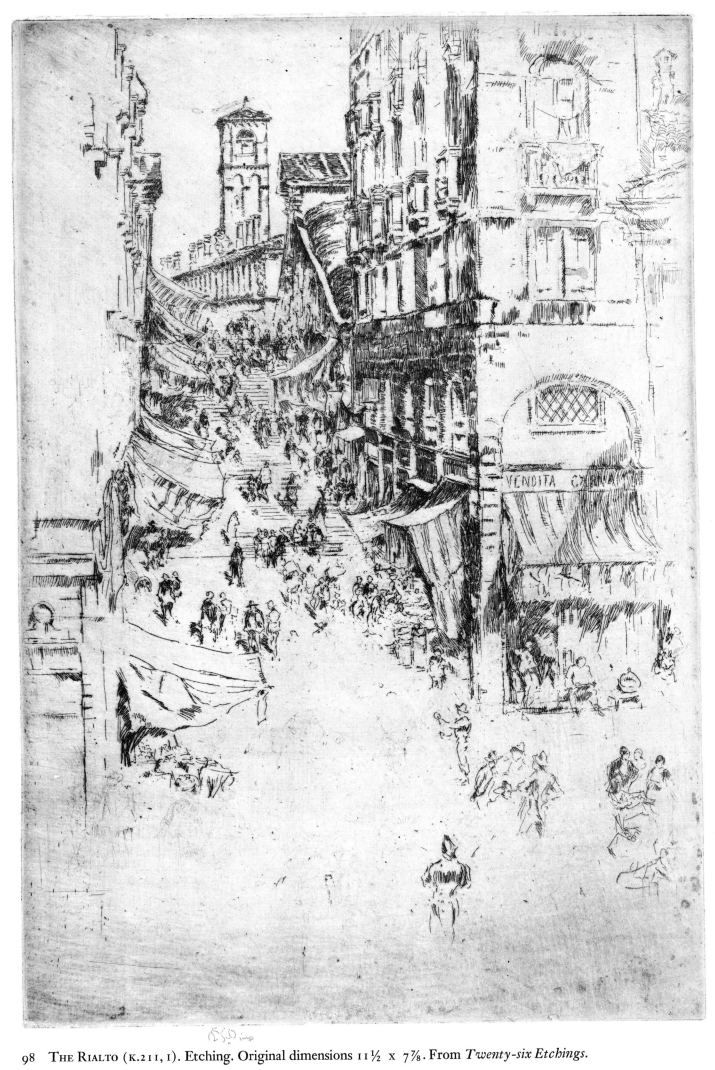

98 THE RIALTO (K.211, 1). Etching. Original dimensions 11½ x 7⅞. From *Twenty-six Etchings*.

99 Long Venice (k.212, v). Etching. Original dimensions 5 × 12¼. From *Twenty-six Etchings.*

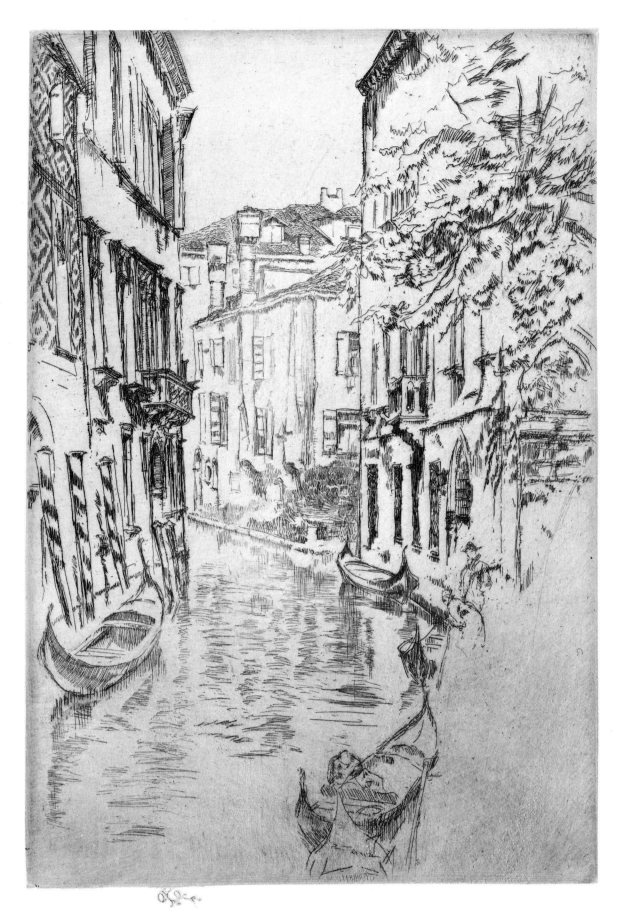

100 QUIET CANAL (K.214, V). Etching. From *Twenty-six Etchings*.

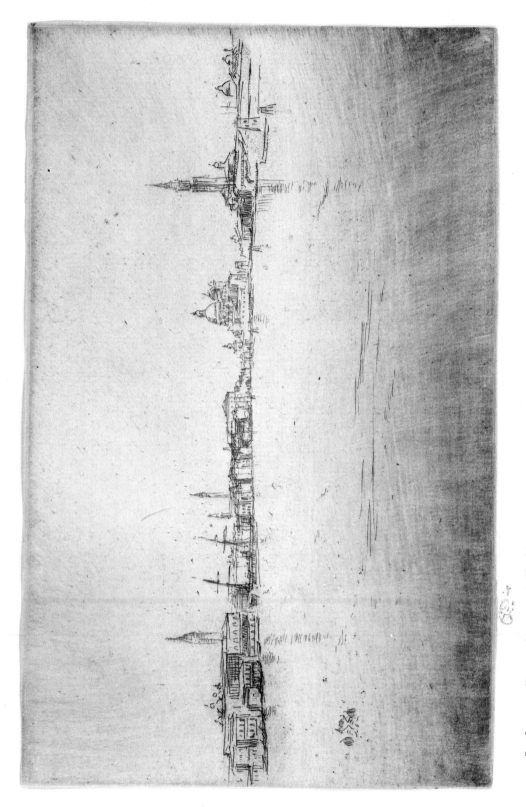

101 LA SALUTE: DAWN (K.215, IV). Etching. From *Twenty-six Etchings*.

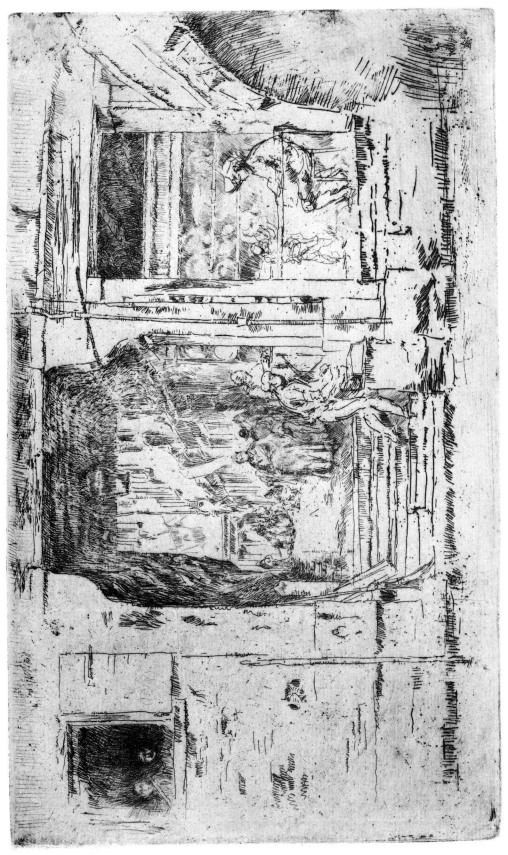

102 FISH-SHOP, VENICE (K.218, v). Etching.

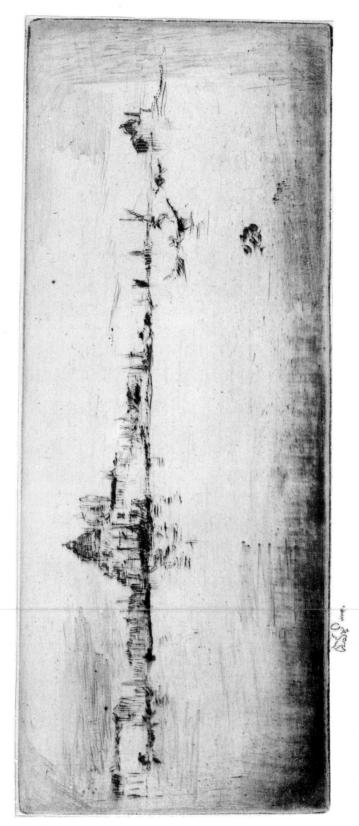

103 LITTLE SALUTE (K.220, II). Drypoint.

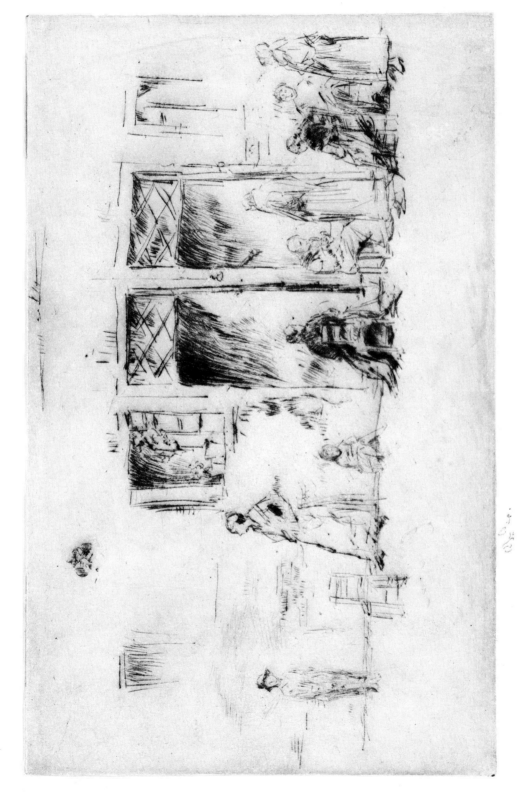

104　OLD WOMEN (K.224, I).　Drypoint.

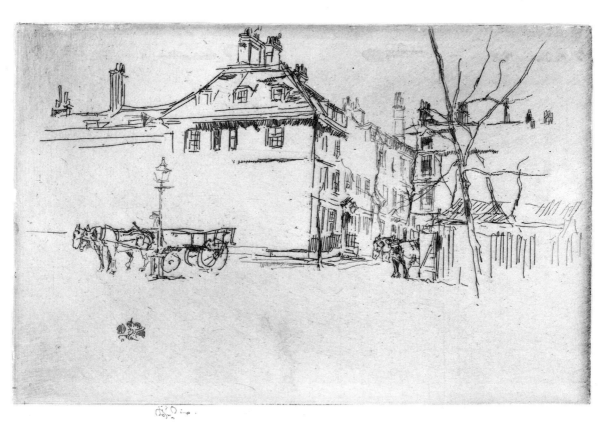

105 TEMPLE (K.234, ONLY STATE). Etching. From *Twenty-six Etchings*.

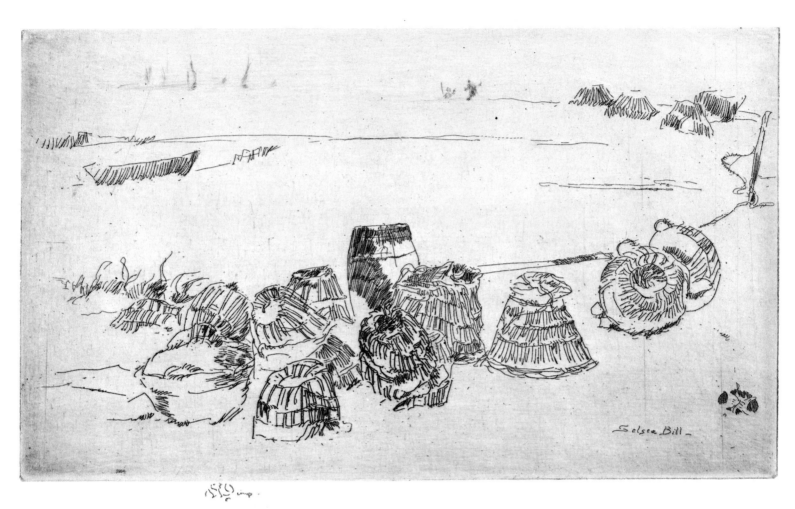

106 LOBSTER-POTS (K.235, I). Etching. From *Twenty-six Etchings*.

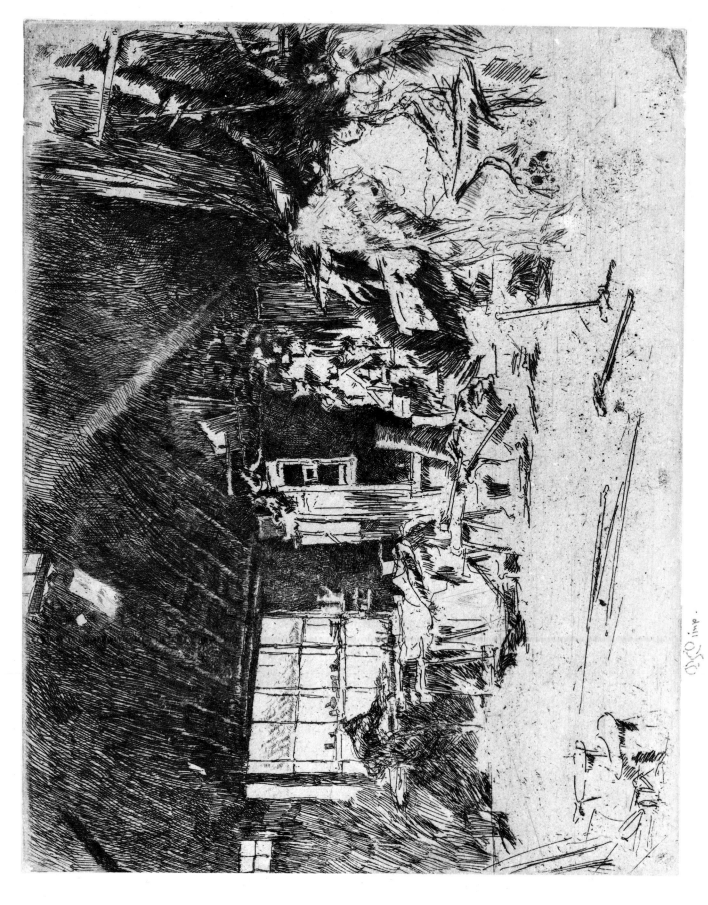

107 THE SMITHY (K.240, III). Etching with drypoint.

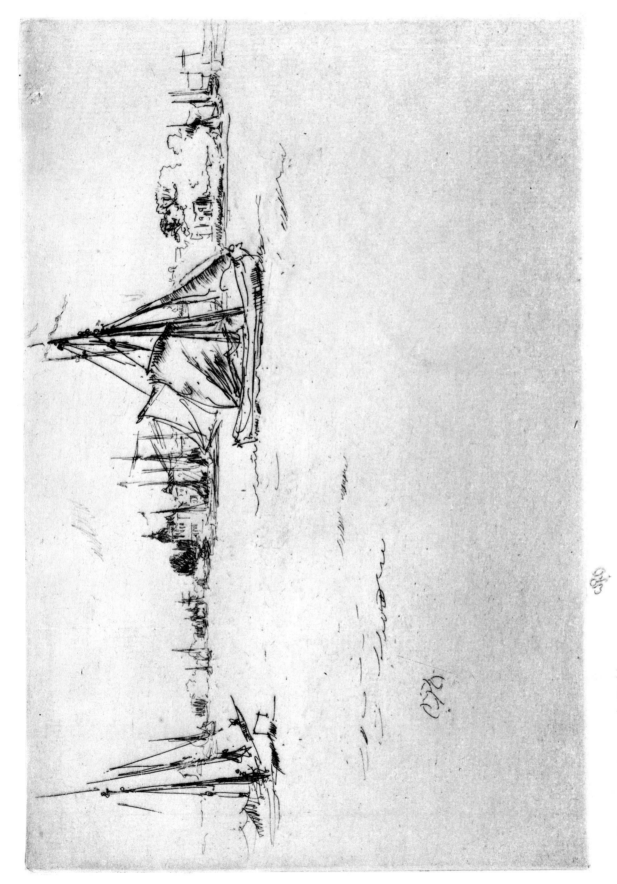

108 DORDRECHT (K.242, II). Etching.

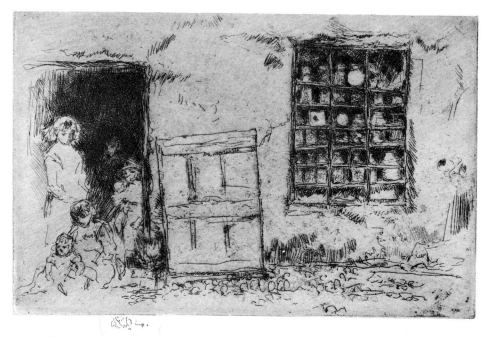

109 THE VILLAGE SWEET-SHOP (K.251, ONLY STATE). Etching.

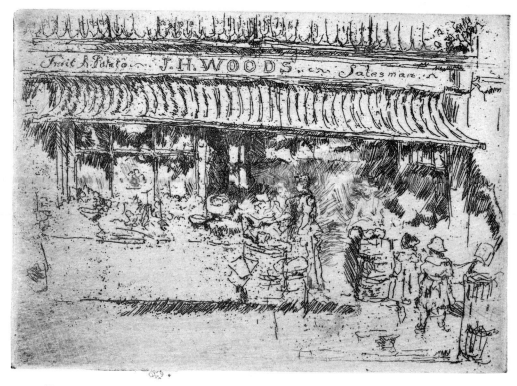

110 WOODS'S FRUIT-SHOP (K.265, II). Etching.

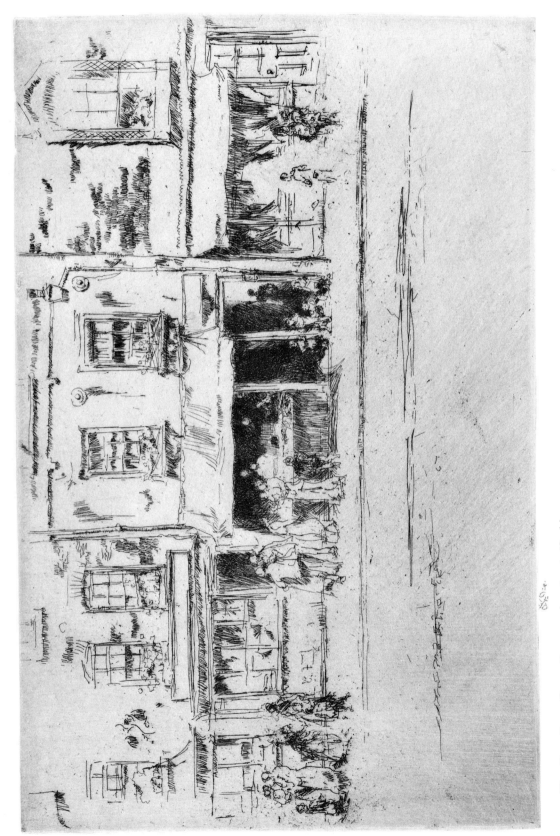

111 THE FISH-SHOP, BUSY CHELSEA (K.264, 1). Etching.

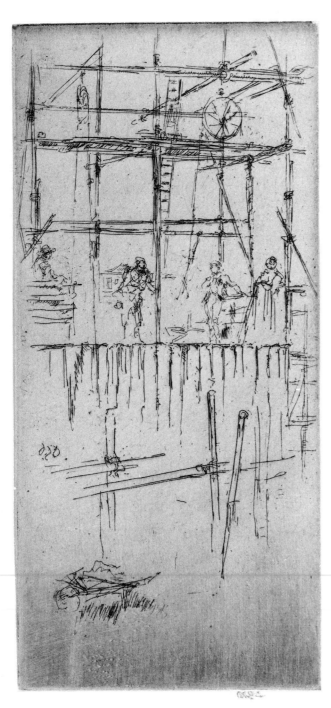

112 SAVOY SCAFFOLDING (K.267, ONLY STATE).
Etching.

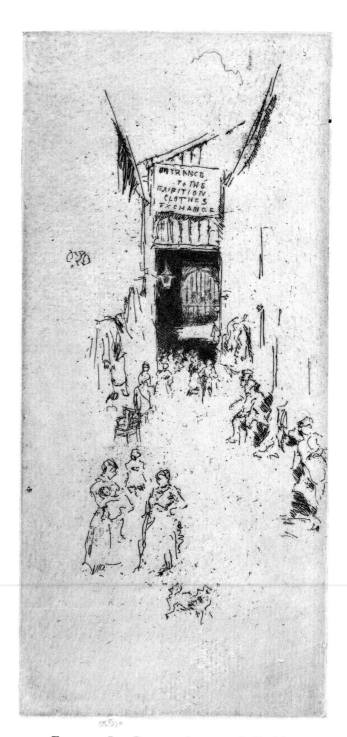

113 FLEUR DE LYS PASSAGE (K.289, III). Etching.

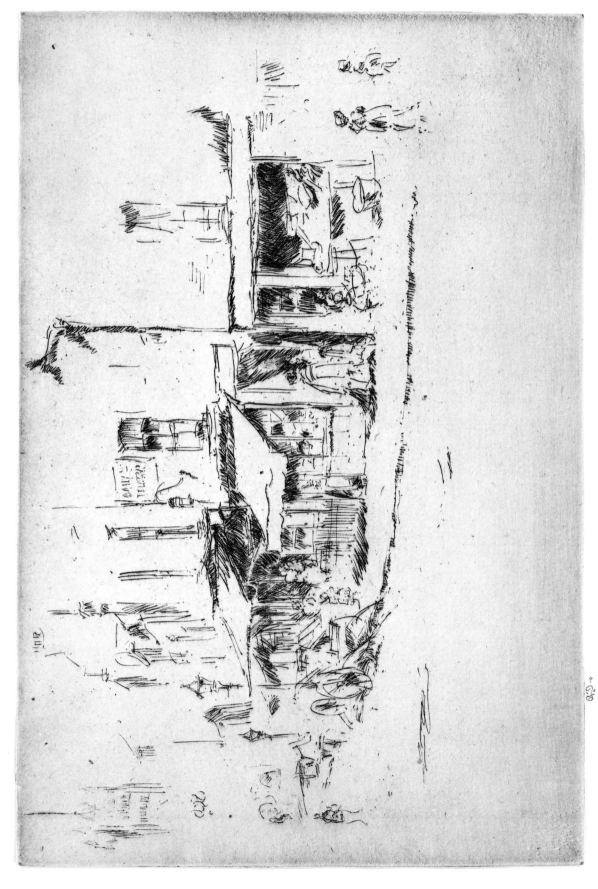

114 ROCHESTER ROW (K.269, 1). Etching.

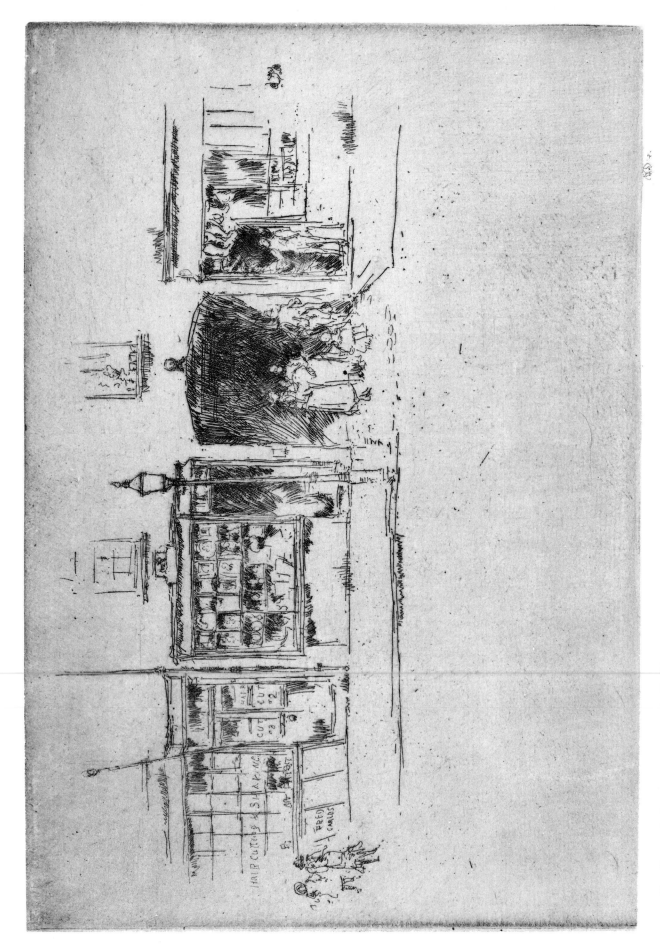

115 The Barber's (k.271, only state). Etching.

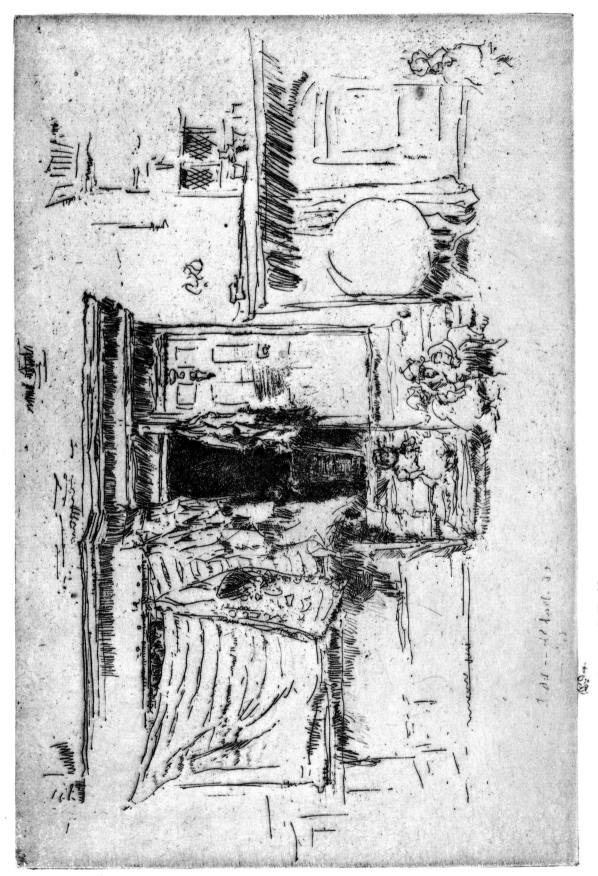

116 RAG-SHOP, MILMAN'S ROW (K.272, II). Etching.

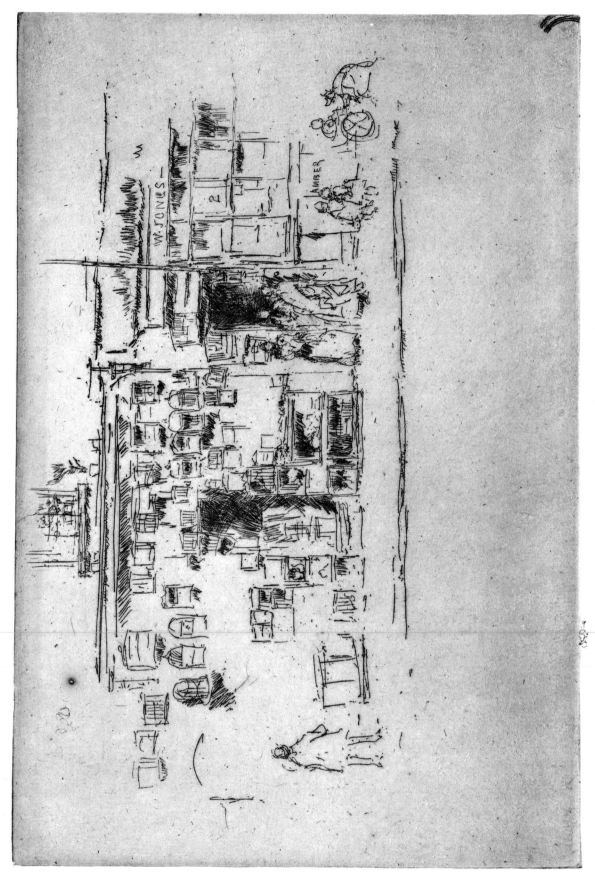

117 Bird-Cages, Chelsea (k.276, only state). Etching.

118 PETTICOAT LANE (K.285, 1). Etching.

119 ST. JAMES'S PLACE, HOUNSDITCH (K.290, ONLY STATE). Etching.

120 MELON-SHOP, HOUNSDITCH (K.293, I). Etching.

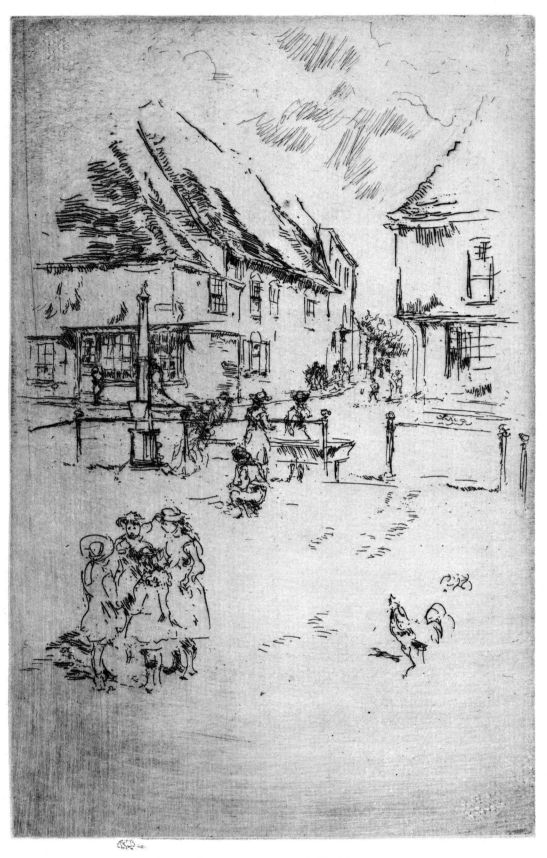

121 THE COCK AND THE PUMP (K.304, ONLY STATE). Etching.

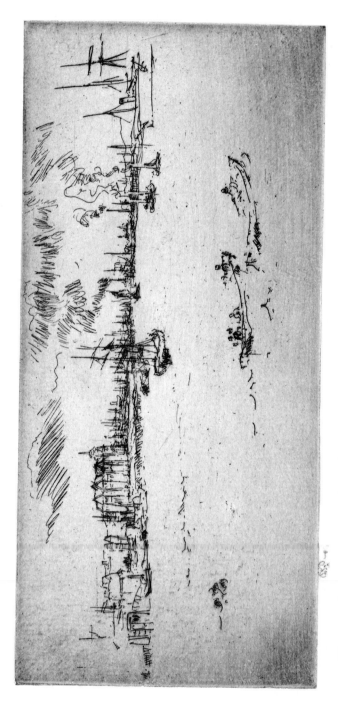

122 TILBURY (K.317, ONLY STATE). Etching.

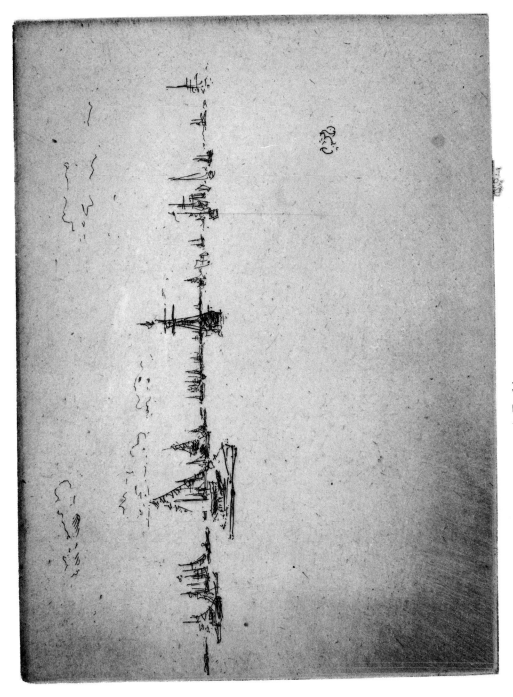

123 The Turret-Ship (k.321, only state). Etching.

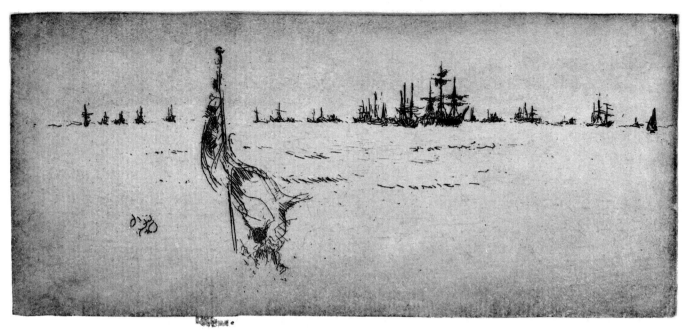

124 DIPPING THE FLAG (K.325, ONLY STATE). Etching.

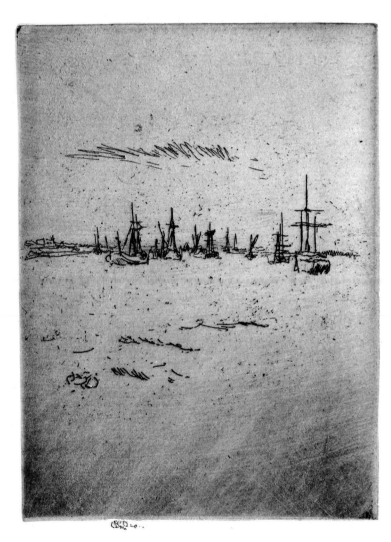

125 RETURN TO TILBURY (K.327, ONLY STATE). Etching.

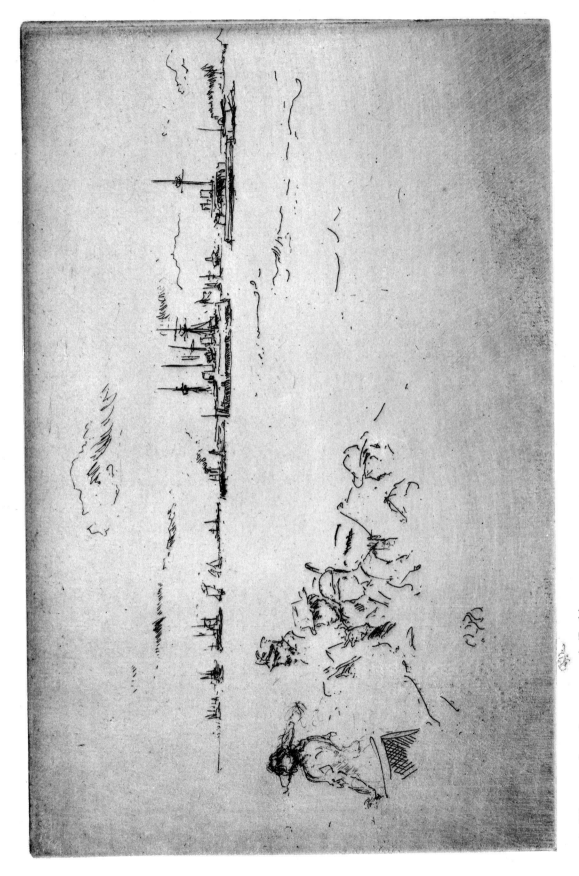

126 MONITORS (K.318, ONLY STATE). Etching.

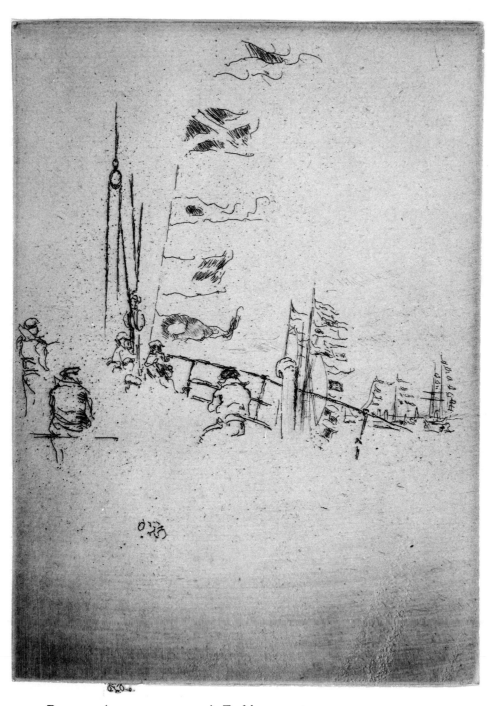

127 BUNTING (K.324, ONLY STATE). Etching.

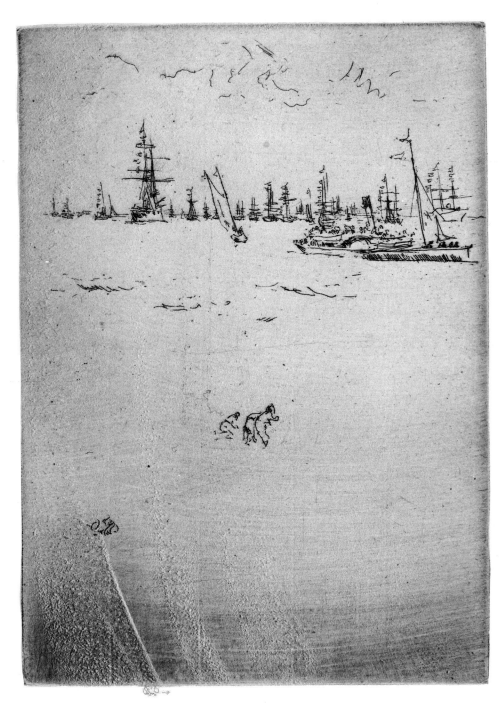

128 VISITORS' BOAT (K.320, ONLY STATE). Etching.

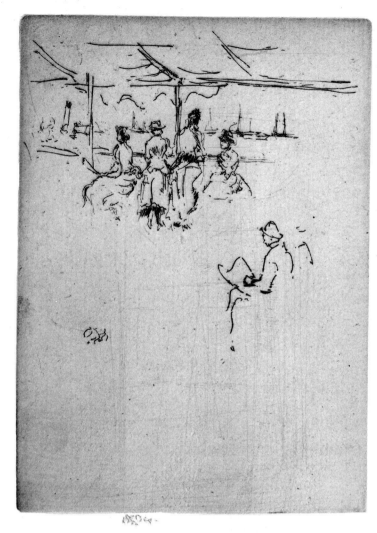

129 RYDE PIER (K.328, ONLY STATE). Etching.

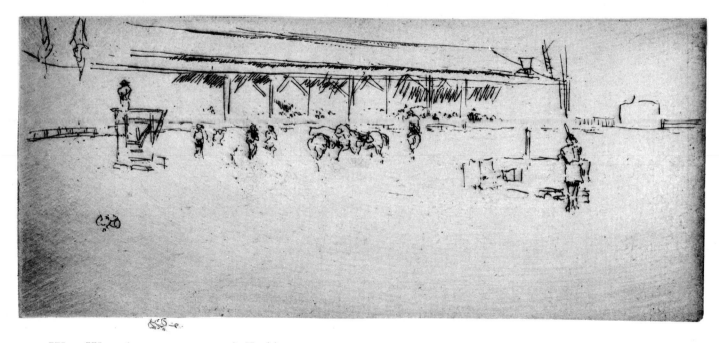

130 WILD WEST (K.314, ONLY STATE). Etching.

131 WILD WEST, BUFFALO BILL (K.313, ONLY STATE). Etching.

132 THE BUCKING HORSE (K.315, ONLY STATE). Etching.

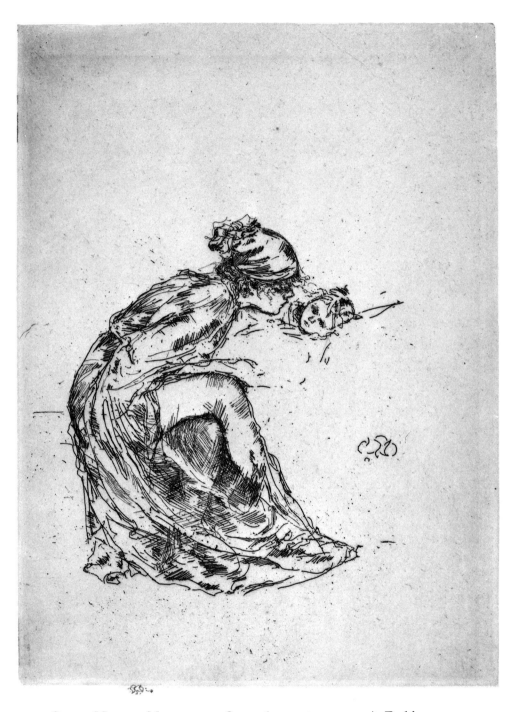

133 CAMEO No. 1, OR MOTHER AND CHILD (K.347, ONLY STATE). Etching.

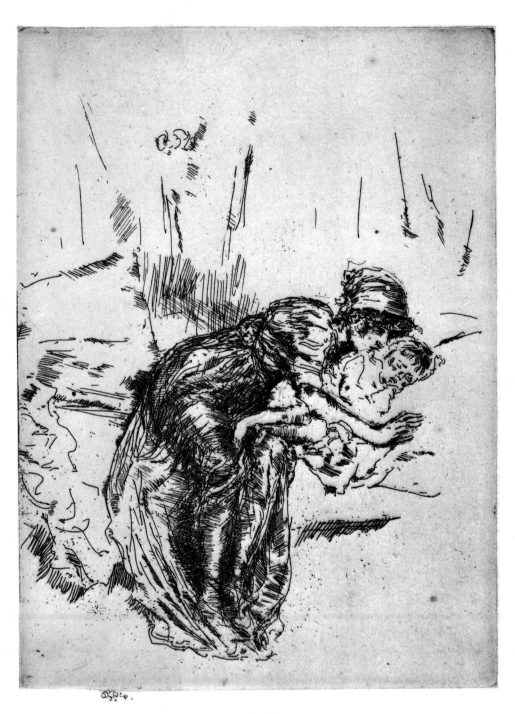

134 CAMEO NO. 2 (K.348, ONLY STATE). Etching.

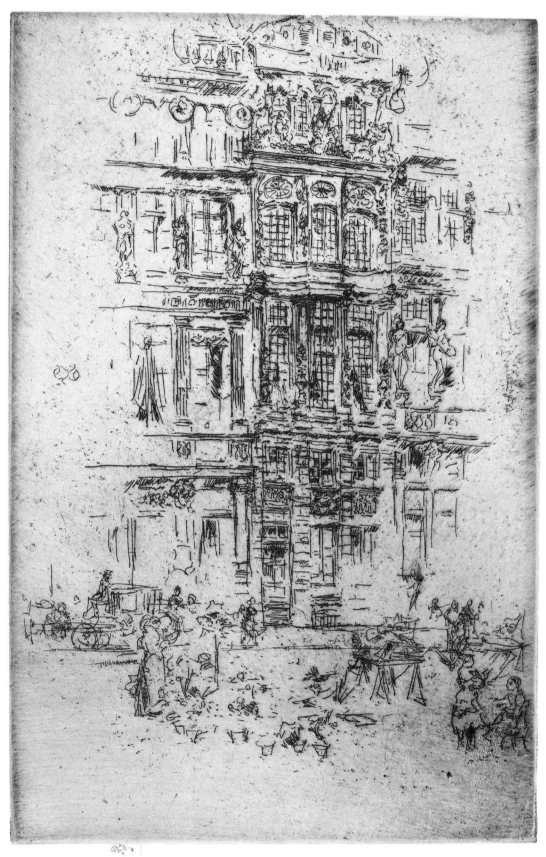

135 PALACES, BRUSSELS (K.361, 1). Etching.

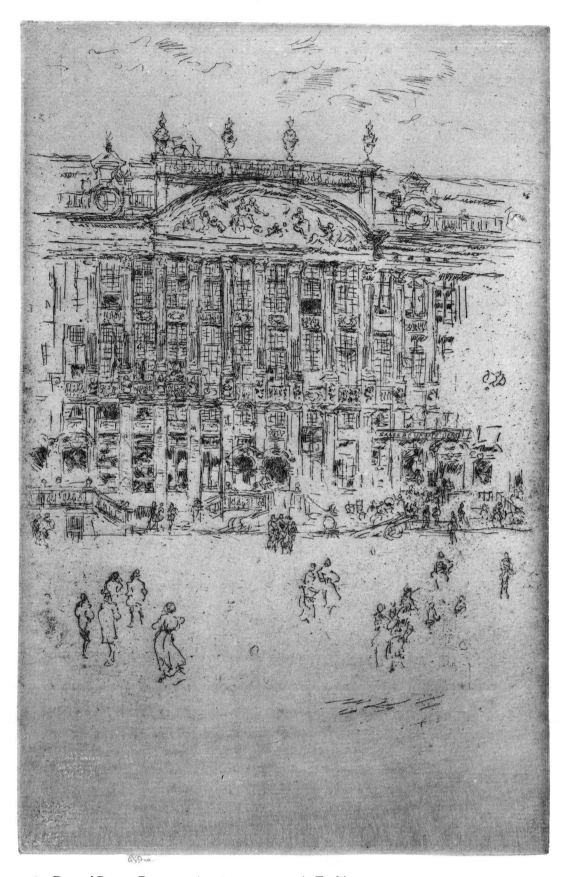

136 GRAND' PLACE, BRUSSELS (K.362, ONLY STATE). Etching.

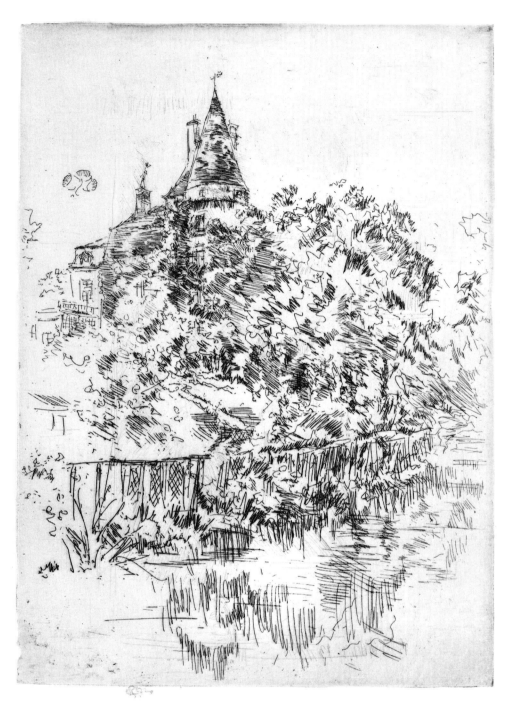

137 CHÂTEAU VERNEUIL (K.380, ONLY STATE). Etching.

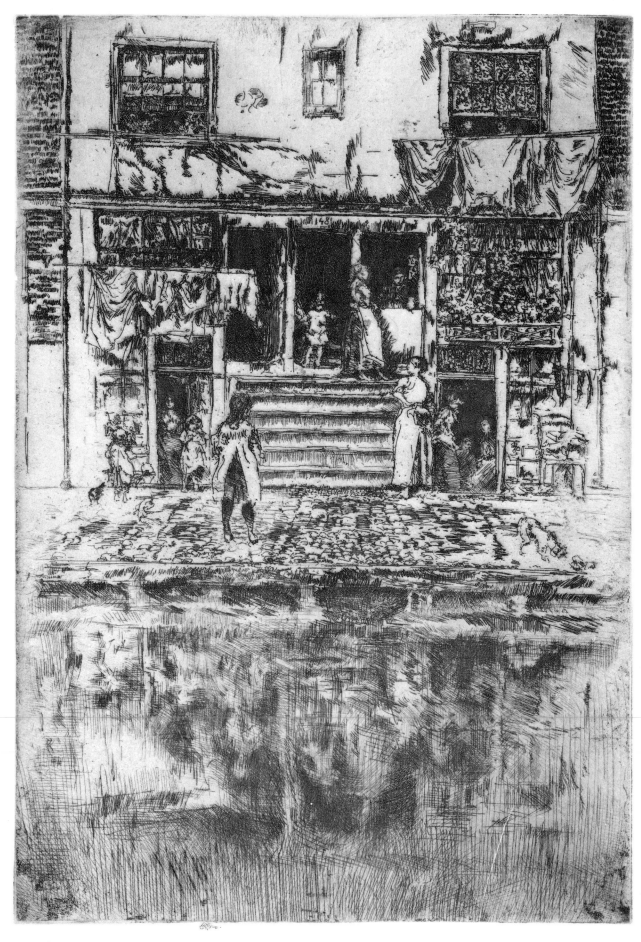

138 STEPS, AMSTERDAM (K.403, IV). Etching with drypoint.

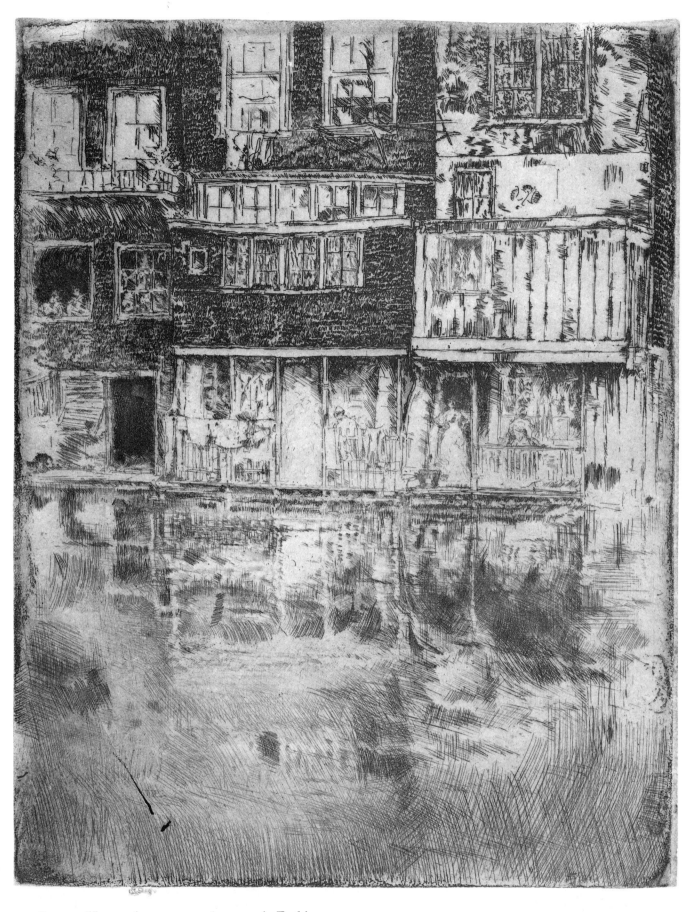

139 SQUARE HOUSE, AMSTERDAM (K.404, 1*a*). Etching.

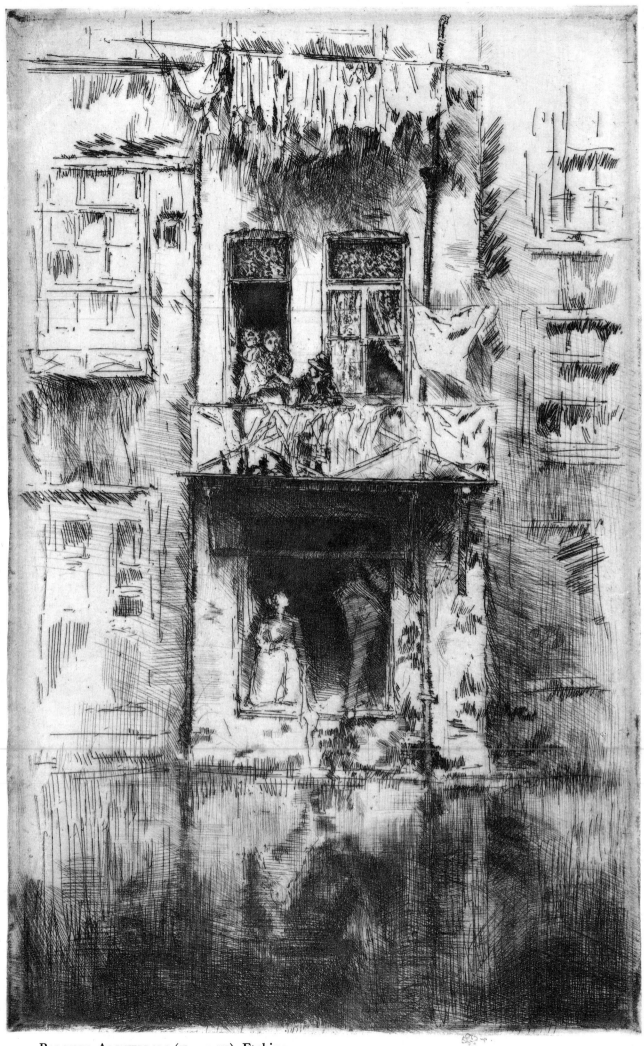

140 BALCONY, AMSTERDAM (K.405, III). Etching.

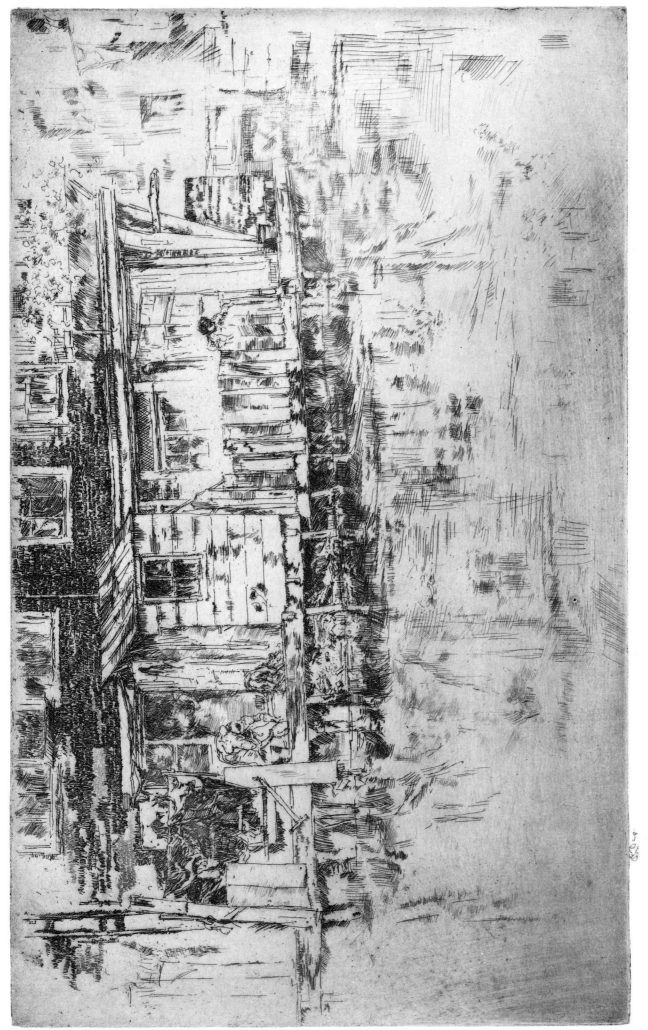

141 Long House—Dyer's—Amsterdam (k.406, 1). Etching.

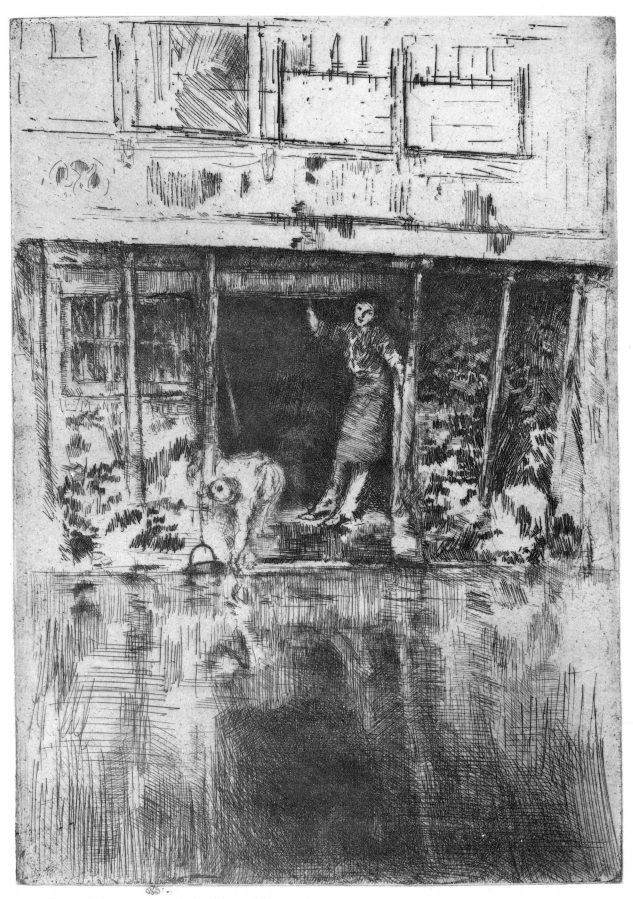

142 PIERROT (K.407, IV OR V). Etching with drypoint.

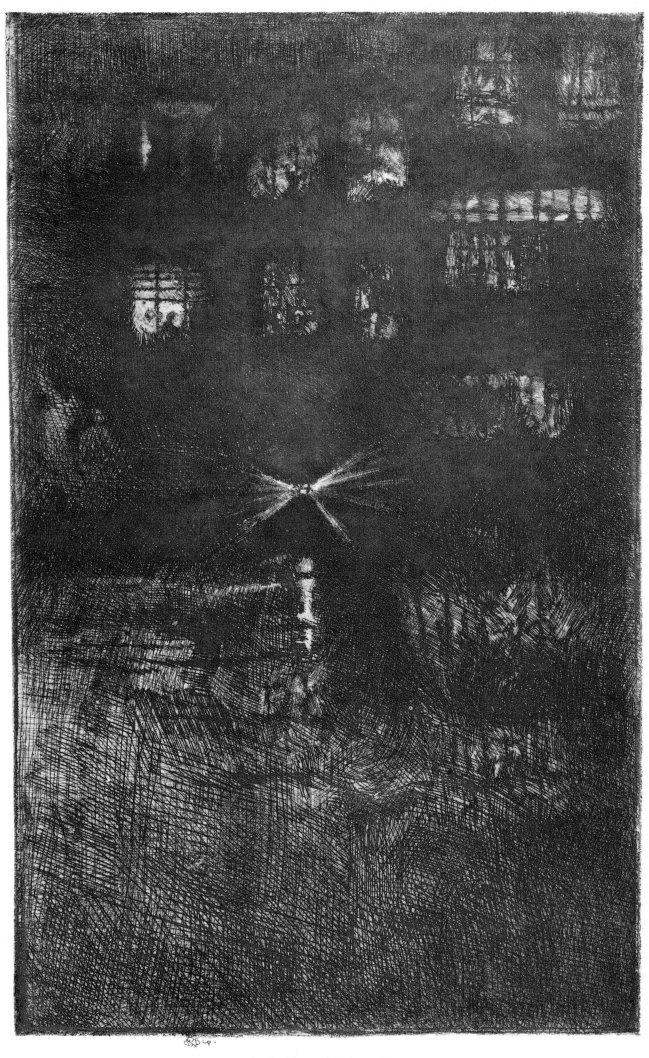

143 NOCTURNE: DANCE-HOUSE (K.408, 1). Etching with drypoint.

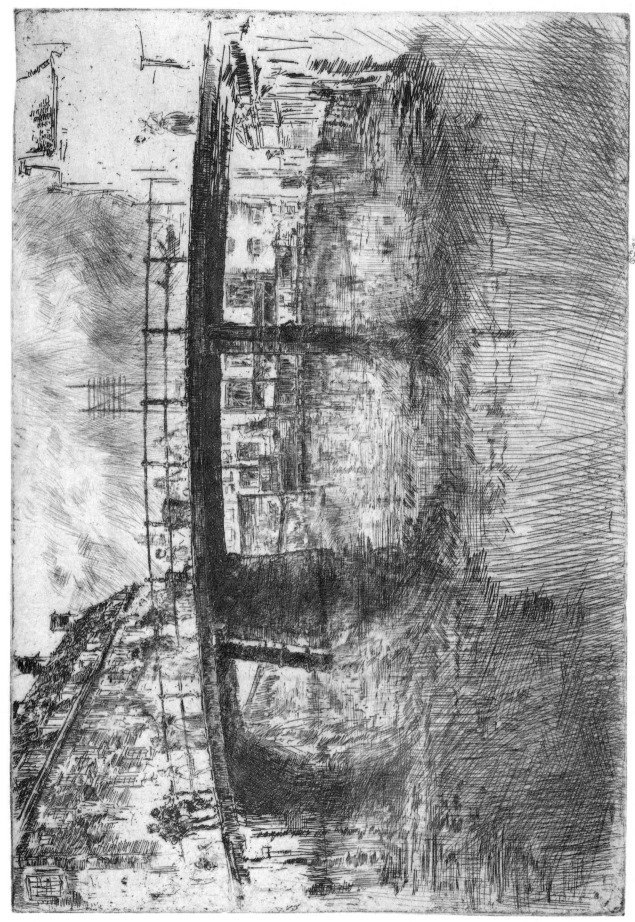

144 Bridge, Amsterdam (k.409, iii). Etching.

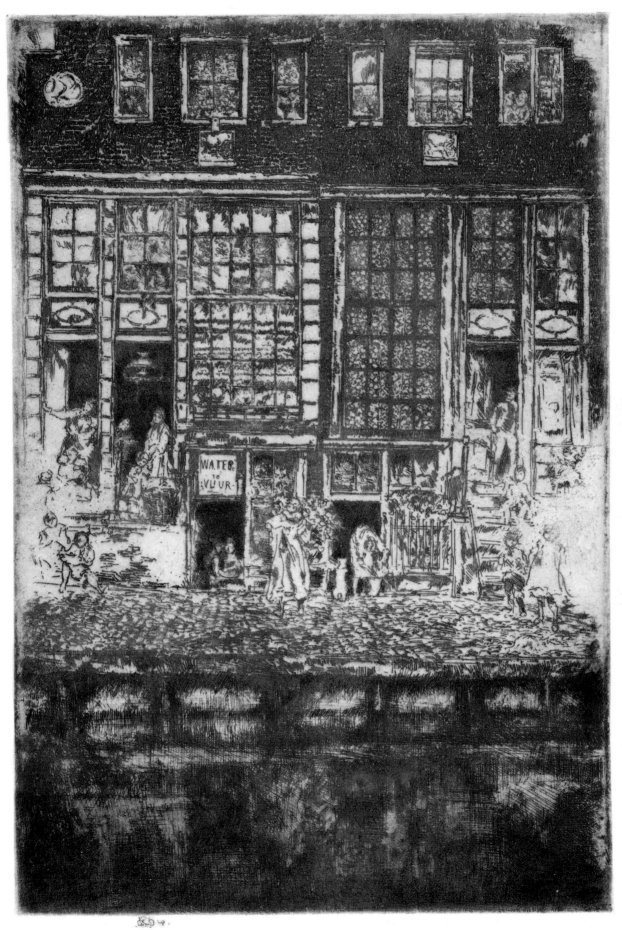

145 THE EMBROIDERED CURTAIN, OR THE LACE CURTAIN (K.410, VIII). Etching with drypoint.

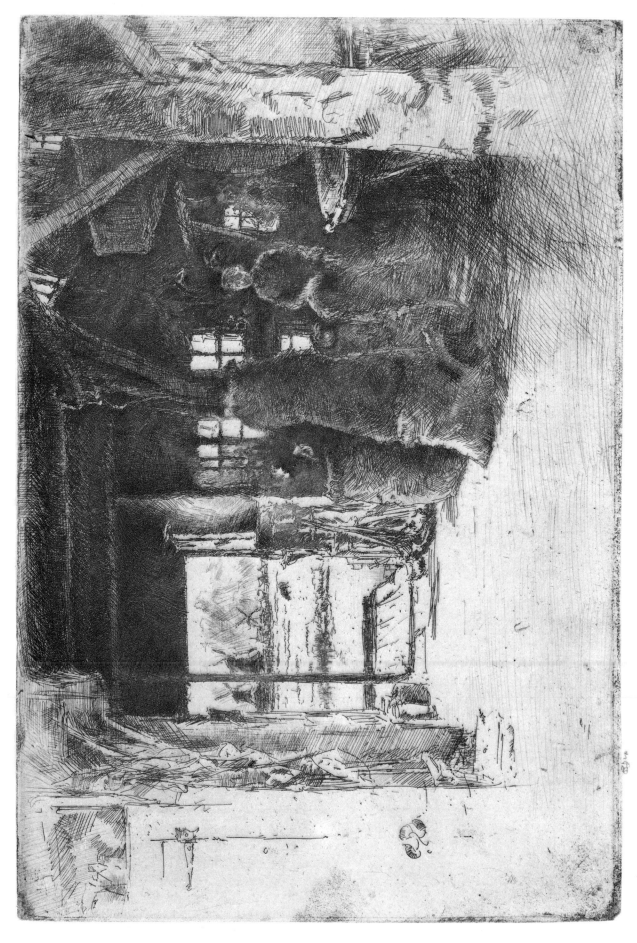

146 THE MILL (K.413, V). Etching with drypoint.

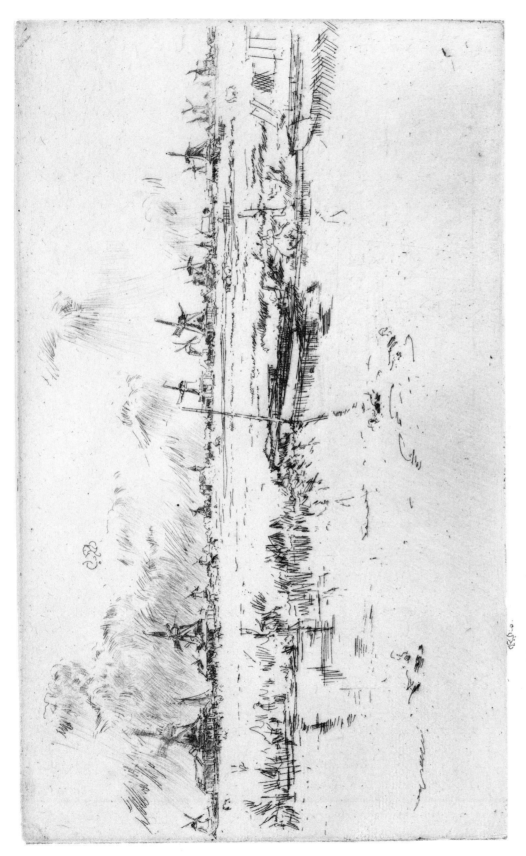

147 ZAANDAM (K.416, II). Etching.

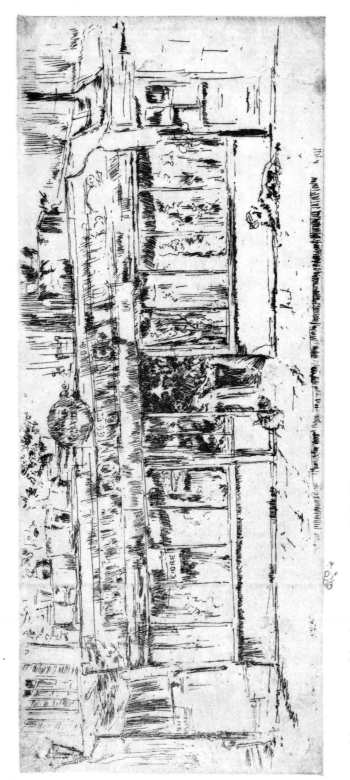

148 Marchand de Vin (k.421, only state). Etching.

Notes on the Plates

THE HEADINGS *of the plate descriptions give the following information: the title of the print as it appears in the Kennedy catalogue (Edward G. Kennedy,"The Etched Work of Whistler,"The Grolier Club of the City of New York, 1910); the Kennedy catalogue number (in the form K.9, K.10, etc.); the state of the print as established by Kennedy (in roman numbers; thus, "K.9, IV" means Kennedy catalogue number 9, fourth state); the medium (etching, drypoint or etching with drypoint); and the dimensions (in inches, height before width).*

Frontispiece: Whistler with the White Lock (K.172, only state). Drypoint. 4 9/16 x 3⅛. According to Wedmore, this self-portrait of the artist, showing the famous "white lock" of which he was so proud, was done in 1879. Only the head was completed before the plate was cancelled, presumably by denting the plate rather than by scratching out the image. Whistler claimed the white lock was a birthmark, common in his family for many generations, but it does not appear in either photographs or self-portraits until the artist was approaching middle age.

1. Little Arthur (K.9, IV). Etching, 3 3/16 x 2⅛. This portrait of the younger of Whistler's Haden nephews shows the plate after it was cut down. As a grown man, Arthur Haden was also subjected to the animosity Whistler directed toward his father, the physician and printmaker Seymour Haden. This is one of the *Twelve Etchings from Nature* (*Douze Eaux Fortes d'après Nature*), published in 1858 (Plate 14 shows the title of this series, also known as the French set).

2. Annie (K.10, IV). Etching with drypoint. 4⅝ x 3⅛. A portrait of Whistler's niece, sister of Arthur Haden, published in the *Twelve Etchings from Nature*. The legs, which are drawn in on the first state (Avery Collection, New York Public Library), were later burnished out and the dress, hair and face reworked. Still later impressions have a portion of the legs added, something Whistler branded "the impertinent work of another."

3. La Mère Gérard (K.11, IV). Etching. 5 1/16 x 3½. This portrait of an elderly eccentric Whistler encountered during his student days in Paris was included in the *Twelve Etchings from Nature*. Another portrait of Mère Gérard (K.12), not published in any set, is considerably rarer. The third state is the finished version; the only change in the fourth state is the addition of the printer Delâtre's name and address at the bottom of the plate.

4. Fumette (K.13, IV). Etching with drypoint. 6⅜ x 4¼. "Fumette" was Whistler's name for the model Eloise, who lived with him during his student days, enchanting him with her ability to recite Musset, but finally infuriating him by tearing up his entire collection of drawings. This plate was extensively rebitten in the third state, which differs considerably from the two earlier states. Traces of foul biting print quite clearly in the lower right corner of this impression. The only change in the fourth state was the addition of Delâtre's name and address. The plate was eventually steel-faced, and numerous modern restrikes exist. This is one of the *Twelve Etchings from Nature*.

5. La Rétameuse (K.14, II). Etching. 4⅜ x 3½. This portrait of a woman who performed the humble but necessary task of retinning cooking pans was one of the *Twelve Etchings from Nature*. In this second state, the names of artist and printer (Delâtre) have been added and some work in the background at the upper left partially burnished out. Traces of fingerprints made either during the biting or printing of the plate show clearly in the upper right corner. Impressions of this plate are scarce, and the plate is presumed to have been destroyed.

6. En Plein Soleil (K.15, II). Etching. 3⅞ x 5¼. This plate was one of the *Twelve Etchings from Nature*. This impression was printed on the thin, gold-colored china paper mounted on plate paper used for the edition published by Delâtre in Paris. The title means "in broad daylight."

7. Liverdun (K.16, II). Etching. 4¼ x 6 1/16. Another of the *Twelve Etchings from Nature*, this print shows a farmyard in a hamlet near Toul in Lorraine, not far from Nancy, that Whistler visited on his walking tour in 1858. The names of artist and printer have been added in this second state, but traces of an earlier, partially removed signature in the upper right are still visible in this impression. According to Wedmore, this print particularly exemplifies "the vision of pretty and curious detail, and the firmness and daintiness of hand in recording it which distinguished the first etchings."

8. The Unsafe Tenement (K.17, III). Etching. 6⅛ x 8¾. Whistler included this plate of a dilapidated farmhouse, drawn in Alsace-Lorraine, in the *Twelve Etchings from Nature*. By the second state, the woman sweeping in the left foreground of the first state had been replaced with a leaning pitchfork. In this third state, the work on the sky has been almost entirely removed, a correction that Whistler's brother-in-law Seymour Haden once proclaimed to be his own work. The title, "The Unsafe Tenement," or "L'Habitation Dangereuse," was Whistler's.

9. Street at Saverne (K.19, IV). Etching. 8⅛ x 6 3/16. During his trip to Alsace-Lorraine in 1858, Whistler visited a fellow student from Paris at Saverne, and this plate was etched during his stay. The state shown is the fourth and final stage; impressions of the subsequent fifth state are modern restrikes. Published in the *Twelve Etchings from Nature*, this print is Whistler's earliest surviving "nocturne" (night scene) in any medium.

10. Gretchen at Heidelberg (K.20, only state). Etching. 8 x 6 3/16. The Pennells in their *Life* of Whistler identified the subject of this etching as the daughter of the owner of an inn in Cologne where Whistler stayed on his trip to Alsace-Lorraine and the Rhineland in 1858; however, Whistler himself wrote the title shown above on the impression in the Avery Collection. The butterfly signature dates from a period considerably later than the making of this plate, but Whistler added this monogram to many of the impressions printed earlier at the request of friends, for instance S. P. Avery.

11. La Vieille aux Loques (K.21, II). Etching. 8⅛ x 5¾. The state shown is the second, published in the *Twelve Etchings from Nature*, with Delâtre's name and address, and additional work on the doorstep. This early plate remained one of the artist's favorite works and was among those selected by Whistler to be shown at the Columbian Exposition at Chicago in 1893. The plate is known to have been cancelled or destroyed. The title means "the old rag-woman."

12. La Marchande de Moutarde (K.22, III). Etching with drypoint. 6⅛ x 3½. Whistler wrote on the impression of this plate once in the Haden collection: "Marchand (*sic*) de Potions in Cologne." Made during his trip to eastern France and the Rhine Valley in 1858, the plate was published with the *Twelve Etchings from Nature* in the same year. This state has Delâtre's name and address added, and bears additional work on the bracket over the girl's head, on the edge of the table and in the area over the shelf with the pots. In 1886 it was reissued in an edition of 200 impressions for *English Etchings*, using old Whatman paper dated 1814; a few additional impressions were made at the same time on seventeenth-century Dutch paper. The plate was then cancelled. The title means "the mustard vendor."

13. The Kitchen (K.24, II). Etching with dry point. 8⅞ x 6⅛. First issued with the *Twelve Etchings from*

Nature in 1858, this plate was later published by The Fine Art Society in 1885 in a special edition of fifty impressions, printed and signed by Whistler. An inscription on the impression in the Haden collection identified the scene as a "cuisine à Lutzelbourg [Luxembourg]." After the printing of the limited edition for the Society, the plate was destroyed. The impression illustrated is of the second state, before the later reworking.

14. Whistler Sketching; title plate of the *Twelve Etchings from Nature* (K.25, only state). Etching. 4⅜ x 5¾.
An impression of this title plate for the French set was pasted on the original wrappers of each of the sets published by August Delâtre for Whistler. Each set also contained another impression of this plate, printed on thin, gold-colored China paper like the other subjects (this illustration is from a China-paper impression). Thus the set actually contains thirteen prints. The Pennells in their *Life* stated that Whistler's companion Ernest Delannoy posed for this plate, wearing Whistler's clothes. A note in Whistler's hand on the impression once in the Haden collection states that the plate was done at Cologne. An alternate version of this scene, perhaps originally intended for the title page and then abandoned, is known, in a possibly unique impression.

15. The Wine-Glass (K.27, II.) Etching with drypoint. 3¼ x 2⅛.
This little print is unique in Whistler's work, for he never again did a still-life subject. Etched in London in 1859, the print is very scarce, and the plate is known to have been destroyed. It has been compared for quality with Rembrandt's shell.

16. Reading in Bed (K.28, I). Etching. 4⅜ x 3⅛.
According to Wedmore, this plate was made about 1861. In the second state, shading was removed from the pillow under the girl, and added to the curtain at the right above her head. The shape of the nose was also radically changed from this original version—according to some, in order to disguise a too obvious likeness. The plate is assumed to have been destroyed.

17. Greenwich Park (K.35, I). Etching. 4 15/16 x 7⅛.
Whistler was never at ease in the countryside, and made very few prints of pure landscape. This plate, sometimes incorrectly called "Ken-sington Gardens," was made about 1859, when Whistler accompanied his brother-in-law Seymour Haden on sketching expeditions to Greenwich Park. The illustration shows the first state, before additional work throughout. The plate is known to have been cancelled or destroyed.

18. Thames Warehouses (K.38, I). Etching. 3 x 8.
In the published states of this plate, the lightly etched figure with the pole in the boat at the right was erased. In this impression he and his pole are quite distinct, as are the lines in the sky behind the boats in the distance. The plate was etched in 1859, and published in 1871 by Ellis and Green in the portfolio entitled *Sixteen Etchings of Scenes on the Thames and Other Subjects*, the so-called Thames set. The plate is known to have been cancelled or destroyed.

19. Old Westminster Bridge (K.39, I). Etching. 2⅞ x 7 15/16.
Another of the *Sixteen Etchings*, this plate shows in the middle distance the Houses of Parliament and Westminster Bridge, and to the right the roofs of Lambeth, south of the Thames. The etching was signed and dated 1859, and Whistler sent an impression of it to the Royal Academy exhibition in 1863. This impression of the first state, before additional work to the areas of sky and water, shows both the finest lines and shaded areas strongly and clearly printed. The plate is known to have been cancelled or destroyed.

20. Limehouse (K.40, II). Etching. 5 x 7⅞.
Another of the plates Whistler etched on the Thames in 1859, this print was exhibited at the Royal Academy in 1861 under the title "The Thames at Limehouse." The illustration shows the second state, with additional work on the boats in the foreground, but before additional lines on the distant ships and on the clouds in the sky. It was included in the *Sixteen Etchings*. The plate is known to have been cancelled or destroyed.

21. Eagle Wharf (K.41, only state). Etching. 5⅜ x 8⅜.
Also known as "Tyzac, Whiteley & Co." from the signboard over one of the wharfside buildings, this plate was included in the published Thames set. It was etched in 1859 from a spot on the Thames opposite Rotherhithe. The plate is known to have been cancelled or destroyed.

22. Black Lion Wharf (K.42, II). Etching. 5⅞ x 8⅞.

This plate, another of the Thames set, was etched in 1859, and first exhibited at the Royal Academy in 1860. Two years later, when it was again shown at an International Exhibition at the South Kensington Museum along with "Thames Warehouses," the two plates won the artist praise as "the most admirable etcher of the present day." The plate is known to have been cancelled or destroyed.

23. Thames Police (K.44, II). Etching with drypoint. 5⅞ x 8⅞.

Entitled "Wapping Wharf" when it was published in the Thames set, this print shows the old station house of the Thames Police that was rebuilt in 1869, some ten years after the plate was made. The illustration shows the print in the second state, with considerable drypoint work added to the plate, particularly in the sky. The plate is known to have been cancelled or destroyed.

24. Longshoremen (K.45, only state). Drypoint. 5⅞ x 8¾.

Done in 1859 at a riverside tavern on the Thames, it was not included in the published Thames set, and is comparatively rare. The plate is known to have been cancelled or destroyed.

25. The Lime-Burner (K.46, II). Etching with drypoint. 9⅞ x 6⅞.

Another of the plates published in the Thames set, this was etched in 1859 and exhibited at the Royal Academy in 1860 as "W. Jones, Limeburner, Thames Street." The impression illustrated shows the plate with the additional work to the right of the Limeburner's shoulder. The plate is known to have been cancelled or destroyed.

26. Soupe à Trois Sous (K.49, only state). Etching. 5⅞ x 8⅞.

Whistler etched this plate of a cheap bistro in Paris in 1859; according to the account given by the Pennells, he was working on the plate at midnight, when he was interrupted by a suspicious policeman. The agent could make nothing of the plate, and left the artist to his work. The figure at the extreme left is one Martin, in 1848 the youngest man ever to receive the cross of the Legion of Honor. He subsequently lost the decoration for misconduct. Impressions of this plate are scarce, and the plate is known to have been cancelled or

destroyed. The title means "soup for three sous."

27. Bibi Lalouette (K.51, II). Etching with drypoint. 9 x 6.

The father of Bibi Lalouette owned the restaurant where Whistler and his fellow art students and bohemians of the Latin Quarter ate, and where the cachet vert, a burgundy at one franc the bottle, marked special occasions for the diners. In this state two heads at the bottom, remaining from an earlier use of the plate, have been removed, and the work on the figure and background is completed.

28. Becquet (K.52, III). Etching with drypoint. 10 x 7½.

This portrait of an artist turned musician, a friend from Whistler's early Paris days, was included in the published Thames set under the title of "The Fiddler." The plate on which the portrait was drawn had previously been used for an oblong view of West Point which a friend of Whistler's brought to him for his opinion; stacked muskets can still be seen at the lower right corner of this print. This impression of the third state is signed in the margin with a pencil butterfly.

29. Portrait of Whistler (K.54, I). Drypoint. 8⅞ x 6.

In this first state of an early self-portrait, the crown of the hat at the left is almost white, and the brim only partly shaded. Later the shading was increased by the addition of drypoint lines. Done in Paris in 1859, this portrait shows Whistler in the wide-brimmed straw hat which astonished even the Parisian Latin Quarter, and which led Fantin-Latour to describe the Whistler of his first encounter as "un personnage en chapeau bizarre." The plate is known to have been cancelled or destroyed.

30. Fumette, Standing (K.56, I). Drypoint. 13⅜ x 8½.

In 1859 Whistler drew this larger portrait of Eloise, nicknamed "Fumette," whose portrait crouching had been included in the Twelve Etchings from Nature (Plate 4). Impressions from this plate are scarce, and the plate is presumed destroyed.

31. Venus (K.59, I). Etching with drypoint. 6 x 9.

The impression illustrated is of the especially rare first state of this rare print. The model's ample figure recalls the influence of Courbet's

work on Whistler in his early Paris days, while her features are similar to those of the dancer Finette, the model for a large clothed portrait (K.58) also done in 1859. The plate is presumed to have been destroyed.

32. Annie Haden (K.62, III). Drypoint. 13¾ x 8⅜.

This large drypoint portrait of his niece done in 1860 was the print to which Whistler referred when he told E. G. Kennedy that "if he had to make a decision as to which plate was his best, he would rest his reputation upon 'Annie Haden.'" The plate is presumed to have been destroyed, but it was evidently in Whistler's possession for over twenty years, as the impression illustrated is printed in the manner he eventually adopted after his return from Venice: the margins trimmed to the plate mark with the exception of a tab for the pencil signature. Printed in the pale brown ink used for many of the Venetian subjects, the impression shows the completed plate with new work all over, and a girl's head from a previous etching, which formerly showed at the bottom of the plate, removed.

33. Mr. Mann [Henry Newnham Davis] (K.63, II). Drypoint. 8 15/16 x 6.

Some controversy exists about the identification of the subject of this drypoint portrait signed and dated 1860. Whistler himself wrote "Mr. Mann" on the impression in the Avery Collection (New York Public Library), and the sitter has sometimes been more specifically identified as Joshua H. Mann. It is now, however, generally accepted that the gentleman portrayed was Henry Newnham Davis of Silchester House, Hampshire. The impression illustrated bears the pencil butterfly that Whistler began to add to impressions of plates he himself printed at about the time of his trip to Venice; however, he frequently added the pencil monogram to impressions of earlier plates at the request of friends. The plate is presumed to have been cancelled.

34. Axenfeld (K.64, III). Drypoint. 8⅞ x 5⅞.

Axenfeld was a friend of Whistler's Paris days, about whom little is remembered other than that he was a writer, and the brother of a distinguished physician. This drypoint was always considered one of Whistler's most powerful portraits, and the artist himself confessed to Howard Mansfield a special fondness for it. An impression was exhibited at the

Royal Academy in 1861 as "Mons. Oxenfeld, Literateur, Paris." The plate is known to have been cancelled or destroyed.

35. Rotherhithe (K.66, III). Etching with drypoint. 10¾ x 7¾.

Included in the published Thames set as "Wapping," this plate is usually known by its earlier title "Rotherhithe," under which it was exhibited at the Royal Academy in 1862. The figures in the foreground are seated on the balcony of the Angel Inn at Cherry Gardens, Rotherhithe, from which Whistler painted his oils *Wapping* and *The Thames in Ice*. One of the finest of Whistler's etchings of any period, "Rotherhithe" shows his use of meticulous detail, not for its own sake, but to achieve an overall effect. He drew in every brick in the wall at the right of the plate, because only in this way could he achieve the exact "color" he desired. The plate is known to have been cancelled or destroyed.

36. The Forge (K.68, III?). Drypoint. 7⅞ x 12⅜.

Drawn at Perros-Guirec in Brittany in the summer of 1861, this plate was one of the French subjects included in the so-called Thames Set published in 1871. The impression illustrated shows the completed state of the plate, with additional work throughout. It is most probably a third state, with the white spot in back of the blacksmith's head still partially visible; the illustration of this state in the Kennedy catalogue is somewhat different in appearance, since ink film partially covers the fine drypoint lines already added at this point in the third state. The white spot is completely removed in the following state. This was the first of many views of forges, furnaces and blacksmith shops that the artist was to etch over the years —at Liverpool, along the Thames, in Venice, Belgium and Holland. The plate is known to have been cancelled or destroyed.

37. Millbank (K.71, II). Etching. 4 x 4⅞.

Like "The Little Pool" (Plate 38), this plate was used by Whistler for a time as a sort of business card, and this impression of the second state bears the address of "E. Thomas' Publisher 39. Old Bond Street," with the information that Whistler's works could be obtained there. In the next state, the word "London" was added to the address; later, the inscription was erased. Issued as one of the *Sixteen Etchings*, the plate is known to have been cancelled or destroyed.

38. The Little Pool (K.74, VIII). Etching. 4 x 4 15/16.
This plate underwent many changes at the artist's hands, and impressions are known with contemplated alterations indicated in chalk or ink. The man sketching at the left-hand side of the plate is Percy Thomas; the man standing behind him is his father, Serjeant Thomas, for a brief period Whistler's dealer. In this state both figures wear overcoats, and a group of piles covers the figure formerly placed in front of the two Thomases. Included in the Thames set, this plate bore in earlier states lines of writing announcing that the works of James Whistler, "Etchings and Dry Points," could be had at E. Thomas, Publisher, 39 Old Bond Street. The plate is known to have been cancelled or destroyed.

39. Early Morning, Battersea (K.75, only state). Etching. 4½ x 5 15/16.
This view of Battersea Bridge, only a few yards from Cheyne Walk, then called Lindsey Row, is known by a variety of titles. Wedmore called this print "Cadogan Pier," while the artist himself wrote "Battersea Dawn" on the impression in the Avery Collection. One of the *Sixteen Etchings*, the plate is known to have been destroyed.

40. Old Hungerford Bridge (K.76, III). Etching. 5 5/16 x 8 3/16.
This plate was published in the *Sixteen Etchings*. The bridge shown is the old suspension bridge later removed to Clifton on the Severn near Bristol, to make way for the railway bridge to Charing Cross Station. In this final state, the steamboat in the center is clearly outlined, and foul biting in the sky from the first state has been removed, as have figures at the lower right. Additional changes were also made to bridge and building. The plate is known to have been cancelled or destroyed.

41. Jo's Bent Head (K.78, II). Drypoint. 8 13/16 x 6.
The only change Whistler made between the first and second states of this delicate portrait sketch of his mistress Joanna Heffernan was the addition to the right of the skirt. In the third state the lines are unchanged but the plate was printed with a heavy film of ink, rather than cleanly wiped as in our illustration. The plate is known to have been cancelled or destroyed.

42. The Storm (K.81, only state). Drypoint. 6⅛ x 11¼.
This drypoint is one of the rarest of all Whistler's prints, for only about four impressions are known to have been made from the plate before cancellation. The figure shown hurrying along under a darkened sky is M. W. Ridley, an artist described by P. G. Hamerton as "a true etcher of the school of Whistler."

43. The Punt (K.85, I). Etching. 4¾ x 6½.
Together with the following print in the Kennedy catalogue ("Sketching, No. 1," K.86), this plate was published in 1862 in *Passages from Modern English Poets Illustrated by the Junior Etching Club*. An impression of this state in the Lessing J. Rosenwald Collection, National Gallery of Art, Washington, D.C., bears a long inscription on the lower margin in Whistler's hand: ". . . In a day or two both these plates will be ready—there is very little retouching to do—This is a proof I pulled myself at Day's—after their man Golding [sic] had pulled me a couple . . ." The plate is presumed to have been destroyed.

44. Ross Winans (K.88, I). Etching. 9¾ x 7⅞.
Ross Winans, whose portrait Whistler etched in London about 1861 or 1862, was a native of Baltimore, and a relation of the artist's by marriage. In the second state additional lines were added to the right sleeve, and the fainter of the two signatures which originally appeared on the plate was erased. Impressions of this print are scarce, and the plate is presumed to have been destroyed.

45. Chelsea Wharf (K.89, II). Etching. 3⅝ x 7⅜.
This plate was originally etched in 1863, at about the time Whistler rented his first house in Chelsea. The butterfly, which is only faintly visible in this impression (lower right), was added sometime after 1870, when Whistler adopted this form of signature. The plate is presumed to have been destroyed.

46. Chelsea Bridge and Church (K.95, VI). Etching with drypoint. 4 x 6⅝.
The impression illustrated is the sixth and final version of this subject, as it was published in the set of *Sixteen Etchings*. Much additional work, mostly in drypoint, has greatly altered the appearance from the first states. This impression is signed with the pencil butterfly that Whistler adopted at about the time of his

Venice trip. The plate is known to have been cancelled or destroyed.

47. Weary (K.92, IIa). Drypoint. 7¾ x 5⅛.
Whistler drew this touchingly beautiful portrait of Jo Heffernan, his mistress and model for the paintings *The White Girl* and *The Little White Girl*, in 1863. The story associated with the print is that it was begun when Jo flung herself in a chair and refused to continue posing for an oil painting Whistler was working on. Although an impression of this earlier version of the plate was sent to the Royal Academy in 1863, it was not until 1872 that Whistler "completed" the plate by the addition of extensive drypoint work.

48. Speke Hall, No. 1 (K.96, I). Etching with drypoint. 8⅜ x 5⅞.
This first version of "Speke Hall," begun about 1870, was one of the earliest of the Leyland group of prints. Speke Hall was located near Liverpool, and belonged at the time to a ward of F. R. Leyland. Whistler took this print through numerous states, without ever perhaps achieving exactly the effect he sought. In this first of ten states a figure appears in the foreground; in the next few states, it was considerably altered and then burnished out. Whistler reintroduced the figure in the fifth state, only to remove it again in the final version.

49. The Model Resting (K.100, II). Drypoint. 8 3/16 x 5 3/16.
Whistler added the date "1870" to the impression of this plate now in the Avery Collection. Illustrated is the second state, with additional lines in the background, but before the butterfly signature. The plate for this "elegant, rare drypoint," as Wedmore termed it, is known to have been cancelled or destroyed.

50. F. R. Leyland (K.102, II). Etching. 11⅞ x 6⅞.
F. R. Leyland was Whistler's most important patron, the purchaser of his major oil *La Princesse du Pays de la Porcelaine*, and the owner of the house in Princes' Gate, London, in which Whistler painted the celebrated Peacock Room. Over this last commission, Whistler and Leyland parted enemies. During the ten years of their association, however, Whistler painted and etched Leyland, his wife, his children and even his mother. From Leyland, a talented amateur musician, Whistler received

the suggestion to use the terms "nocturne" and "symphony" to describe certain types of paintings and prints.

51. The Little Velvet Dress (K.106, II). Drypoint. 6⅜ x 4⅝.
A portrait of Mrs. Leyland in a velvet gown. In this plate, unlike the similar K.105, the texture of the material of the dress is fully indicated, and the background is completed. The plate is known to have been cancelled or destroyed.

52. Fanny Leyland (K.108, I). Drypoint. 7¾ x 5¼.
This portrait of the eldest Leyland daughter, admired particularly for the rendering of the girl's blond hair and light-textured muslin dress, was drawn about 1873, according to a note Whistler made on the print of this plate in the Avery Collection. The impression illustrated is of the extremely rare first state, before the butterfly and background were added. Included by Whistler among his own favorite works, this portrait is fairly scarce, and the plate is presumed to have been destroyed.

53. Elinor Leyland (K.109, III). Drypoint. 8⅜ x 5½.
Another Leyland daughter, also drawn about 1873. In the state illustrated, the plate shows additional work on the background and has the butterfly monogram in outline. In later states, the girl's legs are erased and redrawn; the head, skirt and background are further worked on. The plate is known to have been cancelled or destroyed.

54. Florence Leyland (K.110, III). Drypoint. 8⅜ x 5⅜.
Florence was the third Leyland daughter, later the wife of the painter Val Prinsep. She was apparently the only one of the Leyland children to sit for Whistler as an adult. This plate of her as a child in 1873 was subsequently heavily worked over, and the words "I am Flo" written on the plate. Still later, an attempt was made to reduce the additional work all over the plate, which was eventually cancelled or destroyed.

55. Tatting (K.112, only state). Etching with drypoint. 5 x 2 15/16.
This small plate, done about 1873, is said to be a portrait of one of the circle of friends of

the Leyland household, if not a member of the family itself. It was published in 1880 by Messrs. Dowdeswell, London. The plate is presumed to have been cancelled or destroyed.

56. The Muff (K.113, III). Drypoint. 4 15/16 x 2 15/16.
This is another work of the early 1870s, the Leyland period, but the manner of its printing—trimmed to the plate mark, except for the tab with the pencil butterfly signature—indicates that this particular impression was printed sometime after Whistler's return from Venice. The state illustrated is the third and final one; it differs from the two earlier states only in work on the background and the addition of the butterfly to the plate. The plate is presumed to have been destroyed.

57. Maude, Standing (K.114, IX). Drypoint. 8⅞ x 5⅞.
Whistler made many changes in this drypoint portrait of Maude Franklin, who was both his model and his mistress during the late seventies and early eighties, but he seems never to have been satisfied with the results. Many of the individual proofs existing of this plate show further corrections drawn on in ink! In this case the corrections are made in white along the line of the back. The impressions of the last state show that the plate had become corroded, probably because it had been put aside for a while before reprinting, and it is presumed to have been cancelled or destroyed.

58. The Desk (K.133, II). Drypoint. 8 7/16 x 5½.
Impressions of this lightly drawn figure study, dating from the "Leyland period," are extremely scarce, and the plate is presumed to have been destroyed.

59. The Guitar Player (K.140, III). Drypoint. 10⅞ x 7.
A portrait of M. W. Ridley, an artist friend of Whistler's, who appears also in "The Storm," (Plate 42). This portrait was done in 1875, according to a note in Whistler's hand on the impression of the plate in the Avery Collection. The subject is very rare, and the plate is presumed to have been destroyed.

60. The White Tower (K.150, only state). Etching. 3¼ x 7⅜.
Toward the end of the seventies, Whistler turned once more to the Thames as a subject for etching and drypoint, as well as for lithography, with which he had just begun to experiment. Impressions of this unfinished sketch of the White Tower, the principal structure of the Tower of London, and the Custom House, as seen from across the Thames, are scarce. Since Whistler did not reverse his drawing when working directly on the plate, the scene appears in mirror image. This impression is signed with a pencil butterfly on a tab, a practice which became common about the time Whistler issued his second Venice set.

61. The Troubled Thames (K.152, III). Etching. 4 7/16 x 8 15/16.
This view of riverside warehouses seen across the roiled waters of the Thames nearing flood state dates from the later phase of Whistler's Thames prints, when he was more preoccupied with effects of light and atmosphere than with the colorful life and activities found along the banks of the great waterway. The plate is known to have been cancelled or destroyed, and the entire edition was apparently quite small. The illustrated state is the third, which shows only very slight changes from the previous state.

62. London Bridge (K.153, V). Etching. 6 3/16 x 9 3/16.
The impression illustrated is of the final state, with the shading on the boat in the foreground completed. This is the bridge that was dismantled in the 1960s and shipped to the United States. The plate is known to have been cancelled or destroyed.

63. Price's Candleworks (K.154, IIIa). Etching with drypoint. 5 15/16 x 9.
At least two intermediate states of this print have been identified since the Kennedy catalogue was first compiled. The impression illustrated falls between Kennedy's former third and fourth, or final, state. Since another state, intermediate between the original first and second states, has also been discovered, the complete number of states for this plate is now at least six. The print is an example of the effect that Whistler could achieve with the contrasts of night and illumination, making, as Wedmore remarked, "the chimney of a brewery or a candle works . . . not less beautiful than . . . King's College Chapel." The plate is known to have been cancelled or destroyed.

64. Battersea: Dawn (K.155, II). Drypoint, 5¾ x 8¾.

The impression illustrated shows the plate in the second state, before additional work to various portions of the buildings, shipping and water. This impression is signed with a particularly elaborate pencil butterfly and "imp." The plate is presumed to have been cancelled or destroyed.

65. Fishing-Boats, Hastings (K.158, II). Etching. 6 x 9 15/16.

Whistler put the date "1877" on the impression of this plate in the Avery Collection. Whistler's mother lived at Hastings for several years prior to her death in 1881, and this plate was probably done during a visit to the seacoast town. In this second state, a large butterfly now covers the area of the small faint outline that had appeared in the first state, and there are some slight lines added to the sky area at the left. The plate is presumed to have been cancelled or destroyed.

66. Wych Street (K.159, I). Etching. 8 5/16 x 5 5/16.

The large lamp showing in the distance in this first state disappears in the final version. Wych Street is off the Strand, in the heart of Victorian London's theater district. Whistler was an enthusiastic frequenter of theaters and music halls. The plate is presumed to have been cancelled or destroyed.

67. The Thames Towards Erith (K.165, II). Drypoint. 5⅞ x 8⅞.

This second state of the rare drypoint from the late seventies shows changes in the sky and the sail of the large boat in the left middle distance. A boat which had been directly in front of this one has been removed. "Greenhithe" (a place on the Thames about five miles below Erith) was the title Whistler wrote on the impression of this plate in the Mansfield Collection, and the name was recorded in the Mansfield catalogue. The impression illustrated here was formerly in the Royal Library, Windsor Castle. The plate is known to have been cancelled or destroyed.

68. From Pickle-Herring Stairs (K.167, IV). Etching. 5 5/16 x 8 15/16.

The impression illustrated, printed on the old book paper that was Whistler's favorite paper for his prints, is the fourth, showing essentially the completed concept of the subject. In two subsequent states, the artist did little more than add a few lines to the buildings at the left-hand side of the plate, and remove some lines from between the masts at the right. The plate is known to have been cancelled or destroyed.

69. A Sketch from Billingsgate (K.168, VI). Etching. 5 13/16 x 8⅞.

According to a pencil note on the impression in the Avery Collection, this plate was drawn in 1878. As with the earlier series of Thames subjects, Whistler now too found some of his best inspirations in the London of wharfside buildings and business that others found too prosaic. The impression illustrated shows the final version of the plate, which is known to have been destroyed.

70. St. James's Street (K.169, IV). Etching. 11 x 6.

This plate was drawn from a house in Piccadilly at the top of St. James's Street, looking down toward St. James's Palace. A lithograph from this plate appeared in *Vanity Fair* in 1878. In the final state, the plate was reduced, and the clouds almost entirely removed. The composition provides an interesting foretaste of the effects Whistler was to achieve within a few years in the arrangement of groups of figures in a street setting, as in many of his Venice scenes.

71. The Large Pool (K.174, VII). Etching. 7⅜ x 10⅞. Done in 1879, this etching shows the Pool of London at Wapping, scene of several prints of the Thames made some twenty years earlier. The state illustrated is the final one. The plate is presumed to have been cancelled or destroyed, since impressions are scarce.

72. The "Adam and Eve," Old Chelsea (K.175, I). Etching. 6⅞ x 11⅞.

This etching of the riverside houses along the Thames at Chelsea is named for the Adam and Eve inn. The tower in the left background belongs to the old Chelsea Church, where Whistler's funeral services were held. Both the Pennells and Campbell Dodgson singled out this print as marking a clear transition in Whistler's etching style from the earlier plates of the Thames to the later ones of Venice. The plate was issued by Messrs. Hogarth & Son in London at six guineas an impression; the published edition was not printed by Whistler,

and impressions are often unclear. The plate is known to have been destroyed.¹ This illustration shows an impression of the first of Kennedy's states, before the butterfly was added to the plate.

73. Under Old Battersea Bridge (K.176, I). Etching. 8 7/16 x 5⅜.
The later states of this plate show additional work on the piers of the bridge and arch, and in the sky and water. In this earliest of three states the arch of the bridge has only five or six lines and the suspension bridge is in outline. The plate is known to have been cancelled or destroyed.

74. Old Battersea Bridge (K.177, IV). Etching. 7⅞ x 11⅝.
Whistler's house in Lindsey Row, Chelsea, where he lived in the sixties and seventies, overlooked the great wooden Battersea Bridge which spanned the Thames until 1880. Wedmore called this print "one of the noblest, most spacious, most refined of Mr. Whistler's visions of the Thames." The impression shown is that of the fourth state, before the large butterfly at the lower right, added in the second state, was erased and replaced by a smaller one further to the left. The final (fifth) state was published by The Fine Art Society, London, in 1879. The plate is known to have been cancelled or destroyed.

75. Old Putney Bridge (K.178, IV). Etching with drypoint. 7⅞ x 11¼.
Whistler probably sketched this bridge, the second of the old Thames bridges taken down in 1880, while on one of his visits by river to Algernon Swinburne's home at Putney. An impression was exhibited at the Royal Academy in 1879, and it was published in the same year by The Fine Art Society at six guineas. A butterfly signature in pencil, on the lower right-hand corner of the margin, does not appear in the reproduction. The state illustrated is that of the Society's edition. The plate is known to have been cancelled or destroyed.

76. Hurlingham (K.181, III). Etching. 5 7/16 x 7 15/16.
Illustrated is the third and final state of this view on the Thames above London which was etched around 1879. It is printed on old book paper, and has an elaborate pencil butterfly in the margins, which are left uncut. Whistler adopted the practice of adding the pencil but-

terfly signature at roughly this time, but the practice of trimming margins to the plate edge with the exception of a tab began several years later. This plate was published by the Printsellers' Association.

77. Little Venice (K.183, only state). Etching. 7¼ x 10⅜.
This view of Venice from across an expanse of water was drawn, according to Otto Bacher, from one of the islands in the Lagoon which Whistler visited on board a regular excursion steamboat. Evidently the first biting satisfied the artist, and the plate is known in only one state. Published in *Venice, a Series of Twelve Etchings* (the first Venice set) by The Fine Art Society in 1880, the plate is known to have been cancelled or destroyed.

78. Nocturne (K.184, IV). Etching with drypoint. 7⅞ x 11⅝.
In his first explorations of the medium of lithography in London in the late 1870s, Whistler made two "nocturnes" of the Thames in lithotint. The "nocturne" effects in various plates of the two Venice sets (K.202, 213, 223, 226) were achieved largely by careful wiping and printing the plates with a film of ink remaining on the surface. This print was published in *Venice*, and the plate was destroyed or cancelled after the completion of the edition.

79. The Little Mast (K.185, II). Etching. 10½ x 7¼.
Joseph Pennell said that this scene was drawn in the Via Garibaldi near the Public Gardens in Venice. The state illustrated is Kennedy's second, in which the rich drypoint work, especially in the foreground, has been greatly reduced, in preparation for further changes to the plate. This print was published in *Venice* as a substitution for "The Bridge," and the plate was cancelled or destroyed when the edition was completed.

80. The Little Lagoon (K.186, II). Etching with drypoint. 8⅞ x 6.
This is another plate from *Venice*. The gondola, lightly etched in the first state, is here redrawn with short, heavy lines, and with a strong reflection added in the water below. The plate is known to have been cancelled or destroyed.

81. The Palaces (K.187, III). Etching. 9⅞ x 14⅛.
This plate, published in *Venice*, is the largest of all Whistler's works in this group. The state

illustrated is the third and final state, after the butterfly, added in the previous state, was removed from the plate. The cancelled plate for this print is still in existence.

82. The Piazzetta (K.189, V). Etching with drypoint. 10 x 7⅛.
Although Whistler generally avoided the familiar tourist's Venice when selecting his subjects, he did include some well-known places in his first Venice set, such as this view of the Piazzetta with St. Mark's column in the foreground and the church in the distance. Typically, he drew on his plates without reversing the scene, and the prints are all in mirror image. The plate is known to have been cancelled or destroyed.

83. The Traghetto, No. 2 (K.191, IV). Etching. 9¼ x 12.
This is an impression from the plate that Whistler made to replace "The Traghetto, No. 1." It was published in the first Venice set. Otto Bacher recounts the pains Whistler took in order to duplicate the first state of his earlier plate. He even used a proof of the first plate printed with white paint to obtain a "drawing" for the second. In fact, the second plate begins with the third state of "The Traghetto, No. 1." Whistler then made extensive changes to the left-hand portion of the plate, most of which are present in the state illustrated. The plate is known to have been cancelled or destroyed.

84. The Riva, No. 1 (K. 192, III). Etching. 7⅞ x 11½.
This plate is another of the few scenes of the familiar Venice that Whistler included in his two Venice series (this is in the first set). The house where he lived during most of his stay, the Casa Jankovitz, was located on the Riva degli Schiavoni. The impression illustrated bears the butterfly signature in pencil, but the margins are not trimmed. The plate is known to have been cancelled or destroyed.

85–87. The Two Doorways (K.193, I, IV and VI). Etching with drypoint. 8 x 11½.
This plate and "The Doorway" (K.188) were included among Whistler's own favorite prints —"my beautiful doorways from Venice," as he once wrote of them to Howard Mansfield. Three states of this plate are illustrated here, showing the great variation Whistler achieved in the impressions of his Venice plates. In some cases the changes were due to additional work; in other examples, the manner of inking and wiping the plate accounted for the altered appearance. No. 85 shows the very first state (before Kennedy's original first state) bearing in the lower margin a pencil butterfly and the notations in Whistler's own hand "1st state, 2nd proof" and "Printed in Venice." This state shows most probably only the work done on the spot, sketching from a gondola, as was Whistler's practice. No. 86 shows the fourth state after considerable reworking, including the erasure of some work which had first appeared in K.193, II. The inking of the doorway to the left and the water in the foreground is particularly rich, to contrast with the lighter portions in the upper half of the plate. No. 87 shows the last of Kennedy's recorded states of this plate. There has been extensive work added to the left-hand portion of the plate since the fourth state; there are once again two figures as well as the old man in the left doorway; and the archway of this door as well as the water in front has been retouched and altered. Although this state shows much new drypoint work, the plate as a whole has been much more cleanly wiped, giving a lighter impression than the earlier state. Published in the first Venice set, the plate is known to have been cancelled or destroyed.

88. The Beggars (K.194, IV). Etching with drypoint. 12 x 8¼.
Whistler made such numerous changes in both the figures and the arch in this plate that by the third state it appeared to be almost a different print from the first state. The old man and a girl who originally stood beneath the arch were changed to a young woman and a little girl, then to an old woman and a slightly taller child. The plate also went through many changes in the states succeeding the one illustrated. Published as one of the first Venice set, the plate is known to have been cancelled or destroyed.

89. The Mast (K.195, V). Etching. 13⅜ x 6⅜.
In the foreground of this print is one of the groups of needlewomen working out of doors that Whistler found on almost every street in the poorer quarters of Venice, and that he sketched frequently in various media. The impression illustrated is of the fifth state, with the butterfly added above the head of the boy at the left. Published in the first Venice set,

this plate is known to have been cancelled or destroyed.

90. San Biagio (K.197, IV). Etching. 8¼ x 12. This plate was included in the second Venice set, *A Set of Twenty-six Etchings*, published by Messrs. Dowdeswell of London in 1886. The impression illustrated is most probably Kennedy's fourth, though traces of the shadowy figure to the left of the beached boat are still visible. San Biagio was in the Castella quarter of Venice, near the Casa Jankovitz where Whistler lived. The plate is known to have been cancelled or destroyed.

91. Nocturne: Palaces (K.202, VIII), Etching with drypoint. 11⅝ x 7⅞. This plate, also in the set of *Twenty-six Etchings*, was supposedly done from Whistler's room in the Casa Jankovitz, at the lower end of the Riva degli Schiavoni. From one window of his room he had a view toward the Doge's Palace and the Piazzetta, from another a vista that encompassed the Churches of San Giorgio and Santa Maria della Salute. Most of the changes Whistler made on this plate in its many states consisted of adding or erasing drypoint lines. The effect he achieved depended largely upon the inking and printing of the plate, which was eventually destroyed.

92. Long Lagoon (K.203, I). Etching. 6 x 9. Whistler arrived directly at the effect he wished to achieve in this print, and the only change between the first and second states is the addition of the butterfly. Wedmore described the print as being "faint, of considered slightness, without light and shade, the effect is like that of a silver-point." Published in the second Venice set, the plate is known to have been cancelled or destroyed.

93. The Bridge (K.204, VII). Etching. 11¾ x 7⅞. Howard Mansfield identified this plate as a spot in the Giudecca, the ghetto of Venice. It was originally announced for inclusion in the first Venice set but, no doubt because of the incompleteness of the plate, "The Little Mast" was substituted. "The Bridge" was eventually published in the *Twenty-six Etchings* in 1886. The impression illustrated shows the completed version of the subject, although some of the drypoint lines in the water and sky were removed in the subsequent, final, state. The plate is known to have been cancelled or destroyed.

94. Upright Venice (K.205, II). Etching. 10 x 7. According to Otto Bacher, Whistler first etched the upper part of this view of the Grand Canal from his window in the Casa Jankovitz, pulled a few proofs, then added ground to the lower half of the plate and etched that. The impression illustrated shows this second state with the boats, wharf and foreground added. It was printed with a slight ink tone covering the entire surface of the plate. Published in the *Twenty-six Etchings*, the plate is known to have been cancelled or destroyed.

95. The Riva, No. 2 (K.206, I). Etching. 8¼ x 12. Another view of the Riva degli Schiavoni running from the Piazzetta along the Canale di San Marco, this plate was also published in the *Twenty-six Etchings*. According to Otto Bacher, the etchings of the same scene which Frank Duveneck exhibited in London in 1881, almost causing a quarrel between Whistler and The Fine Art Society, were done first, and were the inspiration for Whistler's two plates of the thoroughfare. The plate is known to have been cancelled or destroyed.

96. Fishing-Boat (K.208, IV). Etching. 6⅛ x 9⅛. Although the third state of this plate, the one first published in the *Twenty-six Etchings*, was the one E. G. Kennedy considered the completed version of the plate, the artist continued to make a number of slight changes during publication of the set. In this example of the fourth state the man's face is now dark owing to the effect of printing. The lines in the awning over his head are now rubbed down and confused. The butterfly in the plate was removed in the third state, but this impression bears a pencil butterfly on the tab. The plate is known to have been cancelled or destroyed.

97. Garden (K.210, IV). Etching with drypoint. 12 x 9¼. Whistler was particularly fond of the unexpected scenes he discovered on his exploration of Venice, such as this enclosed garden seen through a door in a high wall along a canal. The figure of a second boy on the steps leading to the garden, which appeared in earlier states of the plate, was replaced by a cat in the fourth state, published in the *Twenty-six*

Etchings. The plate is known to have been cancelled or destroyed.

98. The Rialto (K.211, I). Etching. 11½ x 7⅞.
In a later state, this plate was published as one of the *Twenty-six Etchings*. It shows a broad street leading up to the Rialto bridge, with the tower of San Giovanni Elemosinario in the background. The plate is known to have been cancelled or destroyed.

99. Long Venice (K.212, V). Etching. 5 x 12¼.
This plate shows the Grand Canal of Venice from the Doge's Palace at the left to far beyond the church of Santa Maria della Salute at the right. The view is in mirror image, since Whistler drew directly on his plates without reversing. The impression illustrated shows the plate in its final form; the effects achieved by wiping the plate to leave a slight film of ink are particularly noticeable in the foreground. Published in the *Twenty-six Etchings*, the plate is known to have been cancelled or destroyed.

100. Quiet Canal (K.214, V). Etching. 9 x 6.
Impressions of the first state of this plate show three prows on the gondola with a man in it, where Whistler corrected the drawing without completely removing earlier versions. Later the extra prows were removed with a hammer and anvil, then the spot was rubbed down with stone and charcoal. The impression illustrated shows the fifth and final state, after these and other alterations had been completed. Published in the *Twenty-six Etchings*, the plate is known to have been cancelled or destroyed.

101. La Salute: Dawn (K.215, IV). Etching. 4⅞ x 7⅞.
At the extreme left are seen faintly the domes of St. Mark's. When the plate was published in the *Twenty-six Etchings*, Whistler removed a gondola in the foreground that had appeared in the first state, and erased clouds and shading in the water. The plate is known to have been cancelled or destroyed.

102. Fish-Shop, Venice (K.218, V). Etching. 5⅛ x 8¾.
The impression illustrated is of Kennedy's fifth of seven states of this plate though impressions of at least one intermediate state have been recorded. This subject was not included in either of the published sets of Venice, though examples appear to be at least as numerous as most of the plates of the *Twenty-six Etchings*. Whistler adored the bustling, active life of the poorer shops or markets, and etched many plates of them, both in London and on the continent.

103. Little Salute (K.220, II). Drypoint. 3 3/16 x 8⅜.
Whistler drew this plate from the window of his room in the Casa Jankovitz. Not included in either of the issued sets of Venice, it was described by Wedmore as "a somewhat vague and unimportant drypoint," but it is nonetheless an excellent example of how Whistler could use the slightest of lines to good effect.

104. Old Women (K.224, I). Drypoint. 4⅞ x 7⅞.
This plate of a group of gossips seated before a doorway in one of the shabbier quarters of Venice was not included in either of the published sets of Venice, and is quite scarce. This impression is signed in pencil and marked "1st proof" in Whistler's hand. It was most probably pulled in Venice.

105. Temple (K.234, only state). Etching. 4 x 6.
This was one of the five non-Venetian subjects published in the so-called second Venice set. Although entitled "Temple," it shows not the actual chapel or church which survived from the days of the Knights Templars, but instead one of the quiet squares of houses within the ancient Temple grounds, which have been inhabited through the centuries by such real celebrities as Dr. Johnson, and by a number of characters in English fiction.

106. Lobster-Pots (K.235, I). Etching. 4⅝ x 7⅞.
One of five English subjects included in the second Venice set, this plate was probably etched during a visit to C. A. Howell's house at Selsea Bill on the seacoast. It was done sometime before 1882, when the affair of the "Paddon papers" put an end to Whistler's friendly relations with Howell. The plate is known to have been cancelled or destroyed.

107. The Smithy (K.240, III). Etching with drypoint. 6⅞ x 8⅞.
An impression of this plate owned by Colnaghi's of London in 1923 was inscribed on the verso "Serang," indicating that it may have been etched on one of the several trips to Belgium Whistler made in the 1880s. Forges

and smithies held a continuing fascination for Whistler, and they appear in a number of his prints, both etchings and lithographs. The figure to the left of the butterfly is shown sketchily in this state.

108. Dordrecht (K.242, II). Etching. 5 15/16 x 8 15/16.
This lightly etched plate was dated 1884 by Wedmore, although it may also have been done during the trip to the Low Countries Whistler made with his brother and sister-in-law in 1887. In this second state, drypoint has been added to the mainsail and jib of the large boat in the center of the plate. Impressions of this print are scarce, as is the rule with prints not included in the various published sets.

109. The Village Sweet-Shop (K.251, only state). Etching. 3 3/16 x 4 13/16
This small plate combines many of the features Whistler found most appealing in his sketching jaunts: the picturesquely dilapidated condition of the buildings, the groups of shabby children playing about the shadowed shop opening. These elements appear in many of the small prints he made about this period.

110. Woods's Fruit-Shop (K.265, II). Etching. 3¾ x 5 3/16.
Mortimer Menpes has recorded in *Whistler as I Knew Him* the artist's typical working practice in making his London plates: he would plant himself in front of the shop chosen and sketch directly on the plate, ignoring any curiosity on the part of passers-by. Additional work on these plates, probably done later in his studio, was usually very slight. Changes in the second state of this print include shading on the windowpane at the left and around the figure of the woman in the center.

111. The Fish-Shop, Busy Chelsea (K.264, I). Etching. 5 7/16 x 8 7/16.
Another of the London street scenes that Whistler produced between his return from Venice and the end of the 1880s, this, according to Wedmore, shows a shop on Milman's Row on a summer midday. The print was issued in a limited edition for the Royal Society of British Artists, of which Whistler was for a time president.

112. Savoy Scaffolding (K.267, only state). Etching. 7 x 3 3/16.
This view of the scaffolding around the Savoy Hotel were sketched from the private office of "Miss Lenoir," the professional name of Mrs. D'Oyly Carte. The plate was made in the winter of 1885–1886, when Whistler visited the Savoy Theatre frequently to discuss the forthcoming production of *Mr. Whistler's Ten O'Clock*, which Miss Lenoir produced in February 1886.

113. Fleur de Lys Passage (K.289, III). Etching. 7 3/16 x 3 3/16.
Despite the difference in title, this plate shows the same scene portrayed in K.287 and 288, the Old Clothes Exchange. This was the latest established of London's noted outdoor markets, largely patronized by the very poor. It was founded in the 1840s in the Petticoat Lane district in an attempt to regulate the frequently rowdy and even violent street trading in second-hand clothing. Illustrated is the final version of this plate, with additional work behind the gateway in the distance, suggesting a garden.

114. Rochester Row (K.269, I). Etching. 5⅞ x 8⅞.
The impression illustrated is of the first state, before the addition of drypoint work to the plate and the shading of the butterfly, which appears here only in outline. Rochester Row is south of the Thames, close to two celebrated London inns, Chaucer's famous Tabard and the much later Elephant and Castle, which gave its name to the surrounding area.

115. The Barber's (K.271, only state). Etching. 6⅜ x 9⅜.
Another of the London street scenes, probably sketched directly on the spot, this satisfied Whistler without any additional work. A similar scene is "Shaving and Shampooing," K.273.

116. Rag-Shop, Milman's Row (K.272, II). Etching. 6 x 9.
According to Mortimer Menpes, one of the tasks of Whistler's "followers" in the 1880s was to locate picturesque shops for him to etch. Once the subject was chosen, Whistler would borrow a chair from a nearby merchant and sit on it until the plate was completed, delighting in the curiosity of passers-by.

117. Bird-Cages, Chelsea (K.276, only state). Etching. 6 x 8 15/16.
The keeping of birds as pets was quite common in the last century. Favored species were not

limited to imported exotics, but included ordinary domestic songbirds trapped in the country and often peddled in the streets, as Henry Mayhew records. The demand was also great enough to support fixed establishments for the selling of cages. A similar subject by Whistler is "Bird-Cages, Drury Lane," K.281.

118. Petticoat Lane (K.285, I). Etching. 3 11/16 x 5 3/16.
This impression is of the first state of Whistler's view of the street in East London which is still the site of a famous outdoor market held once a week. In the only subsequent state, shading was added to the window and doorway. The plate is known to have been cancelled or destroyed.

119. St. James's Place, Hounsditch (K.290, only state). Etching. 3⅛ x 6⅞.
Another East End subject, in which the emphasis is on the vivacity of the life rather than its poverty. Whistler combed the poorer sections of the English capital for topics for his etchings, much as Henry James, and Charles Dickens as the "Uncommercial Traveller," roamed the same areas to find material for their writings.

120. Melon-Shop, Hounsditch (K.293, I). Etching. 5 x 6⅞.
"Sunrise London," as the East End of the city was called in semi-underworld slang of the past century, held a place in Whistler's affection fully as strong as the banks of the Thames and the still-countrified Chelsea. The impression illustrated shows this plate in its first state, with the butterfly still in outline, and before the addition of much work to the figures and the interior of the shop.

121. The Cock and the Pump (K.304, only state). Etching. 8 9/16 x 5½.
Kennedy placed this plate among a group of scenes etched at Sandwich, but gives no specific location for this particular subject. Although the plate is lightly etched, it was printed with a definite film of ink left on, and the wiping marks show very clearly at the lower left.

122 Tilbury (K.317, only state). Etching. 3⅛ x 6 15/16.

123. The Turret-Ship (K.321, only state). Etching. 5 x 6⅞.

124. Dipping the Flag (K.325, only state). Etching. 3⅛ x 6⅞.

125. Return to Tilbury (K.327, only state). Etching. 5 3/16 x 3 13/16.

126. Monitors (K.318, only state). Etching. 5½ x 8 11/16.

127. Bunting (K.324, only state). Etching. 6 11/16 x 4⅞.

128. Visitors' Boat (K.320, only state). Etching. 6⅞ x 4⅞.

129. Ryde Pier (K.328, only state). Etching. 5 3/16 x 3⅝.

These eight plates belong to a group of twelve etchings that Whistler completed in the course of a single afternoon—July 27, 1887—when he witnessed the Naval Review held in honor of Queen Victoria's Golden Jubilee. Quite fittingly, the review began and ended at Tilbury, site of the stirring speech made by Victoria's famous predecessor, Elizabeth I, before the approaching invasion of the Spanish Armada. The artist personally printed a set of these etchings and presented them to the Queen through the First Lord of the Admiralty, but apparently they were never otherwise printed as a set, and are extremely scarce even in individual impressions. Unhappily for posterity, one of Whistler's fellow guests at the Naval Review was the monarch's German grandson, soon to become Kaiser Wilhelm II. He was so impressed by the display of England's maritime prowess that he returned home fired with the amibtion to make Germany a first-class naval power. The result is a matter of history, not art.

130. Wild West (K.314, only state). Etching. 3⅛ x 7⅛.

131. Wild West, Buffalo Bill (K.313, only state). Etching. 5 x 7.

132. The Bucking Horse (K.315, only state). Etching. 3 3/16 x 7 3/16.
When William F. ("Buffalo Bill") Cody brought his Wild West Show to London's Earl's Court in 1887, Whistler attended a performance, taking with him, as was his custom on many jaunts, prepared copper plates small enough to be carried in his pocket. These three plates were etched in the course of an after-

noon's performance, and impressions of all three are quite scarce, especially those signed in pencil. Posthumous impressions without the pencil signature are known.

133. Cameo, No. 1, or Mother and Child (K.347, only state). Etching. 6⅞ x 5.

134. Cameo, No. 2 (K.348, only state). Etching. 6 15/16 x 5.
Whistler thought particularly highly of the first of these two prints (K.347) and asked that it be included in the exhibition of his prints at the Chicago World's Exposition in 1893. Although the work of this period in etching and drypoint include only a few pure figure studies, such as these studies of a woman and child, the theme was a comparatively frequent one in his pastels and lithographs of the time; for example, lithographs close in subject include Way 80, 102, 134, 135 and 136.

135. Palaces, Brussels (K.361, I). Etching. 8⅜ x 5½.
There seems to be no question that Whistler eventually intended to issue a set of etchings of Brussels, but he never carried the project through. Small as it is, this plate would certainly have been among the largest and most imposing of the proposed series.

136. Grand' Place, Brussels (K.362, only state). Etching. 8⅜ x 5½.
During the tour of Belgium made with his brother and sister-in-law in 1887, Whistler followed his usual practice of etching his plates directly, wherever he found a suitable subject. His brother recalled that in Brussels Whistler was sometimes driven to use his etching needle as a weapon to ward off excessively curious bystanders. Like the majority of the plates in the later "Brussels" and "Holland" series, the plate is lightly etched and bitten, but this impression was richly inked for printing tone on the plate.

137. Château Verneuil (K.380, only state). Etching. 6⅞ x 4⅞.
This plate is one of a number of etchings Whistler made during his honeymoon trip through Touraine in 1888—a sort of busman's holiday—following his mariage to Beatrix Birnie Phillip, the widow of E. A. Godwin.

138. Steps, Amsterdam (K.403, IV). Etching with drypoint. 9½ x 6½.

In addition to the series of Brussels prints which never materialized, Whistler evidently planned a set of Amsterdam subjects, which also was never carried out. According to the artist's own statements, the technique of many of the later etchings, particularly the Brussels and Amsterdam plates, combined the technique of the early Thames plates with the impressionism of the Venetian subjects. The Amsterdam series of the late 1880s forms the last important group of Whistler's etched work. In the opinion of many students and critics, the artist seemed to recover his finest inspiration in the land of Rembrandt, which he had first visited a quarter of a century before. The impression illustrated shows the final version of the plate.

139. Square House, Amsterdam (K.404, *Ia*). Etching. 9 1/16 x 6⅞.
When the Kennedy catalogue was issued in 1910, this was the first state known. Since then, a prior state has been discovered with no butterfly on the plate. There is also somewhat less shading on some of the windowpanes in that earlier state, and the figures along the railing are more lightly drawn.

140. Balcony, Amsterdam (K.405, III). Etching. 10¾ x 6⅞.
The impression illustrated is of the third and final state, with additional work concentrated on the shadow in the water. Like a number of the Amsterdam subjects, this print is reminiscent of Whistler's Venice scenes, with its effects of shadow and reflection in the water, and the lines of hanging wash dominating the upper portion of the plate.

141. Long House—Dyer's—Amsterdam (K.406, I). Etching. 6½ x 10⅝.
The illustration shows one of the extremely small number of impressions of the first state, before the figures of a woman and child were drawn in near the boy leaning over the fence, and additional work was done all over the plate. Possibly fewer than ten impressions of this state were printed by Whistler before beginning alterations to the plate.

142. Pierrot (K.407, IV or V). Etching with drypoint. 9 x 6¼.
There seems to be no published explanation of the title of this print. Possibly it comes from the resemblance of the white clothes and cap of the figure on the left to the traditional costume of the *commedia dell 'arte* figure, just

as Whistler's own title for K.437, "The Bear-skin," was chosen because the woman's hat resembled a soldier's headgear. The impression illustrated appears closer to Kennedy's fifth state than to the fourth, although the difference in effect is perhaps more a matter of inking, wiping and wear to the delicately bitten lines than of specific changes to the plate.

143. Nocturne: Dance-House (K.408, I). Etching with drypoint. 10⅝ x 6 9/16.
This impression matches the description of Kennedy's first state with the two figures in the window at the upper left, and the rays from the lamp smaller than in Kennedy II. The cataloguer himself, however, admitted to some confusion over sequence of states in this plate, and impressions are too few to detect any wear in the plate which might provide a further clue. This print makes an interesting comparison with the "Street at Saverne" (Plate 9), the artist's first night piece, made some thirty years earlier.

144. Bridge, Amsterdam (K.409, III). Etching. 6⅜ x 9 7/16.
This Amsterdam subject contains strong reminiscences of both Venetian and London riverside subjects. The chief changes in the later states were made in the water, sky and shadow effects. The print is comparatively scarce, as are most of the Amsterdam group.

145. The Embroidered Curtain, or The Lace Curtain (K.410, VII). Etching with drypoint. 9⅜ x 6¼.
This plate was first lightly etched, then worked over completely with extremely delicate drypoint lines. It was one of Whistler's own favorites among his plates, and has been called "not unworthy to stand beside Vermeer's *Little Street*." The state illustrated is the seventh and final state in Kennedy's catalogue. Although there is some new work added to the plate, the principal changes in effect appear to

have been achieved by scraping or rubbing the entire plate down with charcoal.

146. The Mill (K.413, V). Etching with drypoint. 6 5/16 x 9 7/16.
The impression illustrated shows the final state of this subject. The shadowy interior, contrasted with the brightly sunlit scene beyond the open doorway, recalls several of Whistler's earlier works, such as "The Forge" (Plate 36) and a number of the Venice subjects. The number of impressions of this print in existence is comparatively small, probably smaller in total than many of the subjects in the second Venice set.

147. Zaandam (K.416, II). Etching 5 1/16 x 8 9/16.
This landscape has been called "one of the most wonderful etchings in all Whistler's oeuvre" and "one of the greatest landscapes ever etched." It was one of Whistler's personal favorites, and one he chose to be shown at Chicago in 1893. The impression illustrated is of the second state, with the addition of delicate drypoint work all over the sky. Impressions of this print are extremely scarce, and this, coupled with its great beauty, has made it one of the most sought after of Whistler's etchings.

148. Marchand de Vin (K.421, only state). Etching. 3 3/16 x 7 15/16.
In the 1890s Whistler was once again resident for much of the time in Paris, and many of his last completed etchings were made in the same city where his career as a printmaker had begun. Some twenty etchings were made during this later residence in Paris, but they indicate only a small portion of his activities, for he was at the same time much preoccupied with making lithographs, painting and conducting an art school as well. The title of this print means "wineseller."